COMPUTER IMAGES

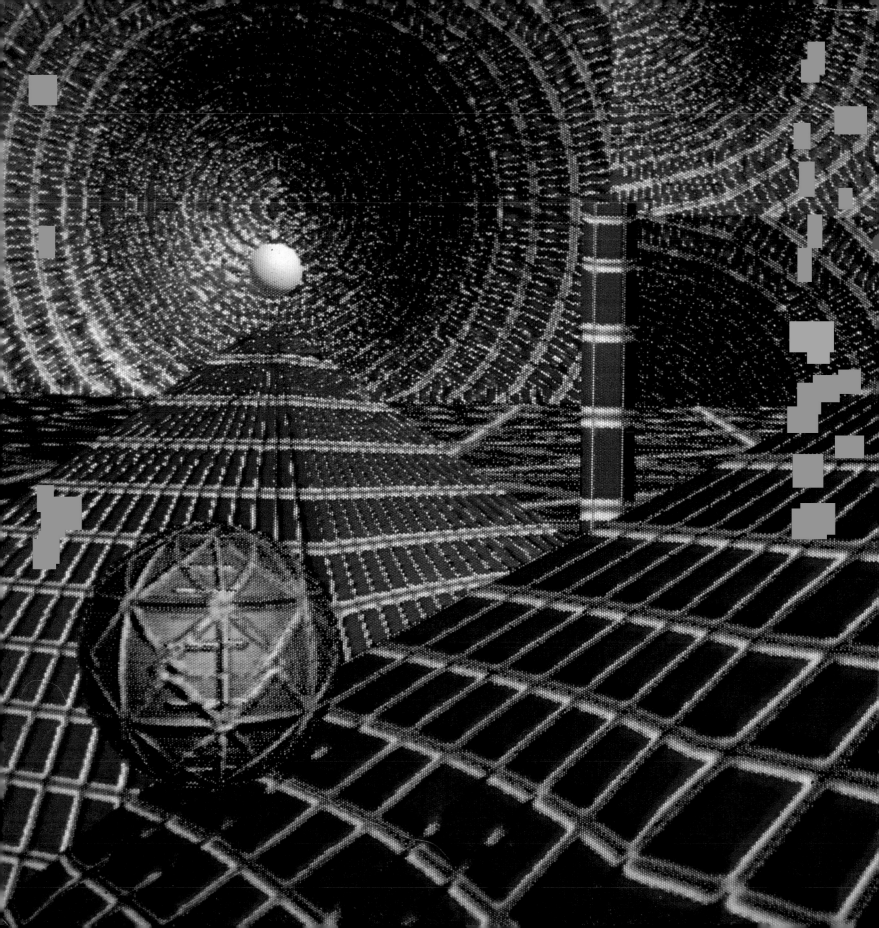

JOSEPH DEKEN

COMPUTER IMAGES

STATE OF THE ART

PICTURE EDITOR
Hildegard Kron

EDITORIAL DIRECTOR
Edward Rosenfeld

THAMES AND HUDSON

First published in Great Britain in 1983
by Thames and Hudson Ltd, London

Printed and bound in Italy

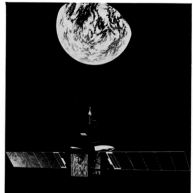

The computer is a machine that is capable of creating images of captivating power and beauty. New techniques, such as electronic collage, dynamics and transformation, interact with such traditional elements as form, shading and color to produce these images and effects.

The invention of the computer, like that of the telescope and the microscope before it, expands not only the range of our senses but our vision of the universe.

Computers have revolutionized the methods by which images are made. Computers specially equipped with graphics devices are sensitive to the movements of the computer artist. These computers function as the artist's apprentice, quickly taking care of all repetitive, complicated and tedious details.

While words can be used to answer some questions, a visual image may provide a clearer and faster explanation. Computer-generated imagery now makes comprehensible the masses of details in fields ranging from microcircuits to macro-engineering. The computer visualizes such information for us by making a picture.

CONTENTS

Unlike the camera, the electronic memory-medium is not simply a passive receptacle to be stamped with impressions but is part of an active engine for the processing of information and the creation of language.

Practice makes perfect in areas from flight training to tank maneuvering, and realistic practice in a computer-controlled simulation environment is more economical, efficient and safe than the real thing.

The computer makes possible an added dimension in which there are new rules for time and space; light bends and changes color as you travel. Objects with familiar forms and powerful connotations move in unexpected environments, obeying laws of physics unknown to Newton or Einstein.

Within the computer, information reactions take place, producing spatial patterns of color, shape and form. Sophisticated reactions lead to stable, actively evolving constructions that mimic the processes of biology and developmental genetics.

The eye carries people to different parts of the world, it is the prince of mathematics, its sciences are most certain, it has measured the heights and the dimensions of the stars, it has created architecture and perspective and divine painting.

Leonardo da Vinci
Treatise on Painting

No medium of Leonardo's day could satisfy the creative impulses set in motion by his eyes and intellect. As a young man, he focused on the two-dimensional world of painting. But the same keen mind that enriched the art world with insights from optics, human anatomy and expressive psychology also uncovered, with inevitable clarity, the limits inherent in painting. The canvas would never be a mirror. The beautiful dynamic geometry of birds in flight would never be captured in a static medium, no matter how clearly artistic and scientific eyes might perceive it. Leonardo therefore turned increasingly to the "paradise of the mathematical sciences," hoping to find a medium where an artist might create as widely as the scope of human vision and intellect. Five hundred years later, in the form of computer image support systems, that medium has finally been realized. In a range of subject matter even wider than the breadth of Leonardo's notebooks, computer image technology is enabling artists and scientists to extend the dimensions of human sight and to launch their own creations into visual flight.

At one level, the pictures here are simply a colorful feast of the quality and diversity of this computer imagery. I have also tried to present these images systematically, in order to provide a conceptual framework in which these visual effects can be understood. There is much more to see here than a behind-the-scenes tour of the mechanics of computer imagery. Beyond the excitement of this powerful new visual technology lies a further vision: by creating an environment of advanced computer images, we are radically changing our human perception of art, science and the world.

For capturing new images, the computer is an instrument of unparalleled reach. Entirely new worlds suddenly come into view: the thermal tides of the human body and the activity of the brain, for examples; the geological and biological patterns of the earth's surface; or the radio-wave signatures of objects in space. Like the historic invention of the microscope and telescope, the development of computer-image processing has expanded our vision far beyond the range of the unaided human senses.

The computer also offers a tool of unprecedented power to create and manipulate images. Toiling away at a single manuscript for days, weeks or months, the medieval scribe could never have imagined the torrent of books the printing press would someday unleash. In our own day, computer technology promises to create and disperse a vast flood of imagery, a development that has been equally unforeseen by many

contemporary artists, photographers and filmmakers. Computer imagery is not only a matter of more pictures being generated, but an entirely new form of visual communication, one that permits the individual viewer to adapt to and interact with the image itself.

No other medium has ever given the artist such complete control. Unlike a painter's canvas, the computer screen will eradicate "paint," just as easily and imperceptibly as it accepts it, or the artist can produce and rearrange complete visual forms with only a single touch of the electronic "brush." Unlike a photographer's portrait, the computer image can be "re-posed" after it has been produced, the lighting or angle rearranged entirely.

The versatility of computer images derives fundamentally from the active electronic memory and processing systems that support them. While the computer memory-medium can store a direct literal representation of a single image, it can also generate an infinite variety of scenes from an internal computational model. The ability to generate these images from a single model far surpasses the laborious scene-by-scene efforts of human technicians.

Like pages rolling from a press, computer images can be frozen and extracted from the modeling process for conventional distribution. Even more interesting, however, is the fact that the viewer can see not just a single frozen image or sequence of scenes, but can interact with the entire computerized image-support system! Such interactive imagery makes it possible for pilots to "fly" in realistic simulated aircraft without ever leaving the ground, or allows soldiers to practice tank maneuvers at a classroom desk. Video travelers can guide their own tours of cities and countries. Nor is the power of illusion confined simply to re-creating realistic situations. The computer can also immerse a willing participant in captivating worlds of fantasy, environments for games and fiction.

The amazing capacity of computer models to generate and reproduce resembles the genetic mechanisms that support biological growth. Seen from this viewpoint, the computer-image system seems not so much a technical tool as it is a life-support environment for the development of lifelike, self-sustaining, and developing structures. Because that environment is unconstrained by any single system of physical laws, it may ultimately produce creatures of astonishing diversity of form and function.

It is far too early to know in detail how the image environment will ultimately evolve. The images here convey the vivid sense of an aesthetic frontier, as well as the excitement of vast new technical and intellectual horizons. Like the ancient merchants who invented clay-token markings without imagining written words or computer programs, or like Galileo with his lenses, we have only the faintest glimpse of the universe our image technology is beginning to unveil.

J. D.

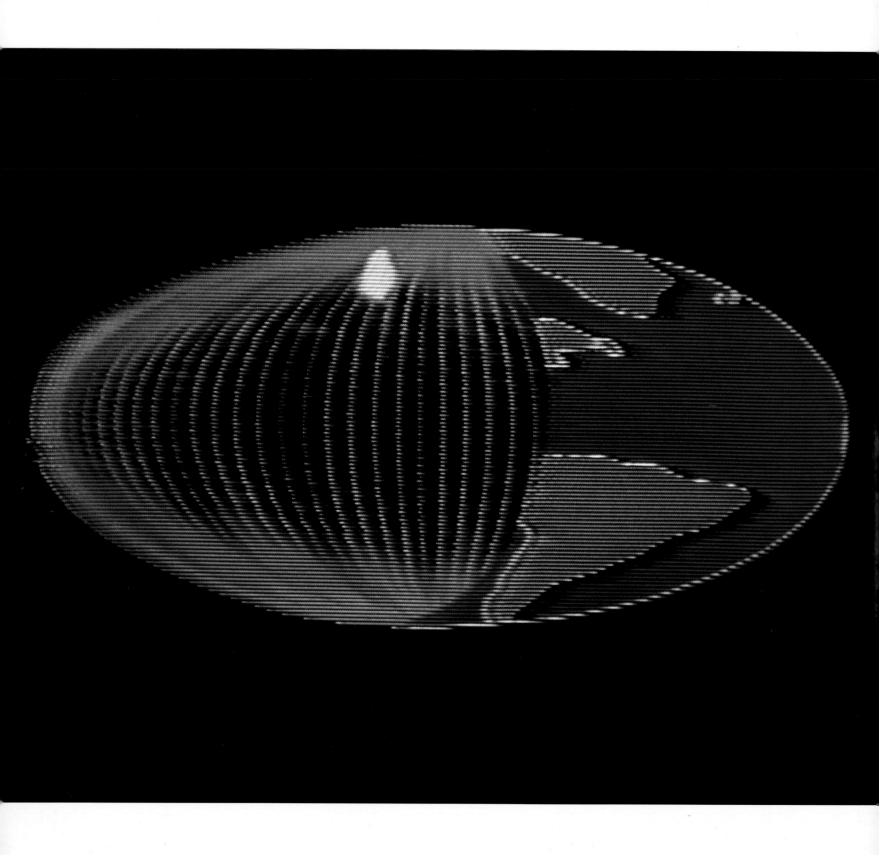

1. COMPUTER IMAGES

The computer is a machine that is capable of creating images of captivating power and beauty. Encompassing globe and galaxy alike, its focus can zoom to the basketball court or probe the structure of molecules with the same fascinating technical ease. Transformed under computer control, television logos whirl in rainbows of color, basketball superstars leap like comets into space (see photos 1 and 2). New techniques, such as electronic collage, dynamics and transformation, interact with such traditional elements as form, shading and color to produce these images and effects. The special effects are marvelous in themselves, but there is more to them than what we see on the surface.

The Image Machine

As these beginning pictures demonstrate, the special effects of computer images can be as commonplace and immediate as television. But the ultimate special effect is far from commonplace and is in fact far from being fully realized. For by creating a visual language in the active medium of computers, image makers have moved us across a human threshold comparable to the moment when some unknown ancestor first created writing by pressing figures into clay.

Back now from teleology to television: when a television station is in need of a spare basketball player,

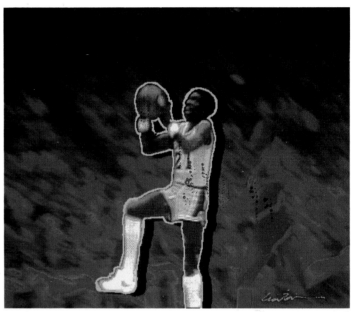

2

1. The launch of any television show is a complicated procedure, and launching a national news show for independent television stations requires special preparation. The producers of "Independent Network News" went to Dolphin Productions in New York City for the development of their logo, the globe, opposite. The logo, which leads into and out of news stories and station breaks, is a very important element in the newscast and is seen at least a half dozen times each broadcast. Dolphin prepared the logo as a series of video sweeps that draw the rotating globe, first sketching it and then changing it into cartoonlike animation. The Dolphin process used to create this logo is known as an analog video effect.

2. This basketball player's image by Lisa Zimmerman of Aurora Systems was originally a freeze-frame taken from a video and brought into the system monochromatically where it was later "painted."

◁ **1**

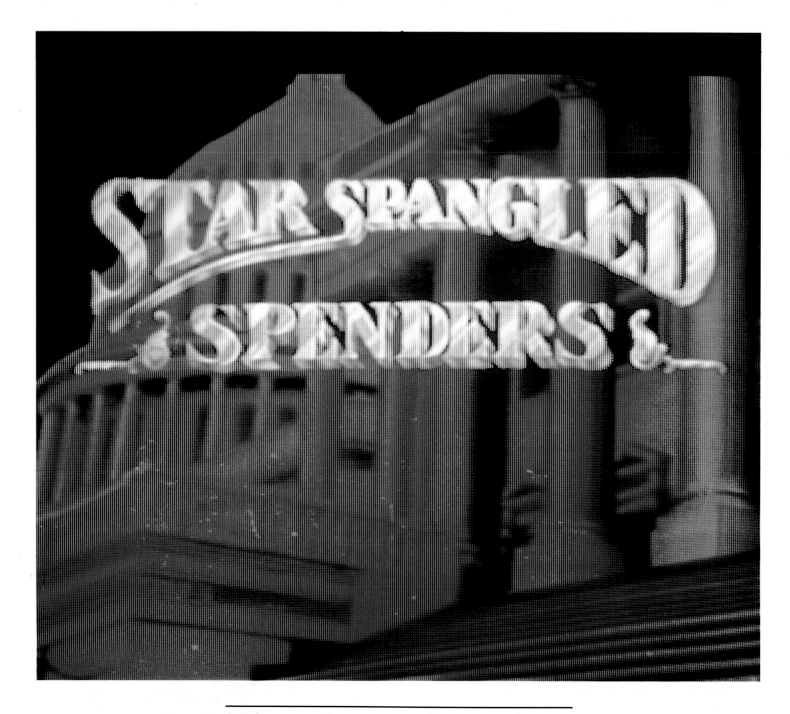

3. Television and computer technologies combine to produce the special effects seen in this bank ad, prepared for TV by the special effects house, Acme Cartoon Company, of Dallas and Amagin, Inc. of Erie, PA.

a title like "Star Spangled Spenders" (see photo 3), or even animated ensembles of trucks and gears, it would be far more efficient to get them by touching a key on a computer than by fumbling around in a film or tape archive. Computers are masters of storing information reliably and retrieving it on demand. Once the stereotyped notion that information only means numbers (like a ballistics formula or a bank balance) is finally laid to rest, visual data can be seen as a fascinating subject for computer storage and retrieval, thereby setting the stage for complete push-button production facilities in which the computer automatically recalls and controls this new data from its memory. While it may be a few years away for your local station, computer devices for titling, for example, are rapidly becoming the norm. A modern producer need no longer anticipate spending weeks on such a project or settling for rough lettering. Instead, the project can be accomplished in an instant by typing the title on a studio keyboard.

The practices of the television studio may sound remote and esoteric despite the familiarity of their effects. But for an increasing number of people, the electronic image is even closer than a weekly sports spectacular or the nightly news. These people create their own electronic images. Although these images appear on the familiar television set, the video is provided by the household's home computer.

The home computer "paintings" presented here (see photos 4 and 5) are simply two freeze-frames of a dynamic electronic painting, which automatically evolves in time after being created by the artist. This evolution is an entirely new dimension of art made possible by computer images. The images made on a home computer may seem grainy or restricted, and reinforce a stereotype that "computer art" means exercises in straight-edge or plane geometry. In the environment of complex and powerful computer systems though, the restrictions of form and effect have vanished. It is exciting to realize that microprocessors are continually bringing personal and home computers nearer to the image power of the larger machines.

4

5

4, 5. Computers can do the most amazing things with an image: change it in size, shape, extension, color, hue, texture or brightness, for example. By using a computer as a painting machine the artist can create imagery that is dynamic—that literally moves. These two frames from such a "moving painting" were done by researchers at Atari to aid in the development of the graphic capabilities of the home computer.

6. *Mural,* opposite, by Paul Jablonka was created on a Data General Eclipse computer and then photographed. Made in 1981, it shows the subtleties and complexities of color, hue and saturation that the computer provides the artist.

7. Joanne Culver's *Frozen Suncone,* right, was done in 1982 on a Digital Equipment Corporation minicomputer PDP 11/45 with Vector General display and a Sandine image processor. The scan lines of the video display unit can still be seen in the final product. As faster, more powerful computer equipment becomes available at cheaper prices, scan lines will disappear from computer art.

7

A Bit of Background

What is it like to create and work with computer images? How does the computer represent a picture for storage or for display? And how can the computer acquire new pictures from artists or from its own direct sensing of the environment?

Representation: Unlike a color photograph or a painting, a typical computer image is not smooth and continuous but contains small individual picture elements, or *pixels*, which are arranged in rows and columns like the individual tiles of a mosaic. These picture elements are all the same shape, and each element is assigned one of a small number of predetermined colors. This mosaic arrangement makes it easy to store pictures even if you are working with a computer that has been primarily designed to handle numbers: for example, if each tile has one of 8 possible colors, coded as 0,1,2,3,4,5,6,7, the mosaic can be stored in the computer's memory as a long list of the code numbers (0–7) of all its tiles and can be taken from the picture in left-to-right, top-to-bottom order. To display the picture, the computer's rapid circuitry then scans its memory in exact synchrony with the beam inside a video-display tube (e.g., a color television). As the beam sweeps over each point on the screen of the display, the number stored in memory for that location releases a voltage that produces the desired color at that spot on the screen.

The mosaic representation also explains why these home-computer images (see photos 4 and 5) often appear rough and granular in contrast to the smoother high-tech images that follow: relatively few numbers can be stored on a small computer, so the mosaic used has only a few large pixels and a small selection of possible colors. Thus, unlike the situation in larger and more complex computers, the boundaries between pixels are easily visible, and colors cannot change smoothly because there are no intermediate colored tiles to blend between different regions.

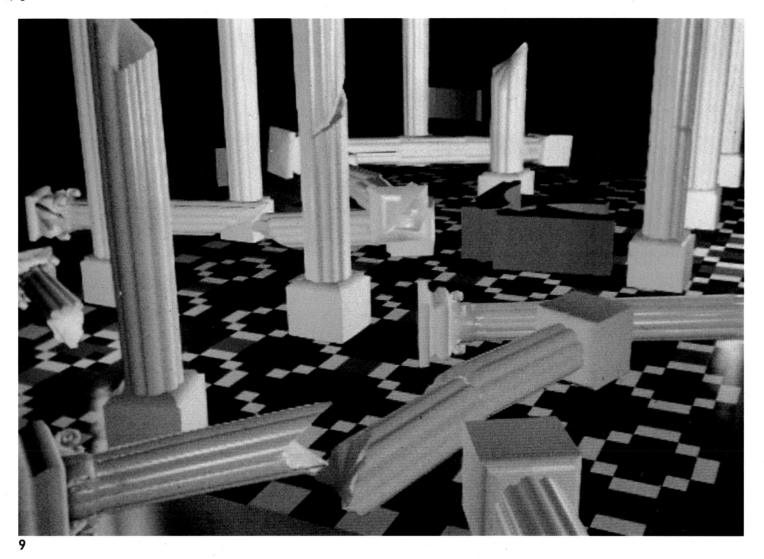

9

8. *Mathscape* by Melvin L. Prueitt, opposite, is the shape of computer art to come. Prueitt does his artwork at the Los Alamos National Laboratory in New Mexico, one of the few institutions in the United States that has a powerful Cray supercomputer. Such a machine is capable of performing millions of mathematical computations every second, resulting in the supple smoothness, brightness and intensity of the colors and forms in the images it produces. Supercomputers are rarely used to create art, however. Most of their very expensive operating time is spent solving problems in weather forecasting, oil and mineral exploration and the design of nuclear weapons systems.

9. *Columns and Arches* was produced in 1981 by Richard Balabuck on a Digital Equipment Corporation minicomputer called the VAX 11/780. Balabuck's work was done at the Computer Graphics Research Group at Ohio State University. This piece was displayed on a custom frame buffer with display by Franklin C. Crow and the data was generated with software developed by Wayne Carlson.

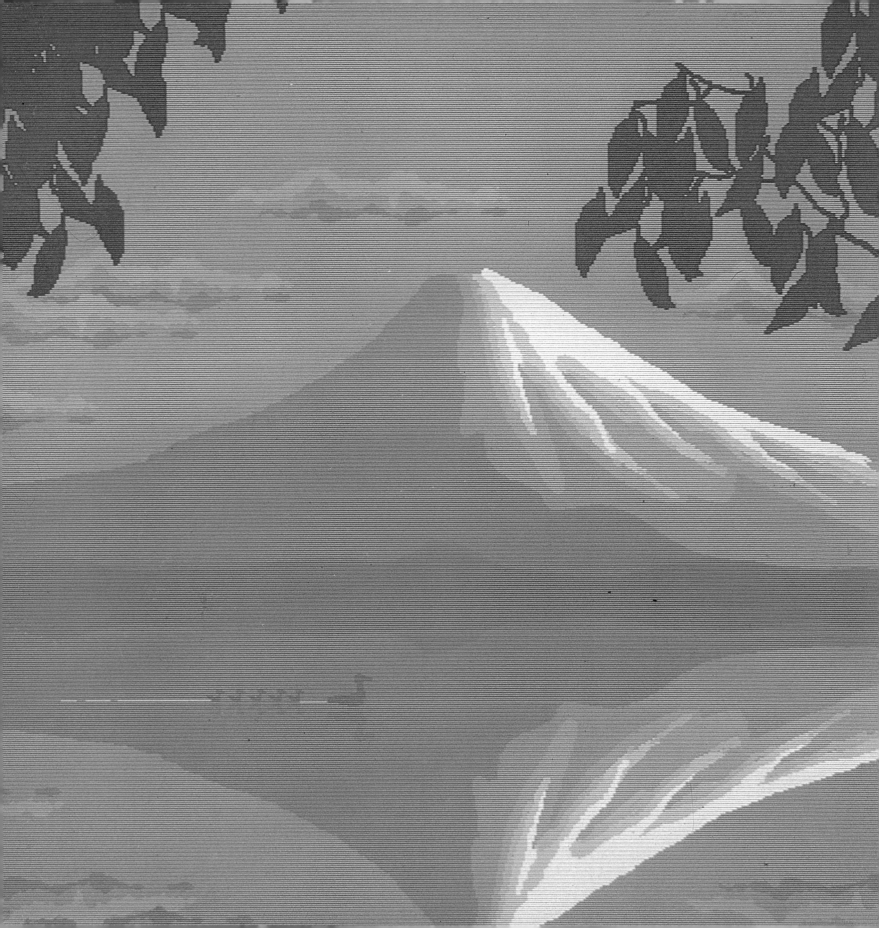

10. Mount Fuji and its reflection were created by Damon Rarey while in Tokyo in only fifteen minutes on an Aurora paint and animation system. The system was developed by the founder of Aurora, Dr. Richard Shoup, who had previously done pioneering work at Xerox PARC on a computer painting system known as Super Paint.

11. Computer special effects are often most powerful when used subtly. This picture of a newscaster seems completely normal when first viewed. What role has the computer played? It was used to enhance the blue of his eyes.

11

Image Acquisition: The mosaic format is well suited to storing, processing and displaying images on conventional computers. However, the question arises: Is it easily suited to creating pictures? If the human artist or technician actually had to build mosaics tile by tile, the answer would be a resounding no, since polished computer images work from mosaics of millions of tiles. Selecting an individual mosaic tile, like painting the single intersection of two threads on a canvas, might be within the capability of an artist, but it is an extremely tedious and difficult task.

One way in which the computer acquires new pictures is from direct environmental sensing. A computer, like many other electronic devices, can sense external events, such as the turning of a television-volume knob,

the movements of the controls in a computer game or even the patterns of light and dark picked up by television cameras connected as "eyes." One important consequence of this fact is that, providing their movements can be electronically sensed (and a host of devices such as electronic pens, pads and panels have been developed for exactly that purpose), computer artists can draw or paint directly on the electronic mosaic. They need as little knowledge of the underlying tiles as painters have of the threads of their canvas. A second consequence is that computers can capture television-camera images with photographic speed and realism, but with a significant added feature: once captured, the image produced is not a still but is an active part of the computer's further processing. It is entirely pos-

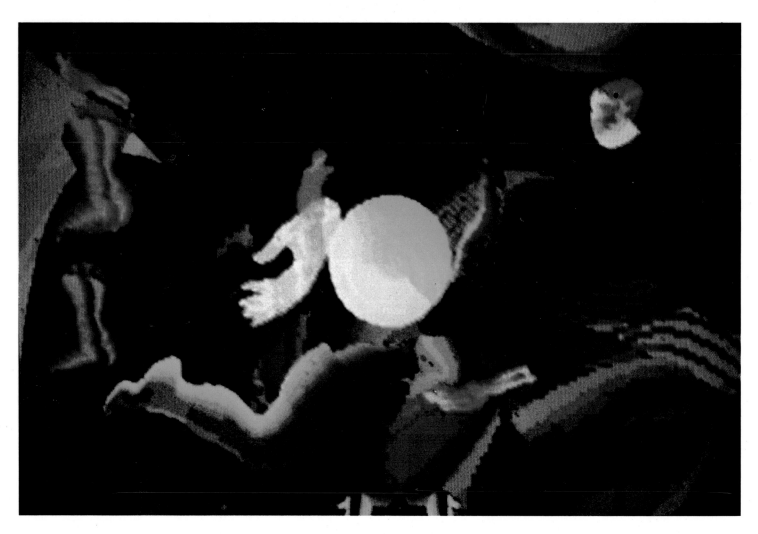

12. *Caroulle* was "painted" by Hervé Huitric and Monique Nahas using electrons. The electrons were manipulated by an LSI 11 frame buffer (a device that acts like a huge mass memory storing the data that tells the computer what the color and intensity is at each point on the display screen so that it knows what has been painted), and a Digital Equipment Corporation minicomputer called the VAX 11/780. The use of the computer to create imagery seemingly indistinguishable from paintings by the great masters is something we'll see more of in the future.

sible for a computer to capture an image (such as the announcer's face in photo 11), then find and automatically replace features of that image, such as his eyes, with substitutes developed by an artist or taken from another captured image.

Special Media
No discussion of special effects should be restricted to the video-display medium. The fact is, the computer interface with the real world is a two-way street. Not only can computers sense but they can control as well. Computers are inherently capable of controlling an

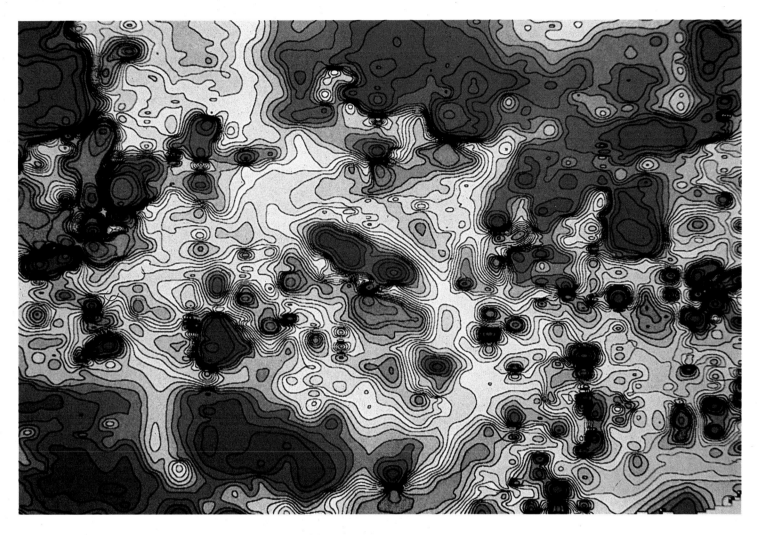

13. This abstraction is really a computerized mapping produced by the Superset Corporation in California.

unlimited range of artistic tools. Any suitably interfaced physical device—from human-graphics instruments such as airbrushes or pens to sophisticated laser chisels—can be wielded under computer guidance to probe unexplored media and effects.

Computer imagery is still in its infancy, and simple economics has focused resources and development on computer tools for commercial factories rather than for artists' studios. Imagine, though, that the beautiful image by Huitric and Nahas (see photo 12) is actually a weaving, which is the impression given by the texture and color of their electronic artistry. The creations of Superset Corporation suggest familiar oils or perhaps

14

even unfamiliar oil-and-water suspension possibilities (see photo 13). Is the man's face, which follows (see photo 14), again by Huitric and Nahas, just a video image with consummate effects of shade and color? Or is it perhaps a laser etching in stone?

Frontiers of Special Effects

Computers can store, retrieve, accept and automatically capture images; and because an image stored in computer memory is not a static record but an integral part of an active, ongoing image-processing system, computers represent a combination of artistic tool and visual medium that is completely unprecedented. Here are some of the dimensions of this new frontier:

Drawing with the Brain: A television camera attached to a computer can do more than simply mimic human vision. It can visualize things human beings cannot see, such as the flamboyant gentleman (see photo 15) who appears in the invisible spectrum of infrared light. As computers convert increasingly more information about the world around us into visual form, artists will be able to use this new mind's eye to influence their images in much the same way traditional art has been influenced by natural visual experience.

Collage and Combination: Superposition of titles and backdrops or the integration of actual face and fictitious eyes in a realistic picture can only suggest—along with the surrealism of some computer images—the eventual dimensions of computer-recombinant imagery. As the image-making potential of computers increases, the number of visual forms stored by and made accessible to them will mushroom. Having far outstripped collage and the traditional techniques of studio scenemaking, the computer gives the artist the capability to summon these images rapidly. They arrive, fresh from the image bank, and arrange themselves for viewing and interplay. Hundreds, thousands of experimental arrangements can therefore be made. The

14. *Impression* was created by Hervé Huitric and Monique Nahas in 1981. Like their piece *Caroulle* on page 20, it was produced on a VAX 11/780 with a Lexidata 3400 display with a LSI frame buffer.

15. Imagery without light? Yes. The dancing figure who was the source of the image opposite was not captured by a normal camera. Instead, a special device called a Hughes probe-eye was employed to "read" the temperature of the dancer and the surrounding space. The computers then took the temperature differentials and displayed them as different colors.

15 ▷

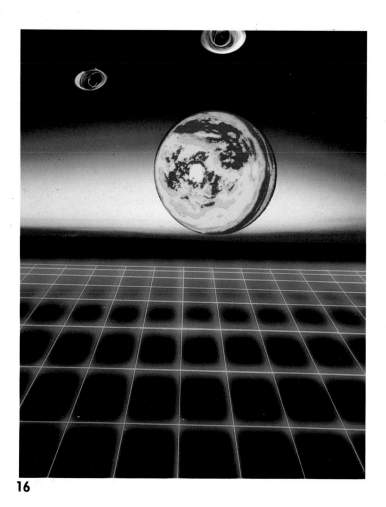

16

16, 17. The computer is capable of building a picture, element by element. The examples on these pages show this kind of composition at its best. Akuma Takegami's planetoid sphere floating over a gridlike landscape, above, seems to be surrounded by flying-saucerlike objects. The image at right, a similar sphere, was created by Robert Abel & Associates who used the Evans and Sutherland Picture System II to create the basic monochromatic line drawing designs and then added color and solid fill by using other techniques. In this particular picture the round object is really a golf ball and the landscape is taken from a television ad for the Maxfli Golf Ball.

17 ▷

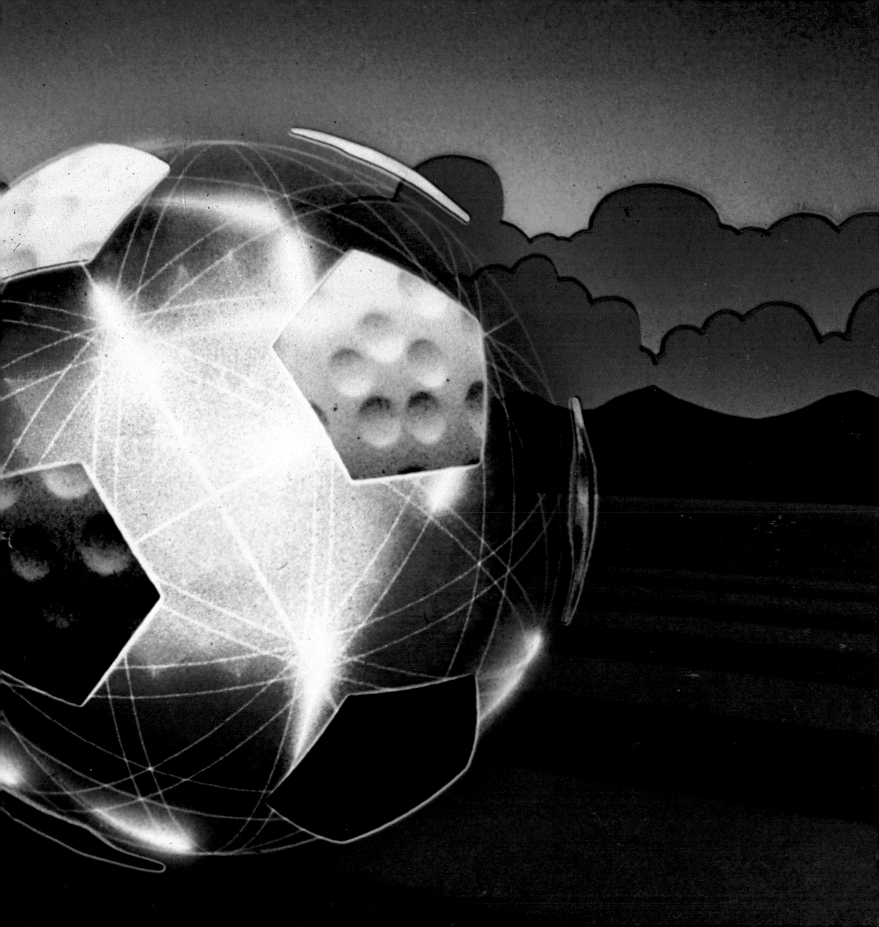

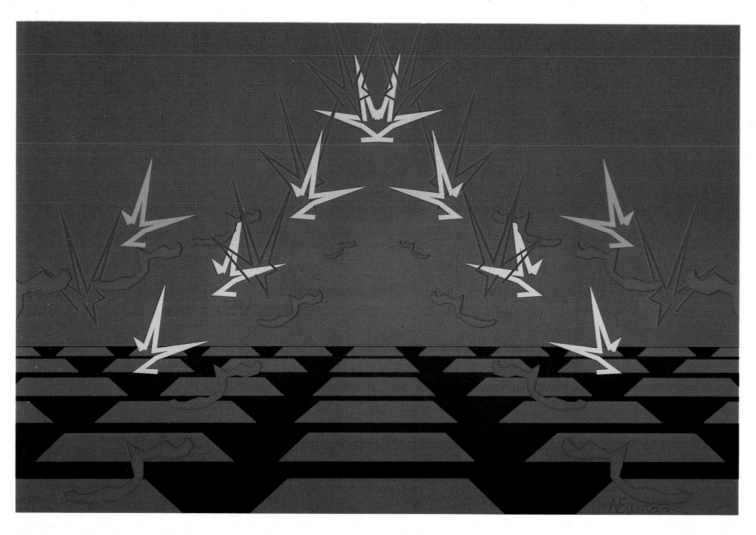

18. In his image *Sharps,* Mike Newman sets up a conflict between bright sharp-edged figures and dark softly-rounded shapes.

final choice may be a work of art in its own right, or it may merely be a step in the creation of one.

Interaction: As a medium for imagery, the computer is entirely unprecedented. Unlike the sculptor, who freezes his or her work in clay or stone, the computer artist can have the image he creates superimposed on the face of a dynamic, responsive entity. (Microprocessor costs have dropped to the point where it is feasible for a sculpture to consist of an entire computer display and processing system.) An entirely new dimension thus comes into play: having created a mask, the artist can now instruct his handiwork in the faces

and moods it is to wear and leave it on the computer, where it independently engages in a dialogue with the viewer, adapting to and interacting with the responses it evokes.

An evolutionary painting might change itself constantly in response to the viewer's expressions of interest, in an attempt to adapt itself to the demands of its own artistic survival of the fittest. The "birds" (see photo 18) might adopt new flight patterns. Displayed on a computer that follows your eye movements as you view it, Greene's *Night Castles* (see photo 19) might become a "Heisenberg" image. There are guards on the walls, but you will not see them if you look at the picture directly. Acme Cartoon's surrealistic postcard (see photo 20) floats in a ball-bearing defiance of balance. Interacting with an unsuspecting viewer, such an image might produce overwhelming vertigo.

Fluid Dynamics: The computer's ability to store and reassemble information can be focused to produce compelling images. A static merger, such as the world leaders composite of Brezhnev, Mitterrand and Reagan (see photo 21), is fascinating. Imagine an entire sequence with such an image—driven by an attached microprocessor and representing the past century—smoothly and continuously portraying the changing visages and relative power of world leaders over the past hundred years. The faces and the facts are on record; the imaging computer can combine them.

Before the computer era, it simply was not possible to create a dynamic image with the same fluency as the images created on a static canvas. (The creativity of a physical mobile is hemmed in by the peculiarities of earth's laws of motion; a successful animation requires individual production of the thousands of movie-frame pieces needed to map the image's journey in time.) But now that the computer has arrived to serve as an obedient, painstaking and rapid technician, we have crossed a watershed in image dynamics.

Imagine the frustration an artist would experience if brushes weren't available and paint had to be ap-

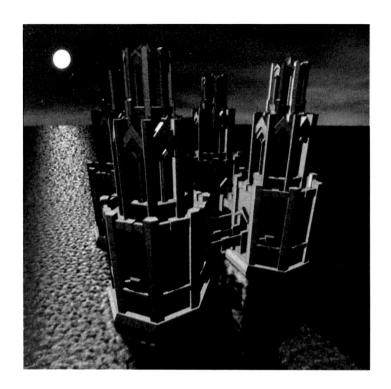

19. The renowned Computer Graphics Laboratory at New York Institute of Technology has been known as the home of state-of-the-art computer image-making hardware and software since its inception more than a decade ago. Ned Greene, one of the computer programmers working at the lab, created this breathtaking image there on a Digital Equipment Corporation minicomputer VAX 11/780 with a Genesco frame buffer storage device. A Dicomed printer was used to get the image from the computer onto a Cebachrome print.

27

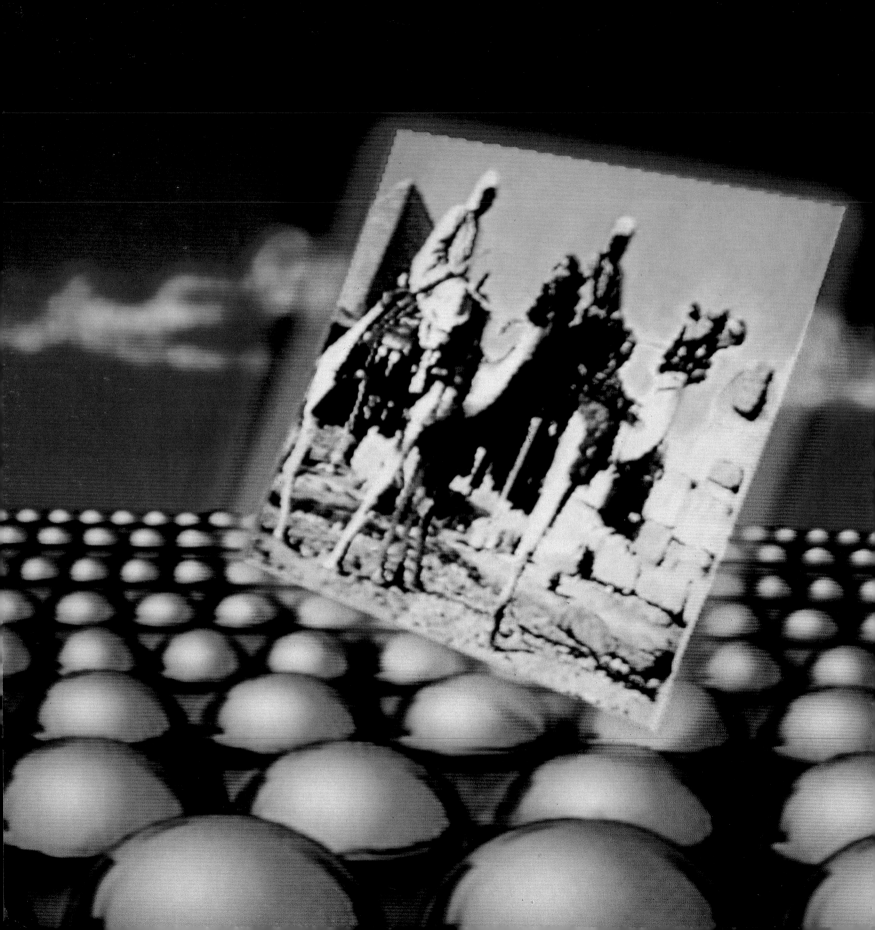

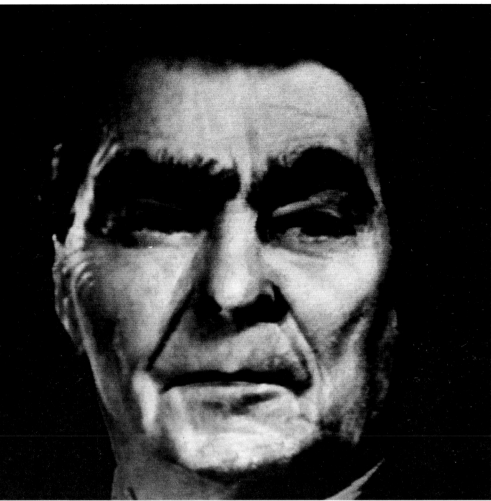

21

20. The computer artists and engineers at Acme Cartoon in Dallas created this image by first using the computer to produce one shining, spherical, reflective ball. That ball was then printed again and again until a grid of balls was constructed. Next, the postcard-like image, which originated as a still photograph, was scanned into the computer and manipulated in three dimensions to create a hovering effect.

21. To make *The Second Nuclear Powers Composite*, Nancy Burson combined the features of the leaders of the five countries possessing nuclear warheads—Reagan, Brezhnev, Mitterand, Thatcher and Xiaoping. The degree to which each face appears in the composite is proportional to the number of warheads in that country.

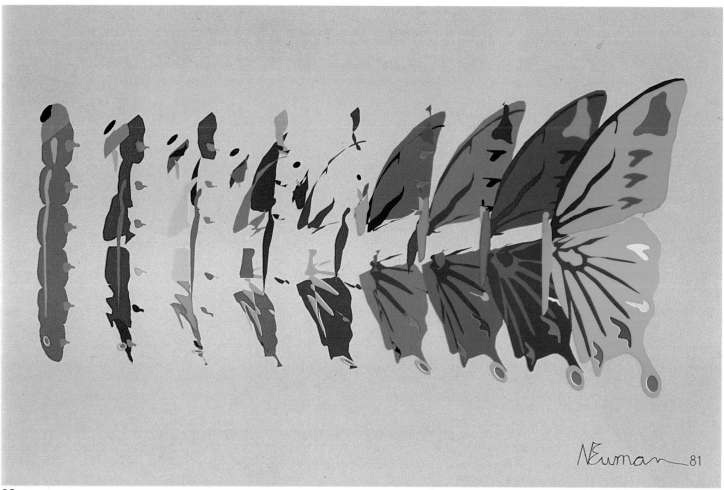

22

22, 23. The software—that tells the computer what to do and how to do it—guides the production of computer image making. Dicomed, the company famous for slide-making machinery, is also well known for computer-imaging software. *Metamorphosis*, above and on the next page, shows the transformation of a caterpillar into a butterfly. The software used to create this transitional imagery is known as *in-betweening*. This process allows the computer operator to enter the beginning and end steps (here a caterpillar and a butterfly, respectively), and then the machine fills in the in-between stages.

While *in-betweening* seems to be simple and easy, it actually requires a great deal of preproduction planning. Though eventually the software enables the machine to supply, as if by magic, various developmental stages, in reality contemporary computers are not intelligent enough to figure out these intervals. A programmer has to create the various stages—in other words, to work out the steps mathematically so that the computer "knows" what stage follows another. However, once all of this detailed and complex data is part of the mathematical language of the software program, then the process can be repeated over and over with little effort. A caterpillar becomes a butterfly in a matter of seconds.

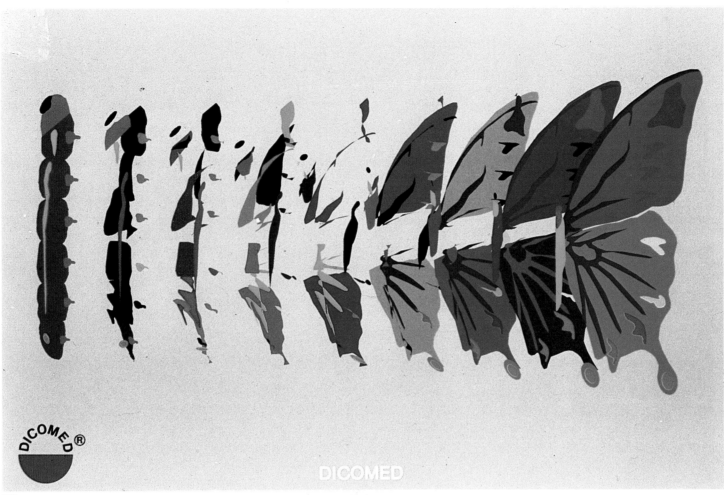

23

plied with the point of a pin! That is exactly the restriction artists have faced until now if they wished to give their images dimensionality in time as well as space: "One point at a time, please. . . ." Now that software "brushes" are available and the time pin has been thrown away, we can expect to see more artists as well as more images incorporating this fundamental fourth dimension—time. The images here (see photos 22–26) cannot convey the effects of the dynamic sequences from which they are extracted. Similarly, it is impossible for this text to recreate the powerful artistic experience of wielding the software "brush" to paint in both space and time.

The key to effective dynamics in computer image making is the idea of a *transformation*. If the rules of a transformation can be conveyed to the computer, the machine can then automatically repeat this transformation successively to produce a dynamic image sequence. Modern graphics computers provide powerfully compact forms for describing transformations. For example, suppose we have the image of a horse on the screen. A copy of the horse on another part of the screen could be made simply by pointing, with a pen or other implement, first to the horse and then to another location where the copy would automatically appear. Additional pointing movements would specify any de-

24. For many people the movie *Tron,* from Walt Disney Productions, was their first view of computer-created imagery. Disney used the services of four sophisticated computer-graphics concerns, Information International, Inc., Robert Abel & Associates, MAGI (Mathematical Applications Group, Inc.), and Digital Effects, in making the film. The action in *Tron* takes place inside a computer game, where warriors challenge and fight each other. In the scene below, electronic warriors are "beamed in" to the game board, ready for battle.

sired combination of relocations, rotations, shrinking or stretching of the horse. With such transformation capability, the artist would be able to progress in a matter of seconds from the initial drawing of the horse to an animated sequence of the horse trotting into the sunset.

A familiar transformation is illustrated in the beautiful sequences in this chapter (see photos 22 and 23). The transformation of a caterpillar to a butterfly here also graphically illustrates *key frames,* or *in-betweening,* a fundamental approach to transformation description. An artist can guide an entire sequence by

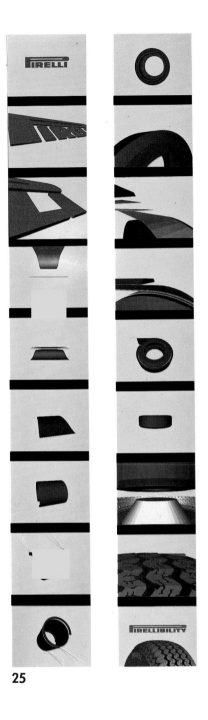
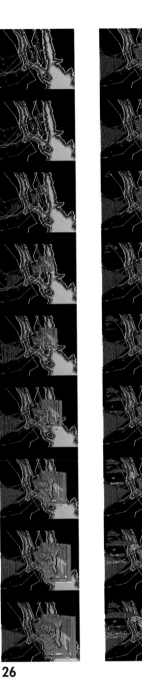

simply drawing the skeletal sequence of key frames as mileposts past which the evolving image must travel. The computer then executes the design: the caterpillar transforms smoothly and gradually, passing in imperceptible computer-generated steps through the artist's key frames to become a butterfly. The artist can work easily with the entire time sequence simply by manipulating the key frames. The butterfly sequences on the right and the left differ in their use of color; perhaps the artist is searching for just the right effect. To change color, only the key frames need to be recolored; computer in-betweening will automatically propagate this color change throughout the thousands of images in the dynamic sequence.

There are other languages for communicating transformations that make better use of the computer's processing capability than is possible in direct key framing. For example, dynamic imagery is often intended to create the illusion, in two dimensions, of objects traveling in three-dimensional space. The computer can easily store and use information about three-dimensional geometry and perspective projection. If the artist wishes to work with images in motion, only the instructions for the desired three-dimensional motion, rather than the explicit key frames, can be given to the computer. The system itself can then compute the two-dimensional images needed to produce that apparent motion. For example, "Warrior number one turns and approaches warrior number two, who flies away to the horizon" (see photo 24). The dimensions of effective human/computer communication are only beginning to be explored.

25

26

25. A 1981 advertisement for Pirelli automobile tires by London's Cucumber Studios shows what the computer can do with industrial images. Here it manipulates the parts, sometimes floating the image.

26. In *Subway*, by Mark Lindquist of Digital Effects, Inc., colors and forms move and change.

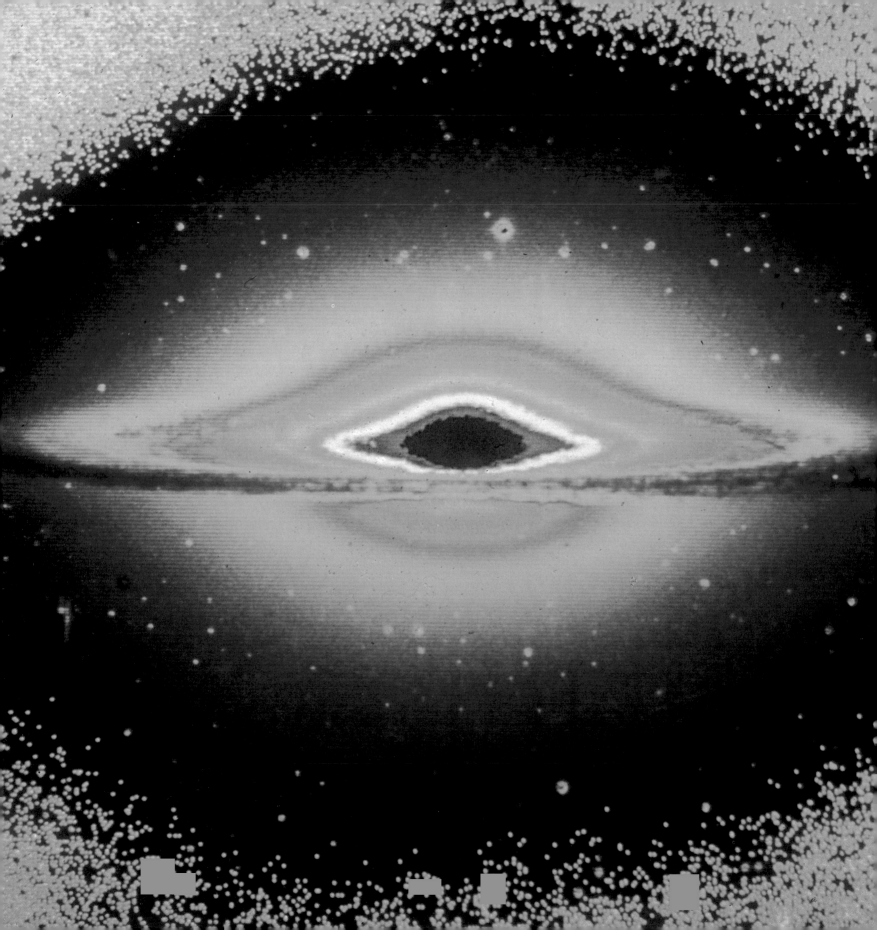

2. NEW WORLDS OF SENSATION

The invention of the computer, like that of the telescope and the microscope before it, expands not only the range of our senses but our vision of the universe. By using new computer devices, we can see temperature by heat waves, clouds by radar, or view the inner secrets of our bodies or our planet.

Sensory Horizons

The human race has experienced historic and mind-expanding moments during which a previously inaccessible world suddenly opened to our senses. At such a moment, we began to see the world differently, and from that point on, to make fundamental changes in our concepts. Galileo's telescope was not merely the window to a dim view of the satellites of Jupiter or the phases of Venus. Van Leeuwenhoek's microscope was not simply the pinnacle of glass-bead technology. These instruments marked the beginning of a scientific age.

The telescope stretched our consciousness, allowing us to have direct contact with the cosmos. The microscope unveiled an unseen living world, one hitherto hidden beneath the ordinary world of sight.

28

27. The various light sources of the Sombrero galaxy, opposite, are combined by the computer into a specific, integrated image of that galaxy. This one was created with Gould equipment.

28. The sperm of old and young *Drosophilia* flies are compared in a computer-augmented image.

◁ **27**

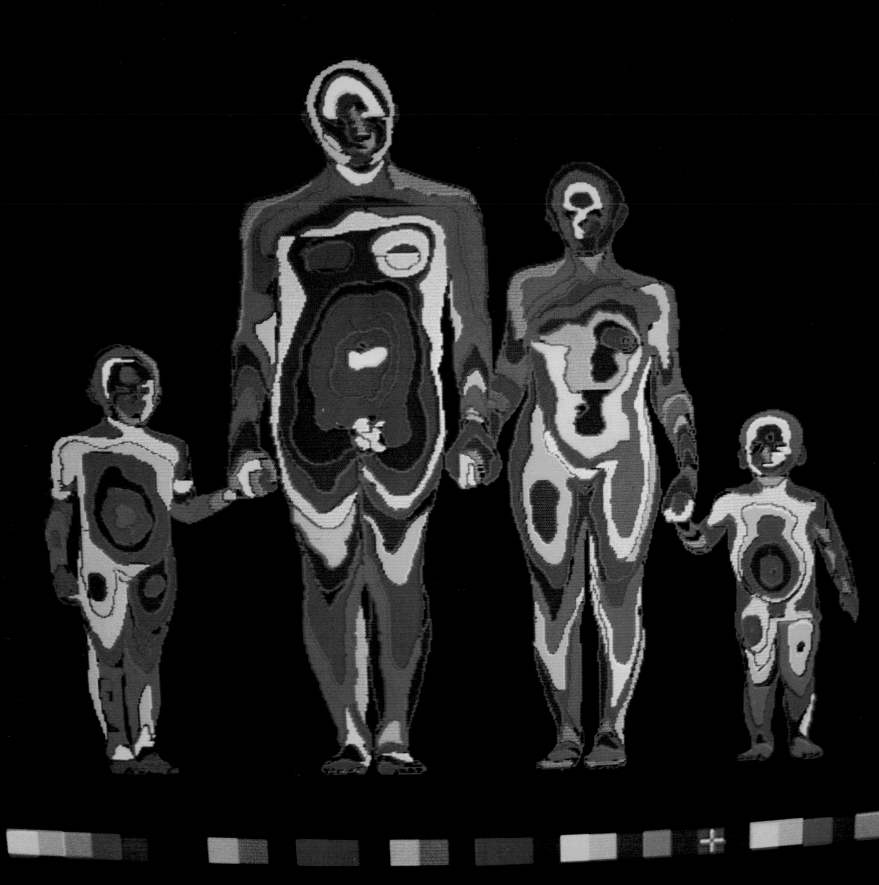

However far we have progressed, whether sending our spaceships out to touch the planet Jupiter, which Galileo only dimly saw, or restructuring the microscopic forms of life itself by genetic engineering, the roots of our new powers and perceptions can be traced to these pioneering breakthroughs that first expanded our senses.

As the computer era begins to dawn upon us, a new sensory breakthrough is taking form: while human beings are limited by evolutionary and genetic history, developing with predetermined eyes, ears and other senses for our body and brain, the computer has become a new kind of brain and physique whose evolution is directly subject to human control.

Guided in its evolution by human intelligence, the computer promises to become an extension of human beings, reaching out like a new hand to sense and shape its surroundings. Using whatever sensors our imagination and technology can produce, the computer can directly grasp new aspects of our universe. There are kinds of light yet to be seen, both below the red and above the blue that border the limited rainbow of natural vision. New stars appear in the sky. Labeled chemical markers "speak" from within a living human brain, describing in detail the metabolic activity of its thought processes. The attentive computer captures it all for us.

Once the computer reaches out for new sensations, its brain can be programmed to translate the information captured by its senses into a humanly perceptible image. The computer, like a faithful explorer, can spin its tale of the unseen world, vividly translating it into the language of human perception by means of pictorial displays, sounds or movements.

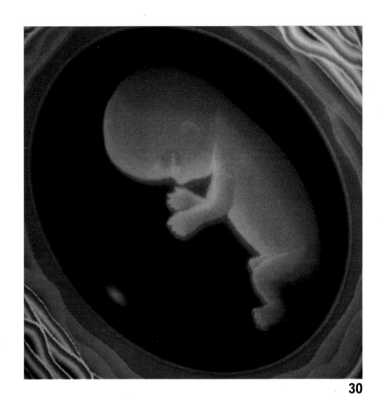

30

29. The thermographic image opposite was made without the benefit of a normal light source. In thermography, the temperature of all areas, in this case the surface areas of the bodies of various humans, is measured and displayed, with different colors symbolically representing the different gradations. A useful medical tool, thermography can help detect disease or disorders by analyzing the presence or absence of heat in the body.

30. This stylized image of a human fetus floating in its protective womb was computer created by Japanese artist Yoichiro Kawaguchi.

Human and Computer Senses

As humans, we are able to see because of three key elements: an external *stimulus* (light); an appropriate *receptor* (the eye), which can be directed to this phenomenon; and a *transducer* (the retina), which trans-

◁ **29**

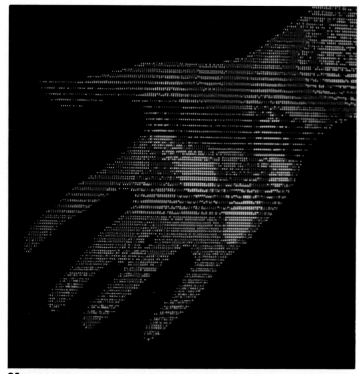

31

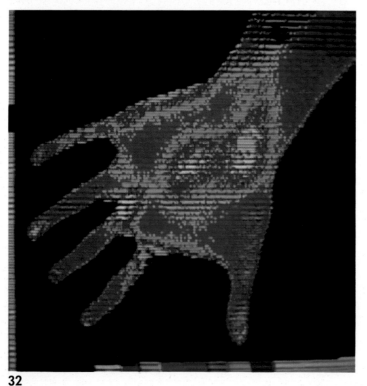

32

lates physical changes caused by the stimulus into the electrochemical language of the human brain. Any other sense, for humans or computers, follows this same pattern: a stimulus captured by a receptor and converted into signals by a transducer.

The human spine, seen with new clarity by computer vision (see photo 33), is the trunkline for our internal signals. The electronic signals of a computer are vastly more mobile than the signals of the spine. They circulate within the computer and also bring about long-range "telepathy": even as the satellite computer's eye captures a radar view of the earth from orbit, its signals are simultaneously guiding a kindred earthbound computer with instructions to draw a humanly visible image.

It is exciting to speculate about the possibility of producing artificial organs that would make direct contact from the outside environment to the human brain possible. The benefits to people who have sensory impairments would be incalculable. Humans could potentially even "see" sound and other nonvisual phenomena directly. With sound, for example, it would be necessary to develop a receptor that could translate pressure variations into electrochemical signals directly channeled into the optic nerve or the brain.

31, 32. Richard Lowenberg specializes in the creation of computer-augmented thermographics. Here two hands can be seen to differ sharply in their thermographic images, which were created by the use of a Hughes probe-eye system with digital display data and a color/temperature scale. According to Lowenberg, "Temperature variation or heat is a form of energy produced by random molecular motion. As we learn more about the nature of energy and information, scientists and engineers are developing highly sophisticated, non-interfering measurements and remote sensing technologies. Thermography (infrared thermal imaging) is the conversion of temperature distribution patterns into visual images. The system is capable of registering temperature variations to fractions of a degree within microseconds."

Similarly, if a human wishes to directly expand his vision into the infrared and ultraviolet regions of light, a new type of retina could be developed and implanted.

Organ-replacement scenarios are not theoretically impossible, but they are certainly not widely feasible or desirable with present technology. Nonetheless, with the aid of the computer, humans are already able to visualize themselves and the world around them by means of invisible phenomena such as sound, heat or ultraviolet light. In a way, sense-organ construction and implantation is already a reality —not directly in humans but by means of surrogate computer intermediaries and translators.

Medicine:
The Sense of Well-Being

Medical imagery furnishes striking examples of the use of our newfound computer senses. Observation is the foundation of health care. Whether for physical fitness and health maintenance, early-problem warning and detection or conventional diagnosis and treatment, it is vital that the body be seen in every possible aspect. Computer sensors are actively being developed and used to explore the human body from without and

33. This lumbar vertebra was done for a doctor at Rutgers Medical School by DEI. Computers enable doctors to diagnose problem areas more easily and accurately.

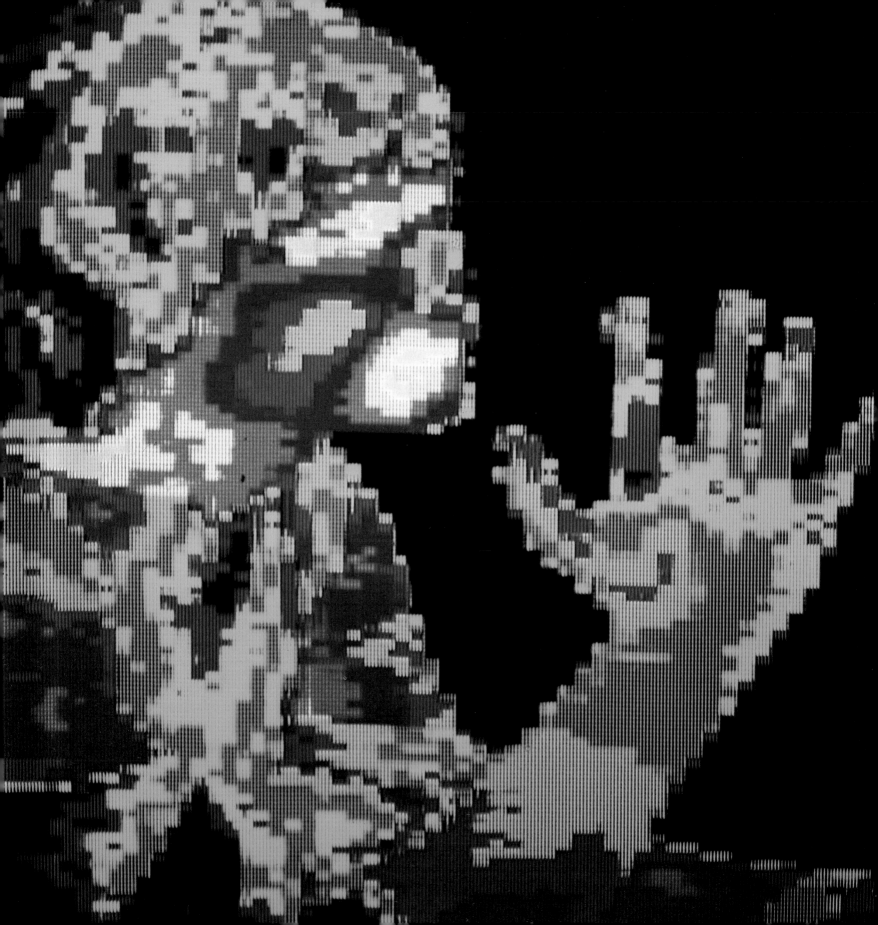

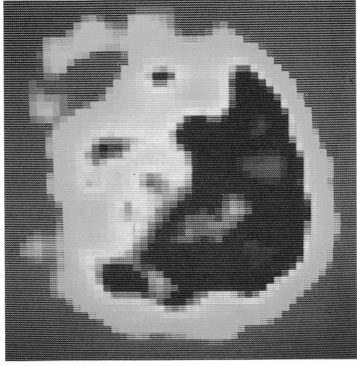

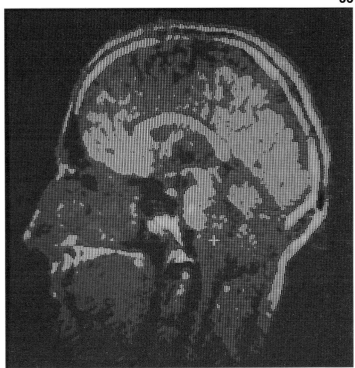

within. The external skin temperature map or the interior brain views (see photos 34-37) are both the result of the computer processing a wealth of sensory data. The computer can do more than simply capture a photographic image: by further processing it can manipulate and enhance images, actively helping to seek out the patterns of health and pinpoint the signatures of disease.

34–37. Computers can easily determine differences in temperature, mass and density, and, if programmed to do so, will visually display changes in them. Richard Lowenberg did the thermographic portrait opposite, in which the color variations reflect degrees of heat. On this page the computer sorts and rearranges information in brain scans. Color differences may indicate the presence of disease.

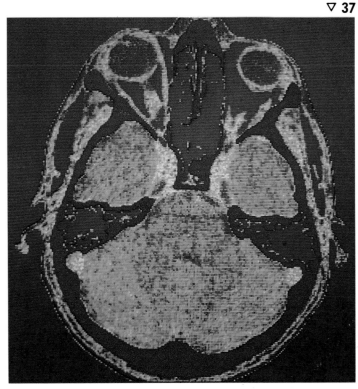

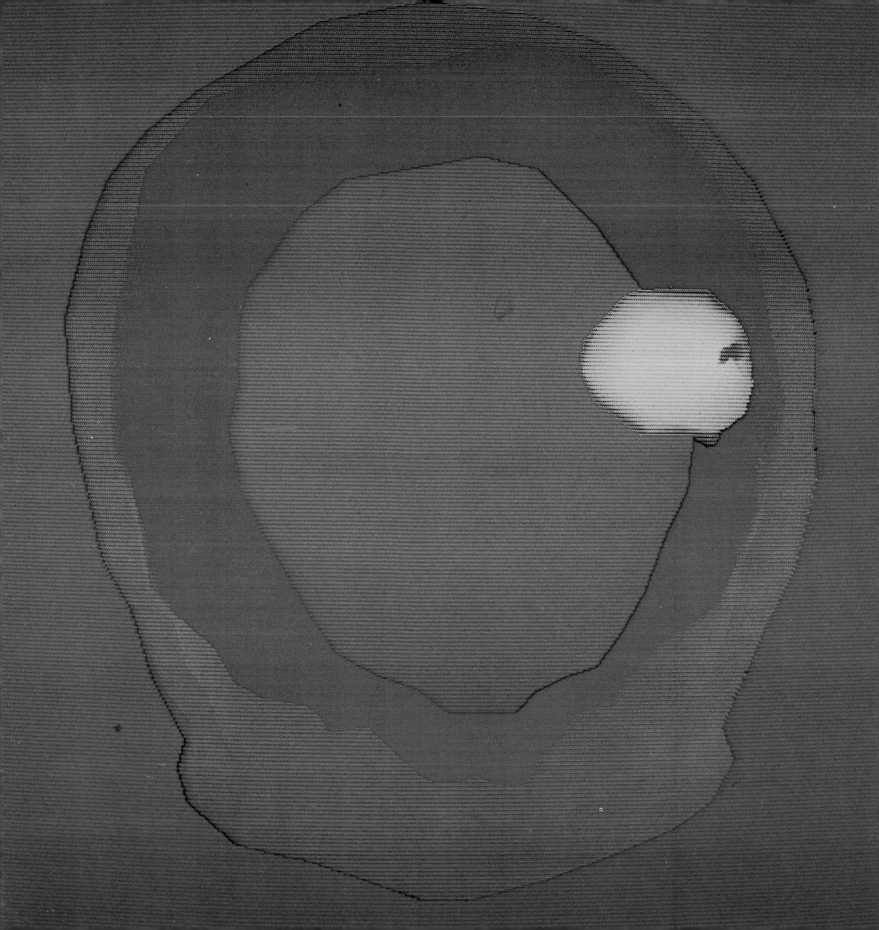

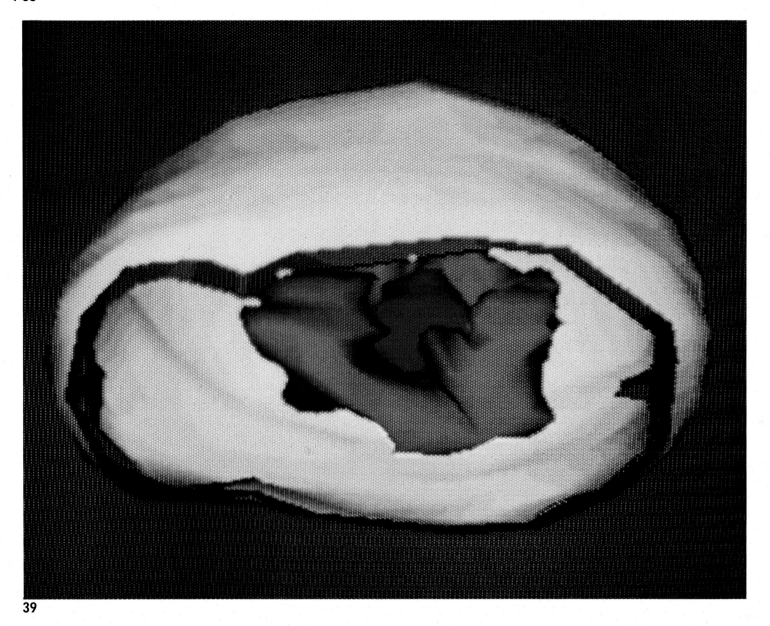

39

38, 39. The images on these pages are internal views of the brain. The picture opposite reveals melanoma. The image above is of a pituitary tumor.

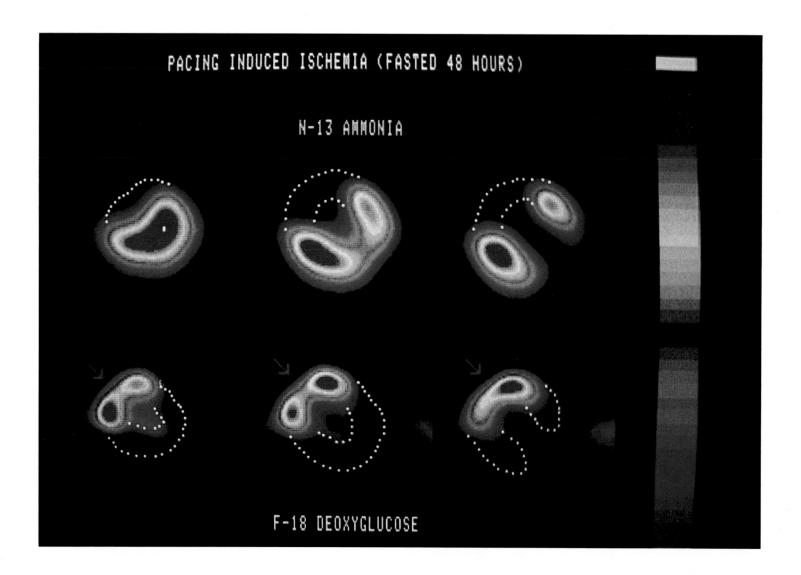

PACING INDUCED ISCHEMIA (FASTED 48 HOURS)

N-13 AMMONIA

F-18 DEOXYGLUCOSE

40. Computers can be used to gather medical information that might otherwise be undetectable. Once a patient is injected with radioactive isotopes, the computer can trace the isotopes as they move through the body and react with other substances. Doctors are then able to "see" the internal activity of the body. In many situations, this graphic display can mean the difference between life and death.

The ability of X-ray techniques to look inside a living person has had a profound effect on both the science of physiology and the practice of medicine. Before the era of the computer, X-ray images were simply captured and displayed on photographic film. As valuable as these images are, they are inherently limited by the characteristics of the film used and by the geometry of the recording device. For example, there is no way to move the image to a better angle after the photograph has been taken.

By comparison, the computer-with-senses is infi-

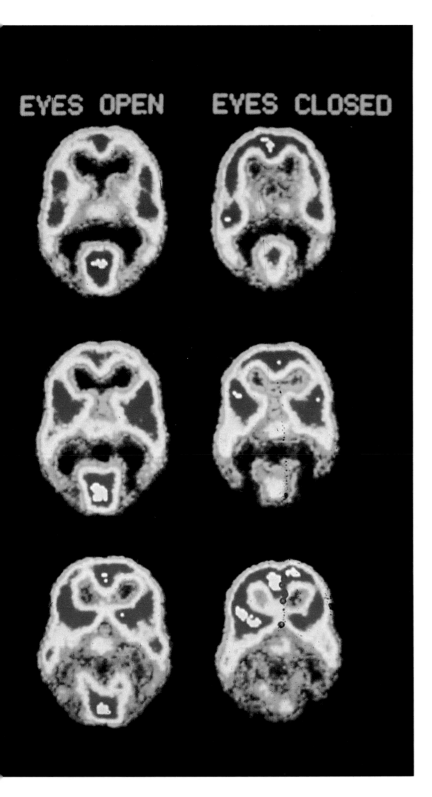

EYES OPEN EYES CLOSED

nitely more flexible. Its sensors can tune in to X-ray radiation and store information about the contents of the skull. The data can be captured from several different perspectives and angles and stored for sophisticated processing. In computerized *tomography*, as illustrated by the images here (see photos 38 and 39), many different one-dimensional readings are mathematically combined and manipulated within the computer to produce complete two-dimensional images (brain "slices"). Unfettered by the geometry of spherical skull and flat external film, the medical practitioner can see the separate details of individual brain slices, from the base to the top of the skull.

With X-ray probes, tomography is far safer than photographic imaging and is precise to a degree formerly reserved for cadavers. Even more marvelous than X-ray vision, a tomographic image can show not only passive brain structure but dynamic brain activity.

If one wishes to observe brain activity directly, X-rays are of little value. An X-ray probe that enters the skull emerges on the other side with only one piece of information: the density of the matter along its path. If the density is low, the X-ray will emerge virtually unchanged. Thus, X-rays are well suited to detecting density differences such as that between bone and tissue or that between a lesion and its surroundings. Unfortunately for X-ray vision, the mechanisms of human brain activity do not cause any substantial changes in density.

41. In this brain scan, done with Gould equipment, a comparison is made between the patient's condition with eyes open and closed. Radioactive isotopes are used to point out the differences in the way the brain functions in these two states.

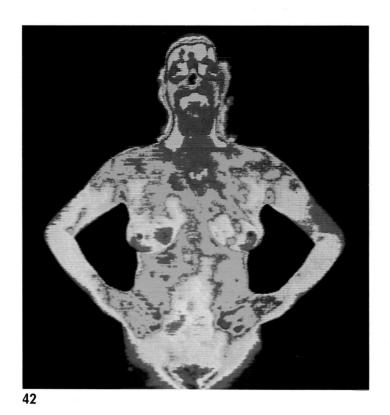

42

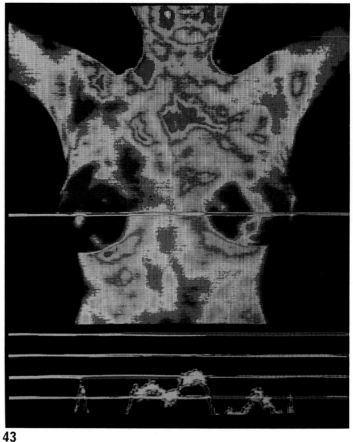

43

42–45. Richard Lowenberg, the creator of these thermographic images, writes, "These photos show slow-scan digitally processed video thermography. Multiple images were produced by storing frames in computer memory. The differences in the infrared emissions from the surface of an object appearing as brightness or color variations in the image are displayed on a conventional television screen. Medical and health care applications (of thermographic imaging) are based on the recognition that the temperature of the skin can vary from place to place depending on the specific cellular or circulatory processes taking place inside the body at any point. Studying the relationship of body temperatures and patterns over time can provide an important understanding of the human thermo-regulatory system and effects of our psycho-sensory environment."

While there is little difference between the density of active and inactive brain cells, there is substantial difference in metabolic rate. A biological cell is like a factory that must import raw materials and consume energy in order to produce output. If brain activity in some area increases, then the cells in that area will begin to absorb more nutrients in order to support their increased output. The secret of such techniques as *positron emission tomography* (PET) is to introduce into the brain nutrients that have been labeled to produce minute amounts of radioactivity. The computer can sense and locate this radioactivity emerging from the skull in the same way that humans see and locate flashing fireflies. Even in total darkness, the flashes pinpoint where the fireflies are concentrated. In the same way, the computer can locate, even from outside the

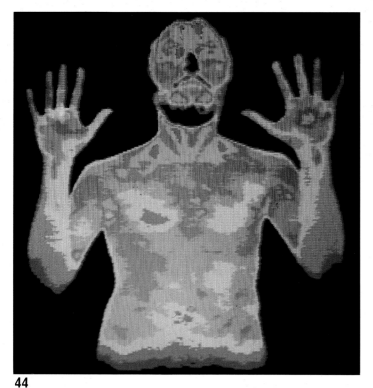

44

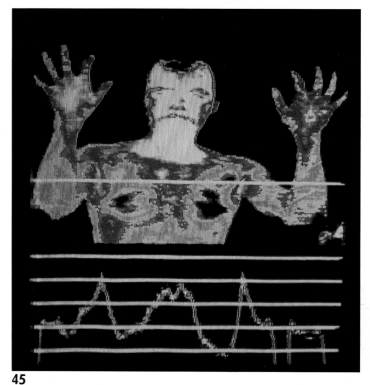

45

brain, the areas where the labeled nutrients are concentrated. These areas are immediately pinpointed as sites of increased neural activity.

Unlike its contents, the surface of the body has always been visible, but it is now beginning to be sensed anew in the area of temperature. Although humans are sensitive to heat, our evolution has not made it important for us to see temperature differences naturally. Nonetheless, the electromagnetic radiation that we feel as heat is conceptually no different from the radiation we see as light. The problem is simply that our eyes, like an old radio with no FM, are only attuned to a narrow portion of the entire spectrum of radiation being broadcast around us. With the newfound computer eyes of *thermography,* we are beginning to see temperature patterns in our bodies and in

Overleaf: 46–55. Richard Lowenberg uses a thermal imaging system in order to create these images of Indian dancing. His system, located in his Bio-Arts Laboratory in San Francisco, combines a camera-like device, known as a video-compatible infrared imager, a digital image processor and a frame buffer for computer storage. This equipment allows Lowenberg to create continuous slow-scan display via video. Each color represents a specific temperature range. Usually ten colors are used for a display. Often gray scales, as opposed to colors, are employed. The image processor digitally analyzes specific temperature differentials, then the specific frames containing this information as video images are stored in the frame buffer for further mathematical and visual comparisons.

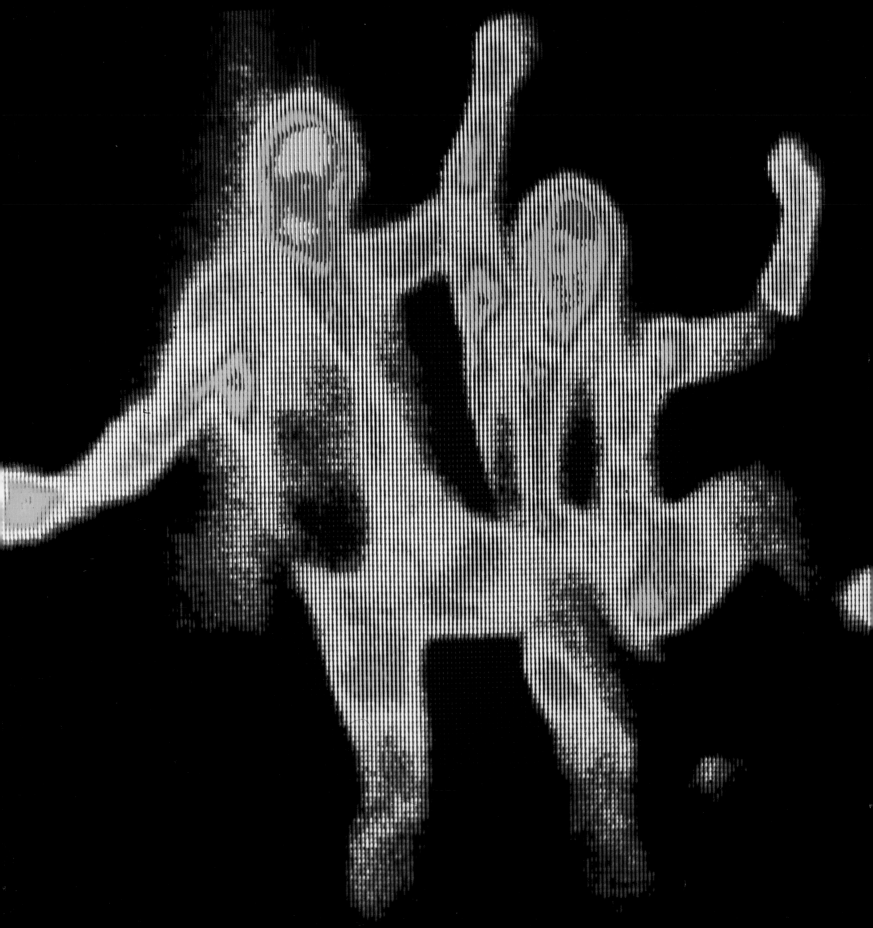

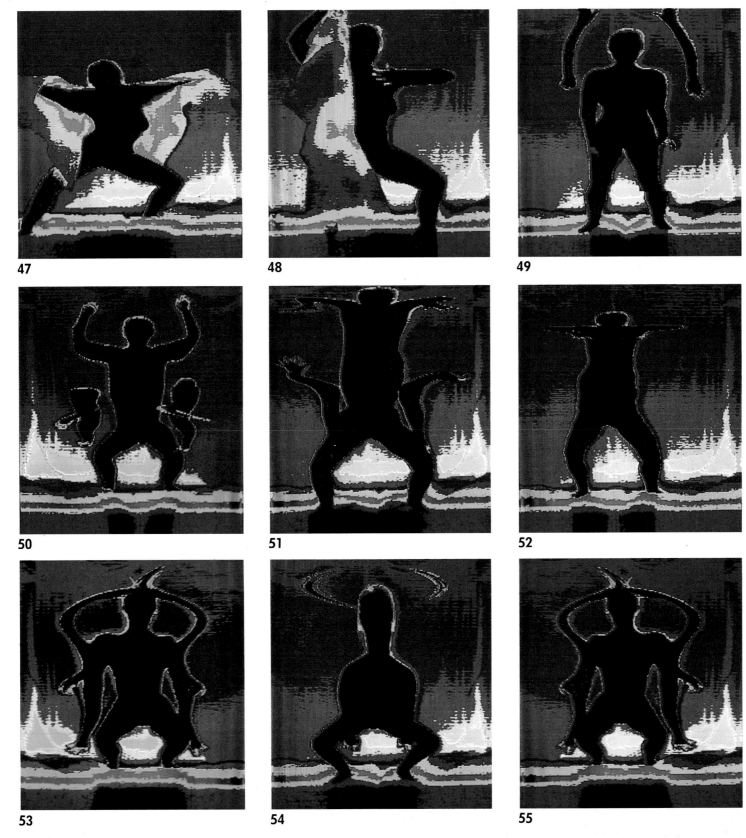

47

48

49

50

51

52

53

54

55

objects around us that are as complex, beautiful and informative as their naturally visible counterparts.

Thermographic techniques, which can produce vivid displays of the invisible tides of skin temperature, have been developed to detect temperature differences of mere fractions of a degree. One can directly see and study the temperature patterns that develop and flow over the human body in response to physical events as varied as breast tumor formation or tension headache buildup. Temperature vision gives an entirely new meaning to the concept of "self-image," a meaning that has significance not only for classical medical techniques but for new directions such as self-help health and biofeedback monitoring.

Expressiveness

Our newfound computer senses promise to expand artistic expression as radically as they have enhanced practical observation. As the preceding images demonstrate, there is a new dimension of light for seeing the patterns and rhythms of physical expression. An entirely new arena of effect has unfolded. What are thermal spotlights, or stage props? Incredibly, the infrared spectrum is a world in which humans, like fireflies, generate their own light.

At such an artistic frontier, imagination and speculation are irresistible. For example, the human ability to make sound can only be developed after the ability to perceive sound is achieved. Although a hundred new dimensions beyond sound have been explored, we are only now beginning to reach the perceptive level. In the dimension of sound, we humans have evolved endeavors as diverse as Congressional debate, cattle calling and *bel canto*. It is not unreasonable to speculate that if phenomena such as temperature or brain metabolism become routinely perceptible, communication, artistic images and performances in these new sense dimensions will also evolve. In future years, human thermal display may be as common as the facial expressions of drama or the chorus of an opera.

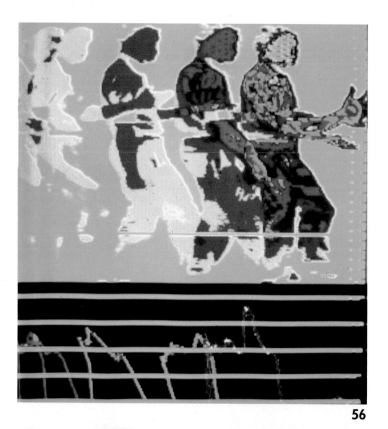

56

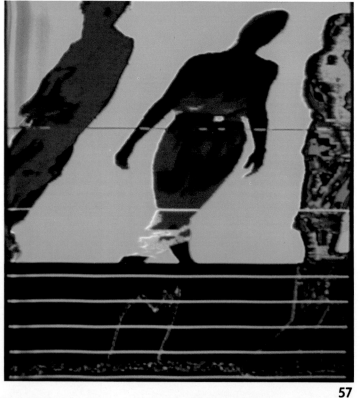

57

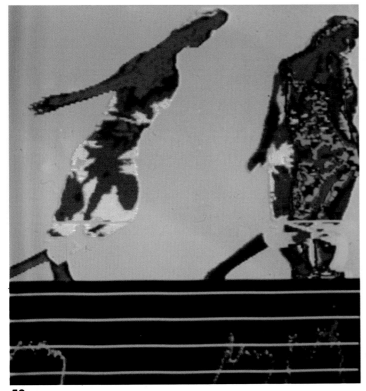

58

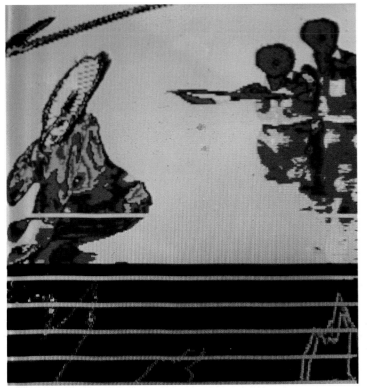

59

A wide variety of innovative artists are working in the area of computer images, and artists of even more diverse backgrounds will undoubtedly gravitate toward the expressive potential of the computer. In many cases, it will be found that art anticipates technology. But technology, too, has already begun to tap the flow of information generated by new dimensions of vision. As Douglas Nelson's work (see photos 62-65, 181-188) attests, no artificial distinction can be made between the technical and the artistic image.

Technology

Whatever artifact we humans make and whatever we use to make it, whether the painter's north light, the potter's hands on clay, or the carpenter's level—our craft and skill depend on our ability to sense and evaluate the product as it develops. The explosion of human awareness through computer senses is only beginning, but already it promises to have a significant effect on technology and clears the path for a systematic study of the structures and devices we make and the way we use them.

56–59. Richard Lowenberg's thermographics reflect changes in body temperature of people in motion.

Overleaf: 60 and 61. Richard Lowenberg displays the heat portrait of a building using the same equipment he did to make the thermographic images of human beings on the preceding pages.

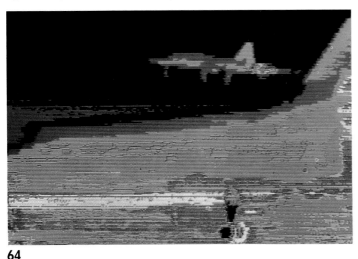

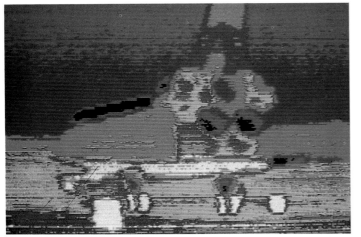

This change is already being seen in architecture. The temperature profile of an architectural structure, like that of a person, is not perceptible by natural vision. Once the computer enables us to see it, though, it can be invaluable in the design of efficient buildings or comfortable architectural environments. External heat losses and internal temperature patterns become clearly visible, and the architect can plan accordingly.

However complex they might be, buildings are at least conveniently static. Other technological products, like the space shuttle, are less apt to pause in their functions to allow a photograph to be taken. Many phenomena, such as the heat-stress buildup on the shuttle due to the friction of atmospheric reentry, only appear dynamically. In order to assess and design for dynamically generated effects, engineers have traditionally resorted to approximate models, mathematics and laboratory experiments. As these computer-generated thermal images of the shuttle illustrate, heat-stress patterns can now be seen and evaluated in real time, even while the spacecraft is in flight (see photos 62-65).

62–65. Douglas B. Nelson combined art and science in these striking images of the familiar U.S. space shuttle. Nelson first recorded black and white images of the shuttle landing on videotape, showing both reflected and emitted heat from the shuttle and from the T-38 chase planes. He then digitized the images with color: the hot temperatures are displayed in the hotter colors—white, orange, and violet—while cooler temperatures are represented by the colors blue, green and black.

66

67

68

Discovery

The brain, which has long hidden its internal features and dynamic activity, is slowly being revealed with the aid of the computer, as are the structural strains and stresses of machines such as the space shuttle. With the new senses the computer lends us, we can clearly detect these hidden patterns. The images presented in this chapter (see photos 66-70) illustrate the valuable new insights that emerge when the earth itself, rather than a skull or an airship, comes under scrutiny.

The geological explorer, like the brain specialist, uses the computer to gather, organize and combine information from hundreds of probes. The scale, of course, is larger: areas of 50,000 square kilometers and more may be covered by a single investigation. X-rays and attenuation models give way to explosive detonations and seismic measurements. As the data is processed, an image develops, not of cranial cavities or thermal cracks but of geological faults and folds. Oil! Like an electronic bloodhound, the computer is capable of sniffing it out.

66-68. The seismic study was developed using SYNCPX on the MPS computer system with a CSM Color Display.

69

70

69,70. Another seismic study, this one was developed using MAP, one of the seven integrated phases in the Cross-Dip Survey processing package, on the MPS computer-graphics system with a CSM Color Display.

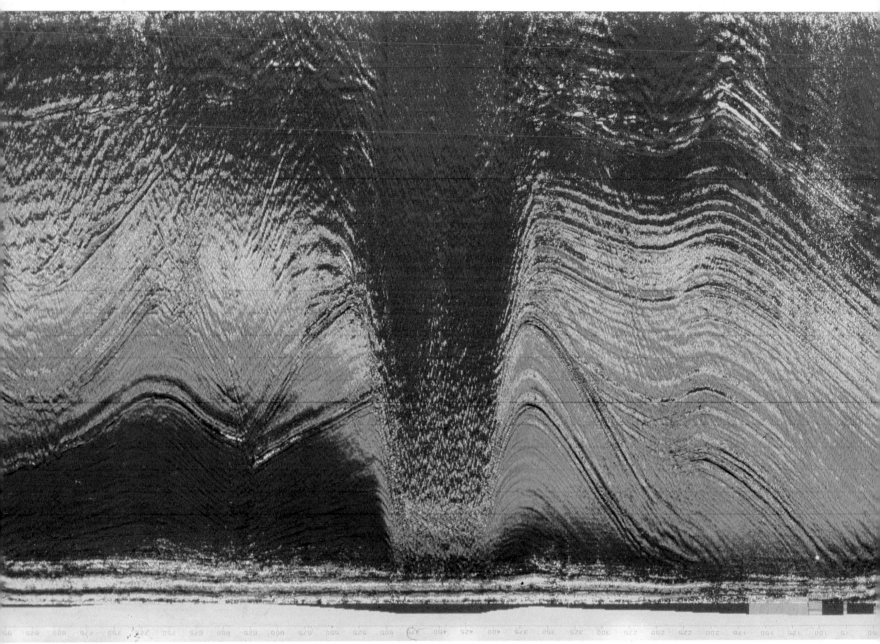

71

Where in the entire globe will the geological patterns that promise successful exploration of oil, minerals or other materials be found? The stakes are high, and the data required can be a literal ocean. Nothing less than a computer would be capable of recording and storing the trillions of bits of information that can emerge from geological studies. And beyond mere storage, the computer effectively combines information from such entirely different sources as satellite, radar, or magnetic and topological measurements. The entire vast array is woven into an enhanced composite image that visualizes the information for us to understand. An example is the image here (see photo 71), which is a geological signature meaning oil, in this case pointing to the famous North Sea discovery.

Science

Discovery and understanding are the counterpoint themes of science. As the reach of human senses expands, new discoveries both challenge old worldviews and confirm new theories. The theoretician's power to explain is challenged by the observer's ability to see. Science is now looking with new eyes, not only at terrestrial phenomena but out into the universe —with obedient robot travelers launched into space turning back for new perspectives on the earth. The computer opens our eyes: from the examination of cells within the body to scanning the environment and the planet, and finally reaching into the cosmos.

Far beyond our own Milky Way galaxy, other worlds generate vast activity. Stars form and collapse, and information reaches us that speaks of the origin of the universe. Not surprisingly, the galaxies take no special account of our human evolution. Their messages do not come conveniently bundled into the humanly visible spectrum of light. Before the advent of computer imaging, entire astronomical worlds could pass the human observer unnoticed.

Astronomers today look to the sky with a wide variety of sensors, covering, for example, the radio-

72

71. This seismic three-dimensional model of the ocean floor of the North Sea bed aided the discovery of oil there. The vertical column is a salt plug and the oil is trapped in the sedimentary layers around it.

72–74. Information in the field of astronomy comes in a variety of forms. Humans have always used their eyes to scan the nighttime sky, and the visual information gained in this manner is still useful. However, in this century, advances in radio astronomy, X-ray astronomy and X-ray chromatography have revolutionized our views of the universe and our place in it. Computers represent the most viable way to display this new information in a form in which it can be analyzed and digested. By giving radio, chemical, X-ray and infrared sources visual representations and by programming a computer to display such data collectively, new portraits of the stars and galaxies are emerging. The spiral galaxy NGC5247, above, and the galaxy Centaurus A and the ringed planet, overleaf, were all created with Gould equipment.

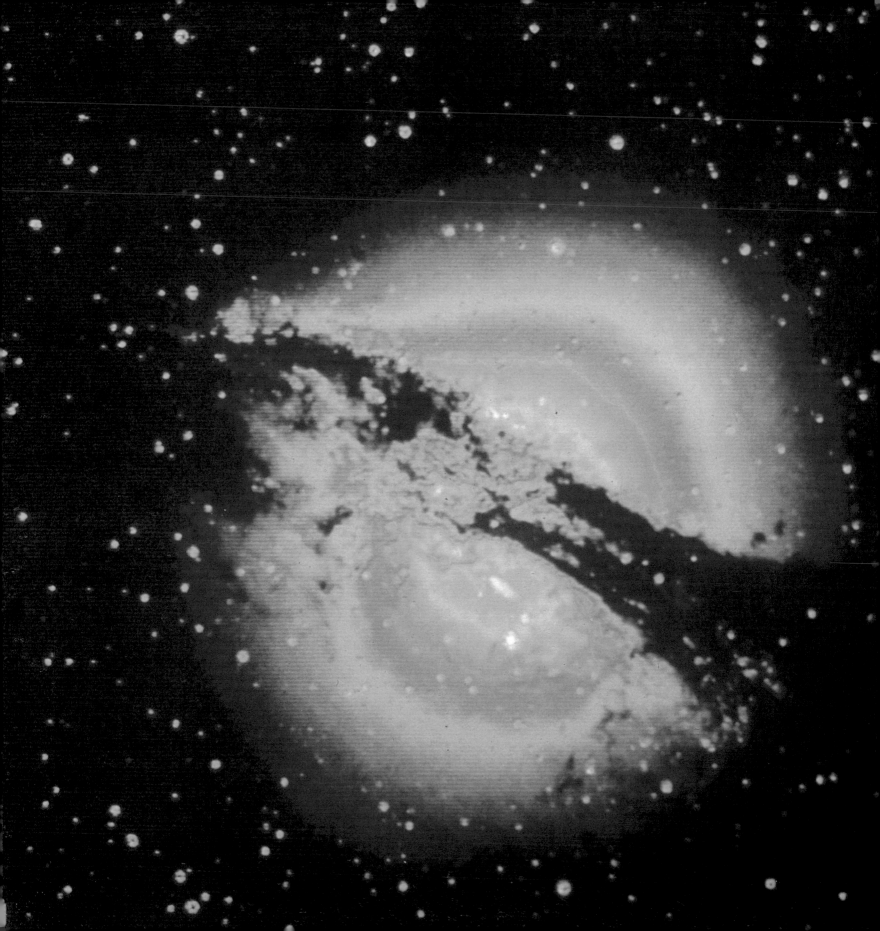

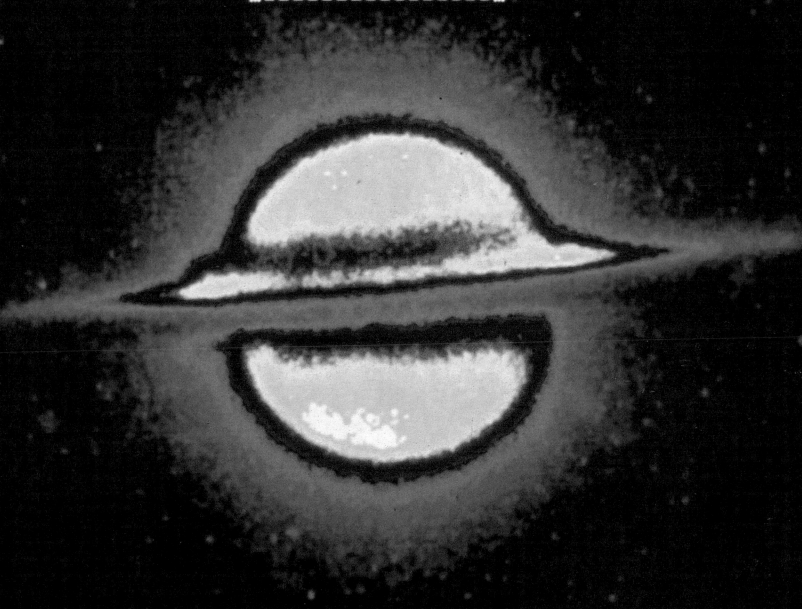

wave spectrum as well as the visible. Galaxies whose activity radiate energy in this spectrum suddenly leap into view. The data captured by a radio telescope is assembled into a mosaic by the computer. Bands of the radio spectrum, analogous to visible hues, are automatically delineated and displayed in color. Image-enhancement techniques can highlight regions and shapes within a galaxy or focus on features that are evolving.

The earthbound telescope, however sophisticated, is inevitably limited in its perspective. Utilizing the computer's marvelous "telepathy," though, we have begun to launch effective new eyes into space itself. These satellite and space-probe imagers such as *Voyager* truly reach out to the universe to capture it with startling clarity. A beautiful example is the image (see photo 75) of Jupiter's moon Io, captured from space and relayed to a spellbound earthly audience, a fitting image in the legacy of Galileo.

Vital new perspectives of our planet itself can be obtained from space. Satellites in space have enabled us to see weather formations and patterns with unprecedented clarity. The weather-satellite map on the nightly news is by now as familiar as the sports scores. Other views of the earth from satellites are less well known but equally important. Satellite sensors scan many different regions of the electromagnetic spectrum and constantly relay data by the gigabit back to earth.

Satellite-geological data has already been mentioned. Its economic impact is staggering: geological formations are delineated from space over a vast expanse and with such clarity that an exploration team working from satellite images can now narrow an oil search down from tens of thousands of square kilometers to less than ten. Expensive aerial surveys, search teams and extensive seismic exploration are all rendered unnecessary by satellite data that costs less to obtain than a truck tire. The satellite image may often be clear enough to assist final selection of the drilling site.

If biological activity rather than geological struc-

75. A computer-enhanced picture of Jupiter's moon Io.

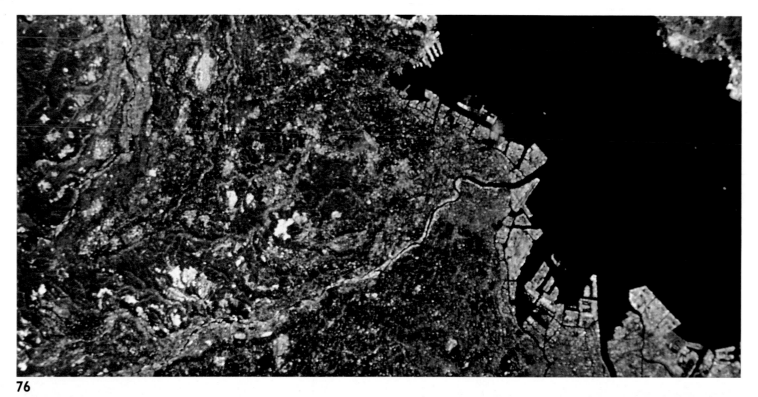

76

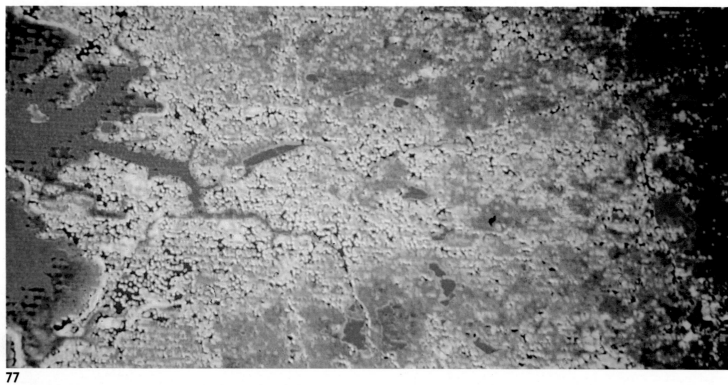

77

64

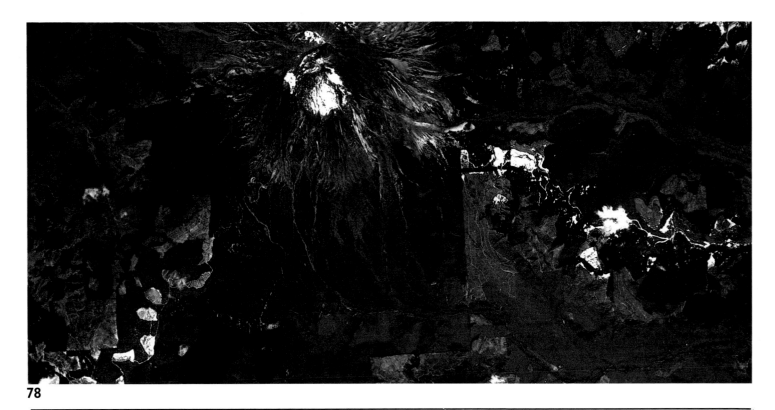

78

76–78. In much the same way that color is used in thermographic image display, color is also used to highlight specific features in satellite photographs. In the image opposite top, created on Dicomed equipment, a bay and the surrounding land are color-coded to bring out specific features that would not be seen in a normal photograph.

Opposite bottom, a Lexidata System 3400 display processor was used to color-highlight areas having similarities in geological characteristics. Above, a photograph of Mount St. Helens in Washington, taken for NASA Ames Research before the volcano erupted, has been computer enhanced.

ture is of interest, other regions of the spectrum, such as the infrared, can be scanned. Landsat images (see photos 76 and 77) use a *false-color* presentation scheme, highlighting patterns of healthy vegetation.

Understanding vegetation and crop patterns is an immediate and important application of satellite infrared data. These enhanced thermal images can pinpoint the effects of droughts, fires and other climatic events. Global trends such as deforestation and the spread of deserts can be accurately traced.

With satellite vision, though, as with all of our new senses, we are only poised on a threshold. With experience, however, we will undoubtedly attain a level of skill that makes today's maps and pattern-detection schemes look primitive. The geological data that signal oil must also speak of earthquakes when monitored closely over time. Other events that have plagued the earth since its formation, such as the eruption of Mt. St. Helens (see photo 78), may someday be safely forecast.

79. An artist at work produced by Mike Newman of Dicomed on a D38+ Design Station and imaged on film at 4,096 line resolution using a D148 color film recorder.

3. CRAFTING IMAGES

Computers have revolutionized the methods by which images are made. Unlike the common keyboard computers, computers specially equipped with graphics devices are sensitive to movements of the computer artist. These computers function as the artist's apprentice, quickly taking care of all repetitive, complicated and tedious details. The craft of making images both contributes to and utilizes computer technology. Through the *computer-aided design* (CAD) of modern circuits, new computers are conceived and produced from images developed with computerized graphics.

The Medium is the Memory

How do artists input their graphics ideas into the computer, and how are these ideas expressed? Where another artist might apply paint to a canvas or clay to an armature, computer craftspeople simply pour information into the computer's memory bank, making their medium the computer's memory. The *mosaic* approach to computer graphics described in Chapter One encourages *memory-map* techniques, the point by point translation of microscopic memory locations onto visible screens. Mosaic-based systems are most popular among busy computer artists because they are highly sophisticated and have been widely promoted. Unfortunately, this method makes little use of the opportunities afforded by the computer's memory. A piece of metal can be either a sculpture or a mold that produces sculptures. Just as a sculptor who works with molds exploits the metal's ability to generate new forms, computer artists may exploit the computer memory's ability to generate images rather than simply store them. As an integral part of an image-processing system, computer memory is the ultimate generative medium. Computer artists develop instructions to the computer in its memory. These instructions then become "image genes" that cannot be viewed directly, unlike the memory-map mosaic. But they serve as a mold to guide the construction of the final product (whether by video, ink pens, chisels, furnaces or any other computer-controlled device). More like biological genes than physical molds, image genes require a sophisticated support system (the computer) in order to be expressed, with the final product emerging only after hundreds or thousands of automatic intermediate steps have been taken.

The medium of computer imagery is the memory, and the memory acts as a mold. As a general guide, that may sound wonderful but perhaps a bit too abstract. One example, suggested by the motorcycle images (see photos 81 and 82), follows: the artist certainly does not conceptualize the motorcycles (top) as a two-dimensional pixel mosaic. Rather, he or she imagines

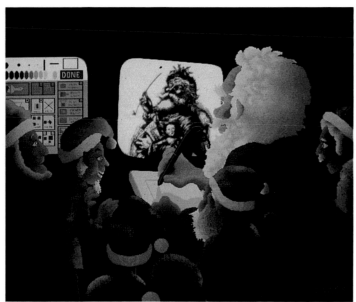

80

80. This computer drawing of a computer drawing was done by Aurora Systems as its 1982 Christmas Card. Santa Claus uses a digitizing tablet, a device that enters drawing instructions for computer imagery, to create another St. Nick, who appears on the screen in the background.

81, 82. The futuristic vehicles, opposite, in the Walt Disney movie *Tron* were created by numbers at MAGI-Synthavision, one of the four computer graphics/special effects groups that contributed computer-generated imagery to the movie. MAGI stands for Mathematical Applications Group, Incorporated because the artists and computer scientists there use formulas and algorithms to instruct the computers in how to create and display images for movie photography.

the motorcycles as three-dimensional objects. (To simplify things, imagine that there is a rear-wheel sphere, a front-wheel disc and an arch that joins them.) Most artists would gladly trade the direct pixel setup for a more advanced system in which they could deposit simple instructions, such as "make a sphere," into the computer's memory, later ordering the computer to draw them automatically when needed (with the desired colors, perspective, etc.). Far from being technical or mathematical (stereotypes currently associated with computer programming), the artist would interact with this advanced memory-medium system through his or her movements. The computer artist is essentially selecting, positioning, fusing and shaping the basic forms to create a specific image.

Interface: Body Language for Artists

A simple gesture such as a wave of the hand can reveal a wealth of information. While a movie camera uses ten distinct pictures to convey this movement, the computer can capture it as thousands of minute colored pixels. If the hand holds a pen, for example, its motion is revealed by the line it leaves, which might be the beginning of an image. How is this hand gesture converted into a computer image? To name the pixels to be colored one by one is hopelessly inefficient compared to old-fashioned pen drawing. Computer-graphics systems necessarily eliminate the artist's familiar tools—pens, paints and brushes—substituting sophisticated interface devices such as sensors that capture hand movements as well as diverse video palettes, and constant visual feedback of what is in essence the artist's electronic canvas.

Let's take a quick visit to a computer-graphics workstation and have a look at the interface devices in action. This particular model (see photo 83), which is very similar to Santa's (see photo 80), has an electronic pen and drawing board and sports two video displays, one of which is a blank image screen; the

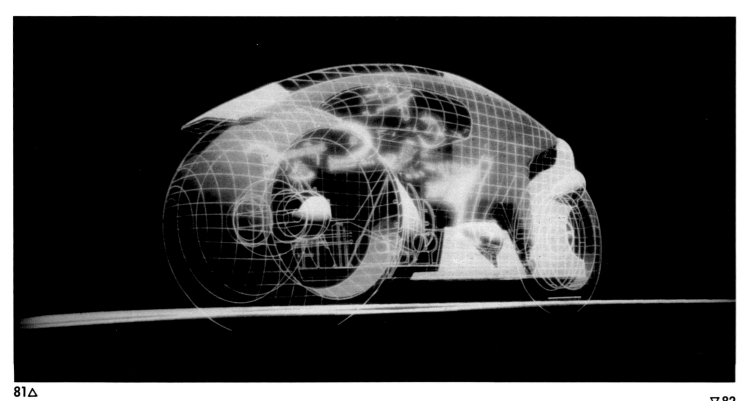

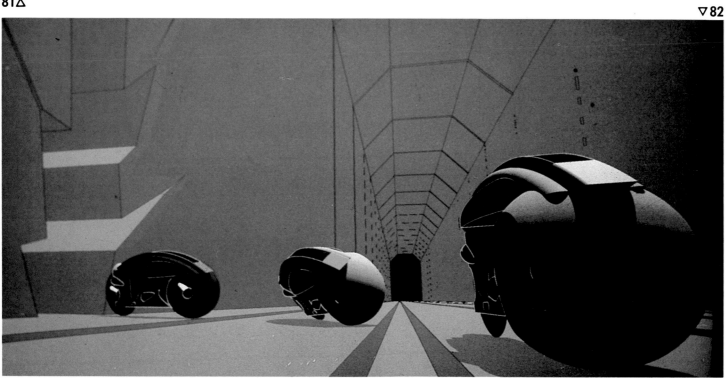

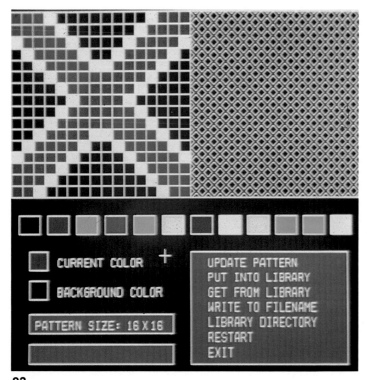

83

83,84. At the same time a computer artist is working on an image, choosing the colors and shapes desired, alternative instructions are displayed on a terminal screen. This screen offers a palette of available colors, as well as a number of other operations from which the artist may choose. These include either storing the image in the memory, recalling a previously created image or erasing the image entirely. One can also manipulate the color and background of the image. The video-palette illustration opposite, by Andrea D'Amico at DEI, shows off the computer's ability to aid the artist—to add "ice" and "spice."

other is a palette screen of available colors and other options. If you hold the pen in one hand, the other hand is free to push the buttons on a control panel. Push the button marked "Palette" and the video palette screen flashes "Ready." Motioning with the pen, notice that a blinking marker is moving over the palette screen, following your movement. Now move the pen, running the marker on the screen over the available colors. You've stopped on a nice bright blue; press "Select" on the control panel. The "Ready" message disappears from the palette screen and a bright blue dot appears on the image screen, moving instantly to echo any pen movements but leaving behind no trace. Now press "Draw" on the control panel and make a circular motion with the pen. A bright blue circle appears on the image screen. You are now a computer artist.

The subject of computer sensors and human body language is as extensive as it is fascinating. To begin

with, sophisticated sensors can provide an artist with a wide range of expression duplicating the effects of pens and brushes. Sensors in a computer-drawing board can detect more than the position of the electronic pen: they can detect pressure against the board, as well as the orientation of the pen. The speed with which the pen is moved affects the image. Video palettes include a wide variety of pen shapes and brush sizes to choose from. In advanced systems, the artist can draw a small pattern and then add that pattern to the video-palette choices as a new brush. When this brush is subsequently chosen to draw with, a single pen stroke on the drawing board automatically repeats the brush-pattern along the pen's path. Thus, visual-texture effects from crosshatch to charcoal, palette knife and more can be developed and rapidly applied.

Little different from the mechanical pantograph arm translating small pen strokes into large ones, the

84

computer sensors and body-language translators literally carry our body motion across to a new space that is formed in the computer's memory. The equipment shown (see photo 85) translates three-dimensional human motion into the illusion of travel over an actual scale model with laser optics directed to the model at the fictitious traveler's exact viewpoint. Scenes are retrieved and displayed on the screen so realistically that it becomes the window of a vehicle that the artist guides to capture and store new images. Processor memory is a far more dynamic space to work in than pen and ink or stone, opening up, as it does, wide new horizons of body-language translation. Visual performances could involve the human body to a far greater extent in the future than they do now. It is as though musically we have just discovered how to make sounds with hollow horn and stretched string. Ahead, however, there are trumpets, clarinets, pianos, synthesizers.

Overleaf: 85. Laser equipment from Singer Link is used in computer simulation.

Overleaf: 86. Digital Effects shows off their special effects in this frame from a Timex ad.

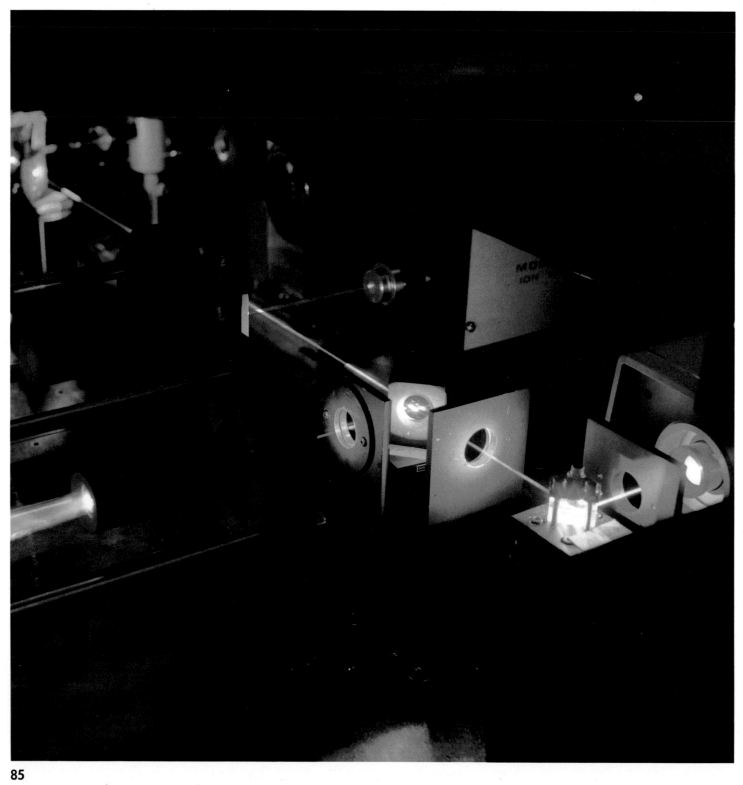

87

87. A computer-generated slide from Digital Equipment Corporation.

88. Lisa Zimmerman of Aurora Systems created this image of Kareem Abdul-Jabbar by bringing a video freeze-frame into the computer's system monochromatically, then recoloring it and eventually making it into a color print.

Overleaf: 89-91. Computer-graphics systems, like the ones at Aurora Systems and Dicomed, are readily adapted for use in TV graphics. They allow for the easy creation of logos, simple charts, graphs, illustrations and even cartoons and animation.

The Image Bank

Modern organists can push a tab to summon a trumpet or an oboe. The modern visual technician can effortlessly recall images ranging in complexity from balls to stripes to basketball players. TV lettering, which was mentioned in Chapter One, is a prime candidate for computer storage and retrieval. But the alphabet used in computer storage is much more general. It may include such things as a dust cloud or a flower petal or a pair of bluejeans. The draft of a plan or technical drawing, for example, may proceed from a collection of fundamental images and symbols that are relocated and reused over the entire drawing. Using a computer image bank, architectural artists have at their fingertips the entire array of symbols used in drawings to represent structures and features such as elevators, stairways and windows, as well as electrical or plumbing connections. Rather than draw these symbols repetitively and laboriously in each location where they are needed, the technician simply chooses a symbol and points to the proper location with the electronic pen. A perfect copy of the desired image is deposited there instantly, and additions and revisions can be made in a matter of seconds.

The visual alphabets used by commercial artists can be a versatile collection of props. As the next few images demonstrate (see photos 89–92), an alphabet letter can be anything that needs to be relocated and repeated within an image or throughout the course of an animation.

Brain Languages: The Imager's Apprentice

It is impressive to type "Kareem" on the computer and instantly conjure up the rather large image of the basketball player (see photo 88). But in order to go beyond using the computer only as an image storehouse, powerful language tools must be developed to manipulate images once they are recalled.

88 ▷

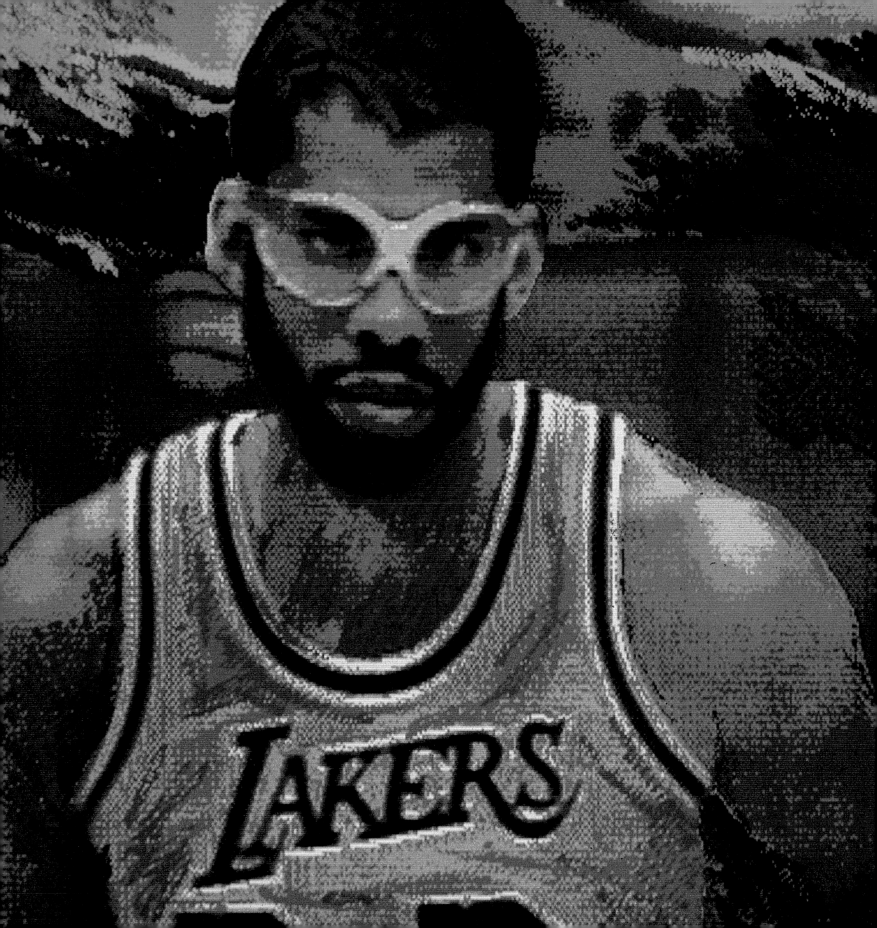

89

90

91

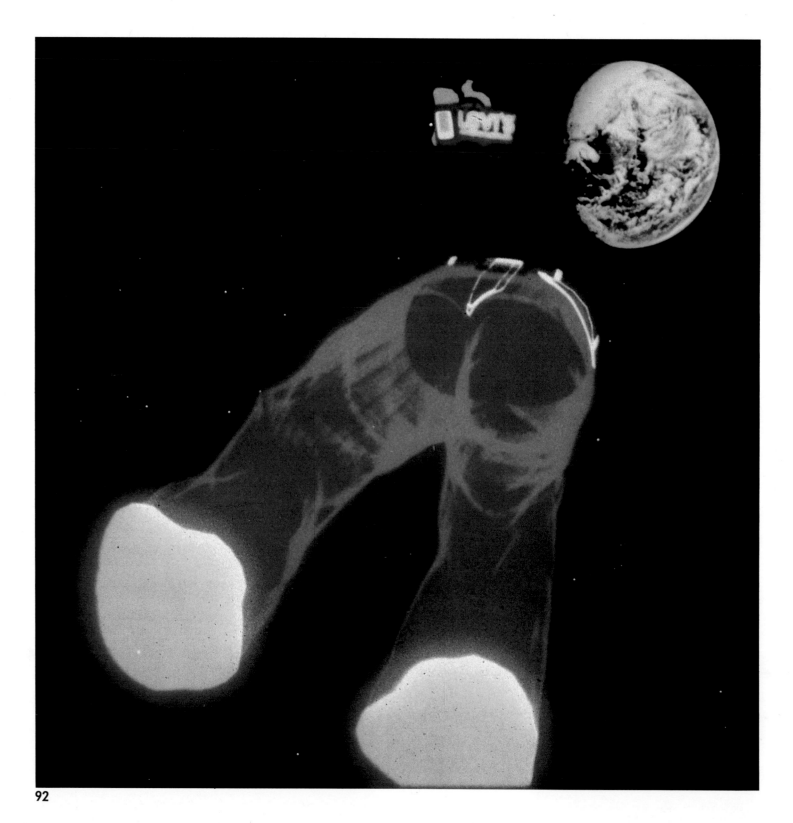

92

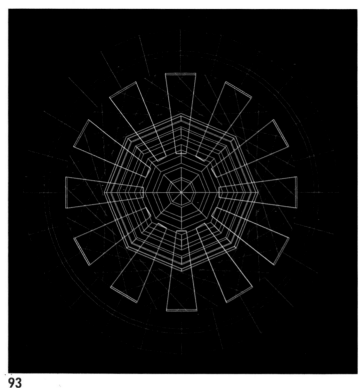

93

94

Computer designers and artists work together to develop various dialects of graphics language that artists will find natural to use and easy to interpret in restructuring visual forms. Using adaptable and powerful graphics languages, an artist can create an enormous array of effects by using the language to produce multiple, diverse transformations and combinations of simple image elements (transformations to support dynamic imagery were introduced in Chapter One). Other graphics-speak transformation commands can build images from much simpler elements than the figures that typically occur in key-frame animation.

These images (see photos 93 and 94) are constructed by the combination and transformation of such elemental forms as a line in a plane or a ribbonlike surface draped and twisted in three dimensions. Graphics language will specify a rule or a pattern for the overall image. Once the pattern has been communicated to the computer's memory, it automatically goes to work, actively generating new transformed lines or ribbon sections throughout the visual space until the entire image is completed. Transformed lines can change position, orientation or color. Transformed ribbon sections, however, have more freedom to change orientation as well as to express internal gradations of color and illumination.

92. Robert Abel and Associates used very sophisticated imaging systems to create the TV ad for Levi jeans opposite.

93, 94. Using the computer to control and create imagery can also lead to new artforms, new ways of imaging and perceiving. The work of computer artists Peter Crown, top, and Jim Hoffman, bottom, shows how the computer explores geometrics. The curving results are a far cry from the "regimented" graphics so often expected from the computer.

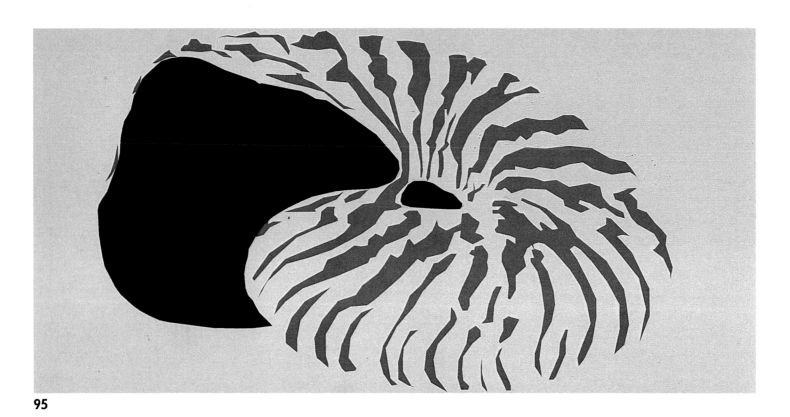

95

95, 96. Both *Shell* and the geodesic spheres in *Closegeo* were created by Mike Newman on Dicomed's D38+ Design Station and imaged on film at 4,096 line resolution, using a D148S color film recorder.

As an artist's apprentice, the computer accepts instructions and reacts by precisely and rapidly executing operations that the master would find impossibly tedious or time-consuming. The remaining images in this chapter (see photos 95-112), and many others illustrated throughout the book, show the handiwork of apprentices in their execution of detail. Much of the excitement in computer graphics systems today stems from the development of new languages for the brain as well as for the body: the apprentices are emerging from a stage in which they were fairly simpleminded and mathematically oriented (due to the computer's historical development) to one in which they are becoming increasingly intelligent and visually oriented. As a result, they can now be commanded to produce sophisticated graphics constructions more easily and by means of concise language: "Paint the shell with red stripes"; "map the sphere with yellow circles and bring it to the foreground" (see photos 95 and 96).

96 ▷

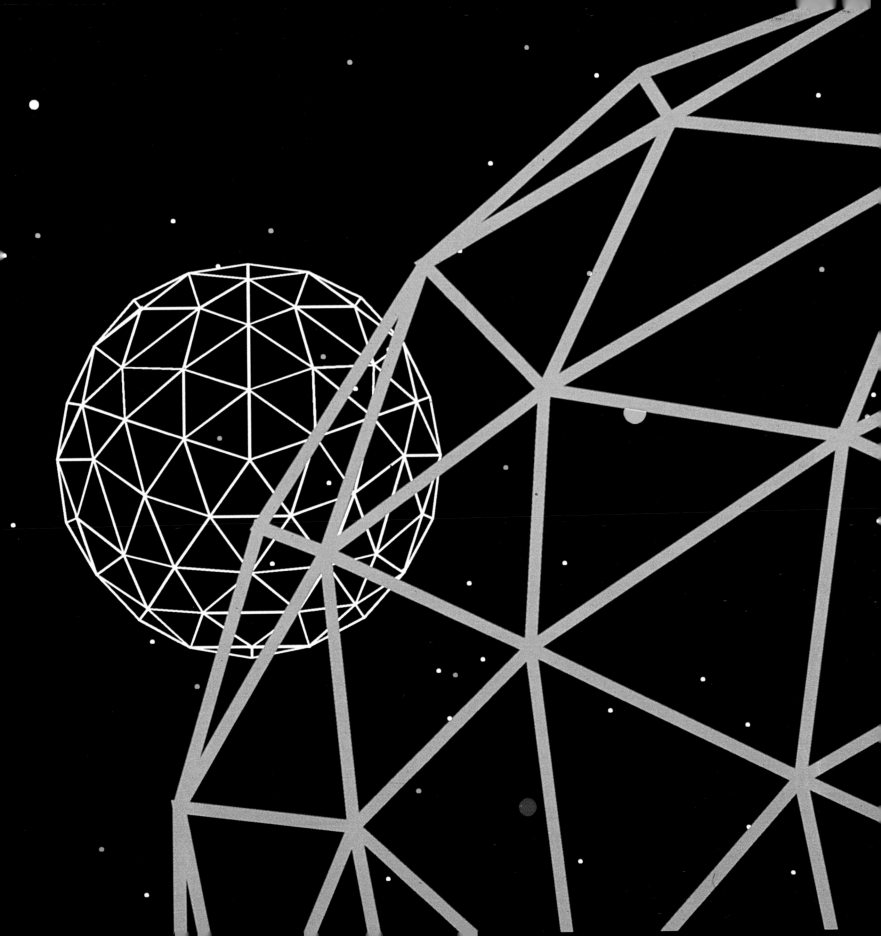

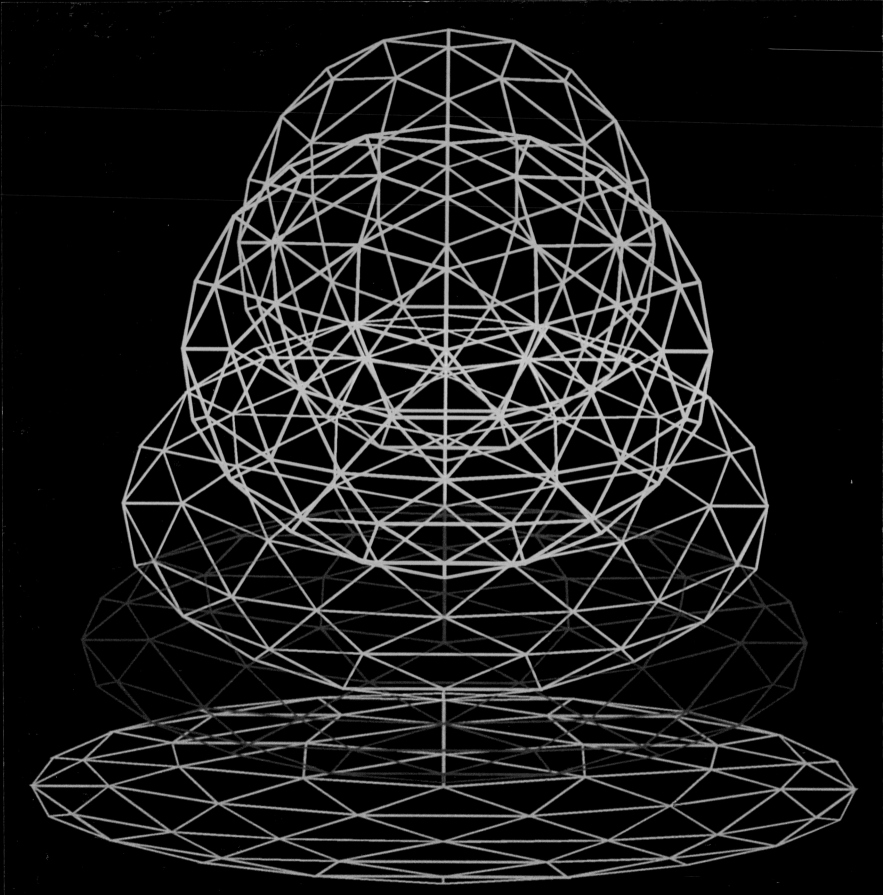

98

The craft of the apprentice is obvious enough. But what language would such a servant speak? While there are limitless possibilities, here are a few examples: first of all, body and brain languages should work together. The brain language might be used to type "Draw," press a button marked "Draw" or even to say "Draw!" to a modern computer equipped with a microphone and speech-recognition capability. Subsequent body language (in the form of pen motion to select color and communicate locations) may produce the final drawing. Or the command might be "Paint!" or "Fill!" In this case the hand motion would select another color, then point within the outline of a figure

97, 98. Mike Newman of Dicomed created the geodesic spheres in *Homage to M.C. Escher and Buckminster Fuller,* opposite, as well as the shapes and forms in *Airwaves,* above.

99

99–101. The visual alphabets used by commercial artists can be a versatile collection of props. An alphabet letter can be anything that needs to be relocated and repeated within an image or throughout the course of an animation—the springs in Mike Newman's *Sprung,* above, for example. Opposite, the addition of rainbow coloring makes the Dicomed equipment-created titles swirl.

to be filled or a shape to be painted three dimensionally. With suitable words or gestures, the two top spheres (see photo 97) could be commanded to produce the remaining three by analogy, or the leftmost star (see photo 98) could generate all the others by theme-and-variation.

How does the apprentice understand such concepts as analogy or theme-and-variation? What language would you use to communicate these concepts? The second question is easier to answer than the first: simply point to images A and B and tell the computer "Analogy!" If all goes well, the computer will pro-

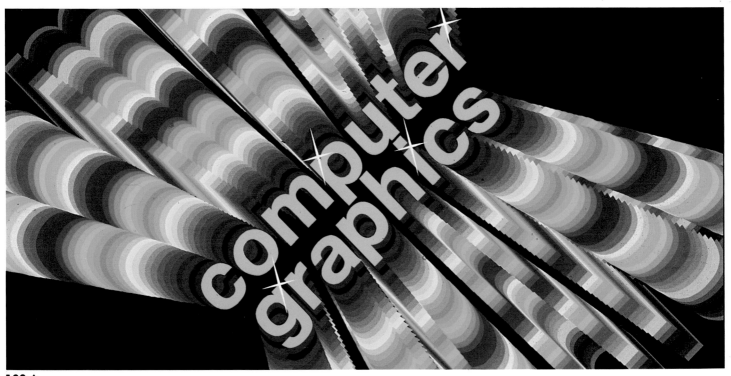

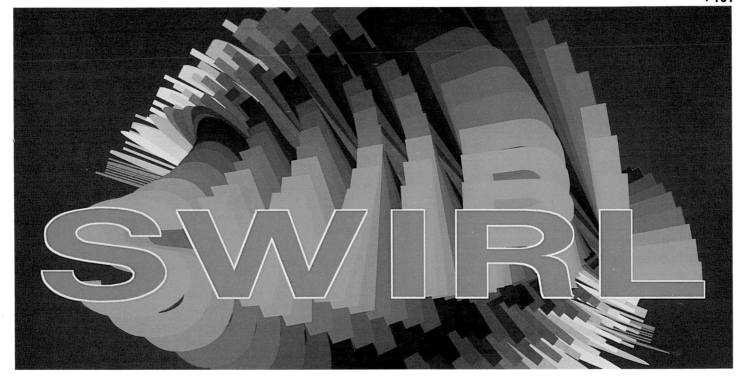

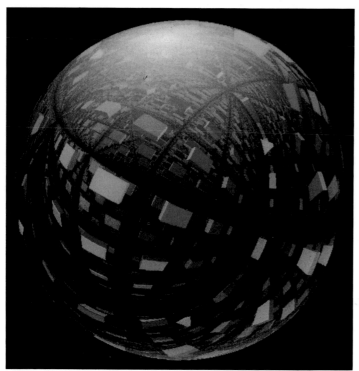

102

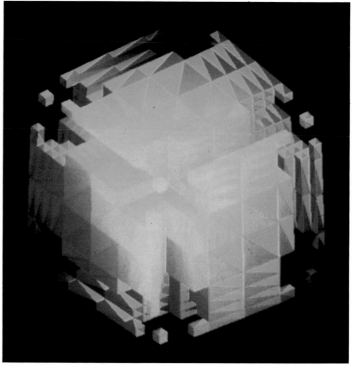

103

102–105. The fragile, abstract computer-generated geometric shapes on this page and the next, by Jim Hoffman of the University of Massachusetts, have specific, mathematical roots. As Hoffman expresses it, "Computers and their associated graphics devices are excellent tools for creating images based on concise mathematical descriptions. The artist need only create and manipulate the description to effect global changes in the images computed from the description. In my work I use simple idealized visual properties; the symmetry, curvature and intersection of three-dimensional forms and the illumination, translucency, texture and reflectance of such forms. The combination of these simple properties can create rich interactions of form and color. The images are envisioned as snapshots of moving three-dimensional images."

duce an image, C, which relates to the image B, as B relates to A. For example, the yellow ring in the towers (see photo 99) could be generated by simply pointing at the blue ring at the top and then at the green below it. (Not only the new ring's size but its color might be an analogy, considering the order of the colors in the rainbow.) Much more difficult, however, is this question: How does the apprentice know the relationship between the two top rings, the successive pairs of words at right and the spheres and stars that we have just seen?

There is one immediate and important way in which the apprentice can be made to understand the relationship between two images. Suppose the apprentice had originally created the second image as a transformation of the first. Analogy is then immediate: apply that same transformation to the second image, and a third image arrives in perfect analogy. Because of the mathematical history of computers, all of the analo-

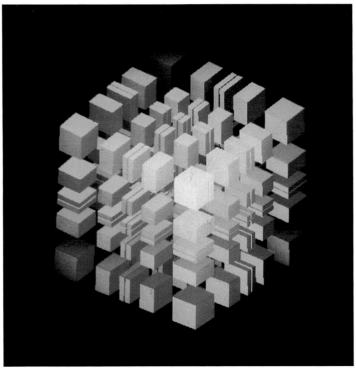

104

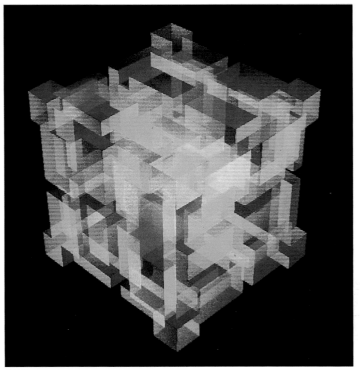

105

gies we have just seen result from stock transformations (stretching, shrinking, relocating and twisting) that are easily implemented on standard computers. It would, however, be extremely shortsighted to dismiss visual analogy and theme-and-variation as being confined to simple shapes and geometric transformations. We are only beginning to explore the concept of image space in the memory-medium, and the familiar world of Euclid is just a starting point. The sphere itself is a reminder that flatland geometry can be successfully adapted to a new vision of the world, whether for geography or for art.

If the computer is expected to analogize a new creation from *any* indicated pair of images, the problem becomes at once more difficult and infinitely more interesting. An apprentice capable of extracting such general analogies would truly be intelligent. In graphics as well as in virtually every other area of computer use, the potential of such *artificial intelligence* is energeti-

cally being pursued. The beautiful sphere-and-cube faceted images (see photos 102-105) furnish an opportunity to describe one possible approach.

Suppose some pair of facets A and B on one of the above images is chosen and the computer is directed to draw a new facet by analogy. On the surface of these objects, with their curving, shrinking and colored facets, we have temporarily lost sight of Euclid's geometry of straight lines and right-angle distances. Using adjacent facets as stepping-stones, though, the computer could trace a path from facet A to facet B. (There may be many such paths; we could select the shortest one.) This path defines the transformation from A to B. In other words, we could tell someone how to reach B from A: "Stand on A facing north, then go ahead two facets, and right four facets." To reach the new image, C, our path is now clear: use the same path that led from A to B, but use B as a starting point. A new image (facet) is reached, completing the analogy.

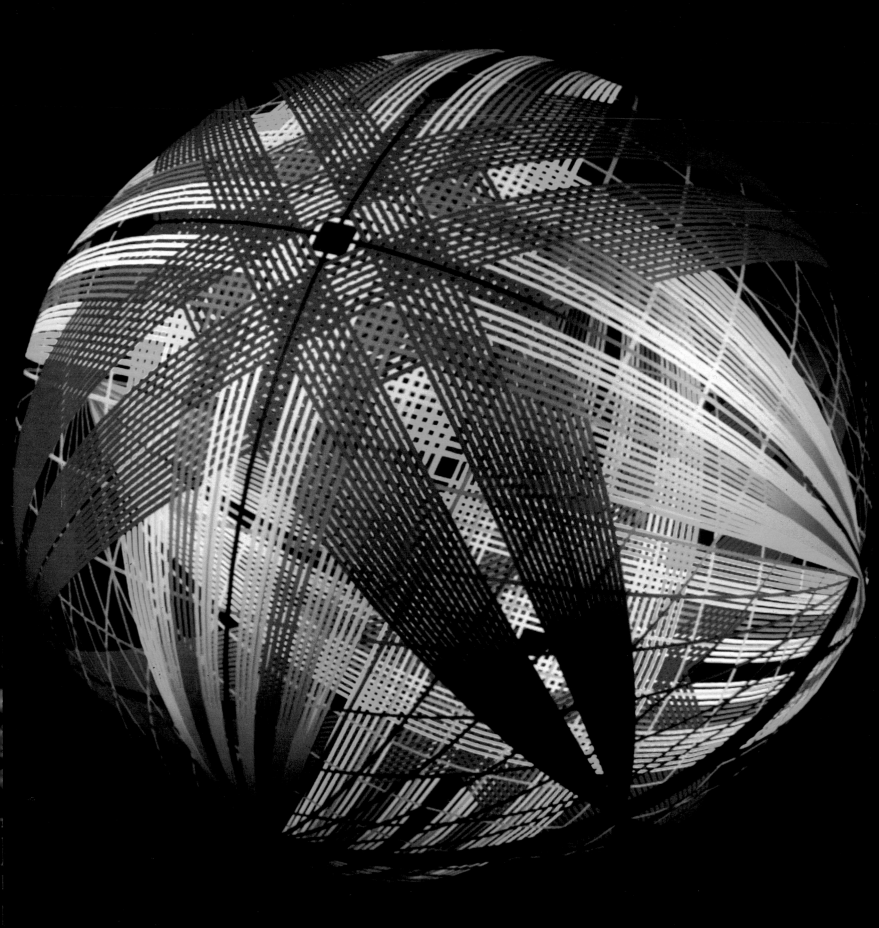

The shapes of the sphere-and-cube faceted images (see photos 102-105) are examples of alternative geometries in which new images (facets) can be created from existing ones. Visual image spaces in computer memory will create entirely new structures, with transformation paths continuing to produce analogies. For example, one might point to a Neanderthal face, then a modern one. By analogy, the computer would be able to create a face belonging to the future.

Output:
The Weaving of Images and Machines

Like a sculptor's mold, an image in computer memory is not usually interesting in itself. The image must be expressed, or output, in some medium. For the computer of the '80s, the *video-display* technology that has already been described is by any measure the most widespread output format currently in use. Other possibilities, however, are common and interesting. In particular, ordinary video display can be adapted to photographic equipment, producing permanent color film or print images as output rather than the fleeting image of a video system. This can have a significant effect in the field of film animation. Even if a computer is not powerful enough to generate twenty images per second, successive images can be captured on movie film or videotape and played back at that rate.

The *pen plotter*, a motorized physical pen moved by computer signals, is another output device that is now available and may lead to future developments. The plotter, though slow, provides the same permanent-image capability as film does relatively cheaply; it does so with a quality that ranges from acceptable to excellent. The plotter is an example of using the memory as mold to guide mechanical action. Similar devices could be developed to make anything from weavings (the first computerized machine was a loom) to oil paintings. (Many plotters can automatically exchange pens while drawing to produce different colors; brushes would be no more difficult to exchange, though they would perhaps be more difficult to control.)

Lasers, as well as electron beams, can be guided by computers to sweep over an area and rapidly paint an image. Guided lasers are another example of both a current technology and a glimpse of a future one: *laser printers* widely available today use the beam to write on a xerographic drum and produce high-quality paper-and-ink copies at very high speed. In the future, lasers of much higher power working under computer control will be able to carve almost any material into desired shapes with unprecedented precision.

The final output form to be discussed is *silicon*. Although it might seem the most futuristic medium to the uninitiated, silicon is the foundation of the most practical use of computer imagery today. A new breed of commercial computer artists is developing graphics languages and *computer-aided design* facilities, raising them to new peaks of power and flexibility. Their visual creations are inventive solutions to challenging graphics puzzles. Silicon chip layout, conform-

106. Computer imagery can create a tapestry of color. Simple forms, like the sphere by Digital Productions, opposite, can be richly embued with texture and graceful inner structure or highlighted by the computer-created appearance of light glowing from within.

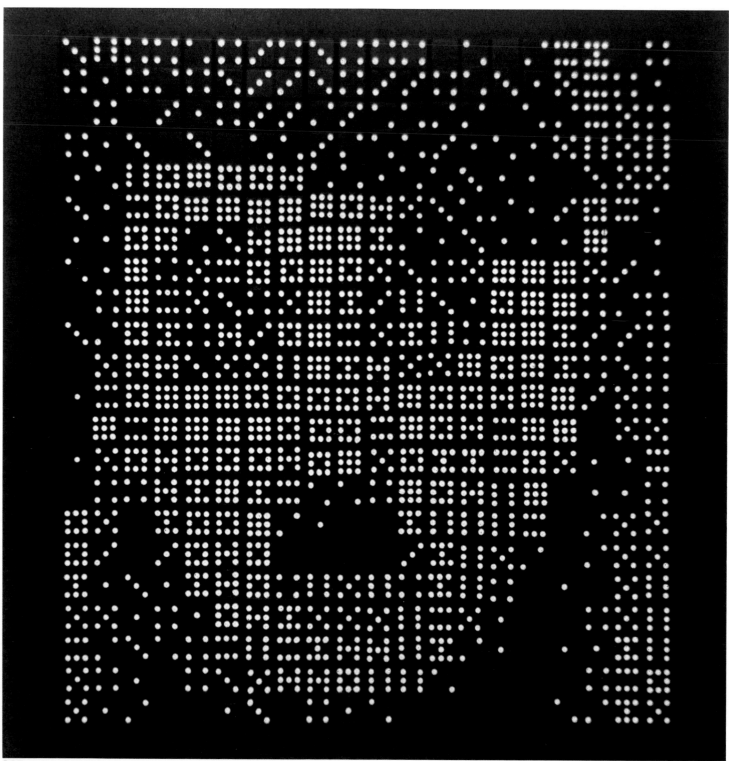

107

108

ing to strict design rules, is an art and a science that would require volumes to describe and computers to implement. The creation of Charlie Chaplin (see photo 107) using only a complete set of dominoes, conveys the flavor well. But there is more to silicon than these fascinating visual forms: these new works of design art also function as the neural structures of new computers. Enlarged for human viewing, they illustrate an impressive beauty in the interweaving of elements and the regularity of their structures. Shrunk to less-than-thumbnail size and etched in silicon, their pattern is revealed to be tens of thousands of active circuit elements functioning as the brain of a modern computer.

107. Ken Knowlton, who created the domino-set portrait of Charlie Chaplin opposite, has been a pioneer in computer art. An associate of Via Video, he created this portrait from four sets of pasted-down dominoes. Knowlton does the portraits by drawing up a program that contains the patterns of four sets of uncut double-nine dominoes. Once these black/white positions are registered in the computer's memory, they can be arranged to match the light/dark pattern of photographs or other graphics.

108. Most computers are now designed using state-of-the-art Computer-Aided Design (CAD) equipment. It takes computer graphics and imaging systems to improve and develop a computer's components, such as this microchip above.

While a graphics computer at which a chip designer works will have essentially the same features as the workstation used by an electronic cartoonist, it also needs a capacity for intensive internal computation. The electronics designer has a peculiar alphabet of symbols, such as logical *gates* that pass or block signals under the control of other signals and *paths* that connect every gate to the rest of the device. An actual silicon device consists of several layers that must be accurately aligned and superimposed during fabrication. Rather than draw each layer separately, image-bank techniques now routinely enable the designer to recall and instantly position not only gates but complete logical subnetworks and place them on a single design. When the design is completed, the workstation computer will automatically separate the appropriate designs for each individual layer. An important additional function of the computer is that it evaluates (e.g., checks for design-rule violations) and tests (simulates running the circuit) directly on the drawing board. The fundamental versatility of the memory-medium is therefore brought to the realization of its ultimate potential here: it not only molds the intermediate effects of visible image, film and silicon furnace but actually recreates and improves upon itself in a manner once unique to biology.

◁ 109

110

111

109–112. These images, by Lexidata, Phillip Harrington and Manfred Kage, show the complexity that goes into the design of computer components. Recent advances have led to what is known as Very Large Scale Integration (VLSI), in which millions of transistors, capacitors and resistors, among other intricate hardware, are placed on a silicon wafer (the chip), usually no larger than an infant's fingernail.

112

113. An image of the Comsat satellite Intelsat V over a NASA photograph of the earth taken from the moon.

4. VISUALIZATION AND COMMUNICATION

"How do cloud patterns develop and migrate over the earth?" asks a meteorologist. "What is the orbit of this satellite?" asks an engineer. "How can a highrise tower be braced to withstand great stresses yet appear streamlined?" asks an architect. While words can be used to answer such questions, a visual image provides a clearer and faster explanation. Computer-generated imagery now makes comprehensible the masses of details in fields ranging from microcircuits to macroengineering. The computer visualizes such information for us by making a picture. This chapter is a tour of the world from near and far, of technology close up, cutaway and seen in perspective through the versatile eye of descriptive computer imagery.

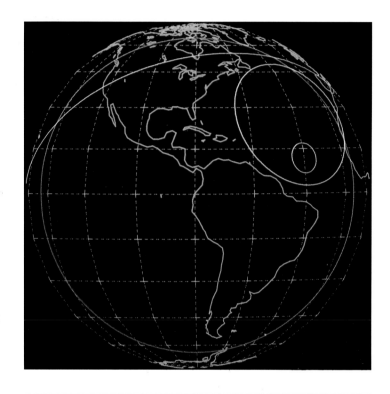

114. This model shows an orthographic view of the earth with a satellite and its orbit. The viewing angle is from another satellite in orbit. The local horizon of the satellite and its relation to the local horizon of various other satellites is shown.

A Picture Is A Megaword

There is an old saying that one picture is worth a thousand words. Until the first pictures were sent from space, we did not fully realize that we had never seen the earth. Map makers had tried to show it, as had globe makers, in ever-increasing degrees of accuracy and detail. But there was no substitute for the view that our leap to space brought us: the sight of earth for the first time from the perspective of the universe. All previous attempts to represent the earth to us paled next to that startling image.

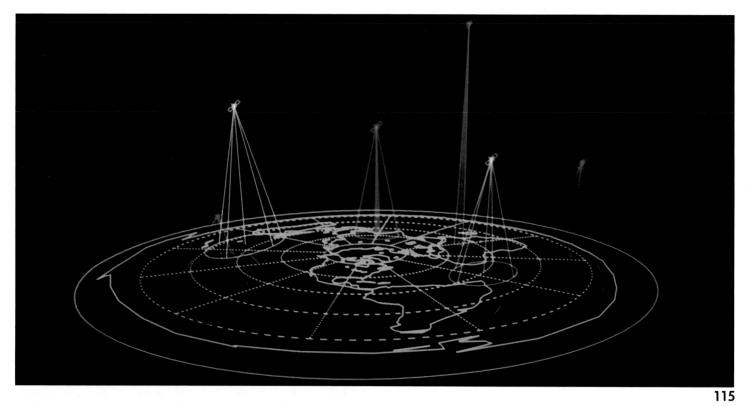

115

115. This photograph, by Martin Marietta Aerospace, is a three-dimensional representation of various satellites in orbit, showing the altitude of each one. The satellites are given different colors on the CSM Color Display to distinguish them from each other.

116. Solar flares captured by Science Applications International.

117–122. Part of the Bell Communications network is pictured opposite in a TV ad prepared for AT&T by Digital Effects, Inc.

116

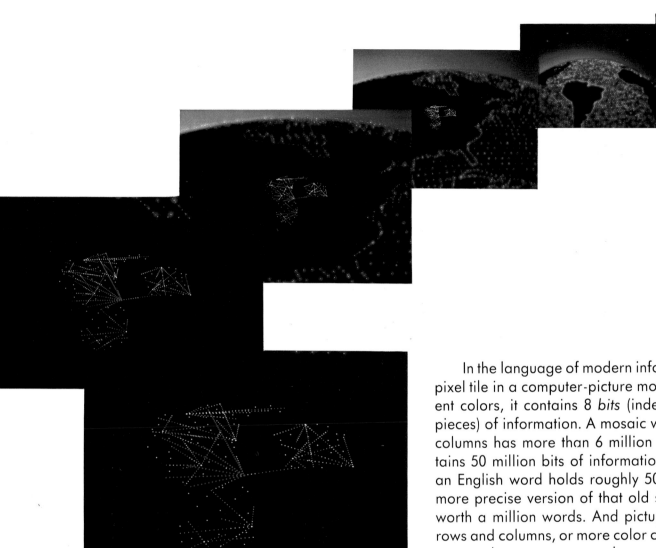

117–122

In the language of modern information theory, if a pixel tile in a computer-picture mosaic has 256 different colors, it contains 8 *bits* (independent yes or no pieces) of information. A mosaic with 2,500 rows and columns has more than 6 million pixels and so contains 50 million bits of information. By this measure, an English word holds roughly 50 bits, so there is a more precise version of that old saying: a picture is worth a million words. And pictures that have more rows and columns, or more color choices for each tile, are worth many more words.

There is a great difference, though, between acquiring the same information from a million words and acquiring it from a picture. Presented with that choice, most of us would choose the picture, since we can grasp its information almost instantly, easily finding an outline or recognizing and remembering a shape. By looking at a map, we are able to see facts; for example, which of the 50 states are roughly rectangular, or (if elevation data are represented by color overlay) where a mountain ridge or a valley can be found. Imagine the difficulty and drudgery of extracting those same

123

124

125

insights from page after page of the equivalent numerical surveyor's data!

Interaction:
The Viewer Enters the Picture

The communicative power of a picture is even greater than simple pixel counting would suggest. When information is presented pictorially, the viewer actively restructures it, focusing on particular aspects. Every person brings a different perspective. The picture serves them all, and it does so in a way that would require an impossible number of words to duplicate. To appreciate the sheer volume of words a picture replaces, we might consider just one situation: the ability to focus on subgroups and make comparisons. In viewing the maps in this book (see photos 123-126), you can easily compare subgroups of states or regions. However, suppose the picture were taken away and you were given the monumental task of describing all of the possible comparisons in words. In order to write a reasonably detailed comparison of the data presented for 2 map regions (population, rainfall, elevation or any other information that has been visually represented), you might require 100 words. If the entire country contains only 3 regions and you restrict yourself to two-at-a-time comparisons, there are only

123–126. The computer-generated maps, top and center, by Digital Equipment Corporation, show the United States with central New England "called out" for special cartographic display. Through such call-outs, as well as color coding, comparison displays and other effects, cartographers can present extraordinary amounts of information quickly and efficiently. The land-use demographic map by Dicomed, bottom, shows the effectiveness of color in illustrating this type of information. Opposite, another map detail by DEC.

126

127. In three-dimensional pursuits such as architecture and engineering, an image often means not only a picture but a scale model. If a simple colored map is constructed as an actual physical object, it is infinitely more functional. With a computer-generated scale-model building, we are not restricted to a picture of a single surface, but can obtain a variety of views by instructing the computer to display different aspects of the building.

3 distinct comparisons to be made, and 300 words should suffice. For a country with 10 regions, you will have to cover 45 different pairs, and 4,500 words will be needed. With 50 regions, you may as well buy a word processor and consider being a professional author, because you will need to write almost 125,000 words. If you are ambitious enough to try writing about all comparisons (not just 2 regions at a time), the explosion will overwhelm your word power: if you describe comparisons within all subgroups of a 3-region country there are 8 possibilities, more than 1,000 comparisons for 10 regions and over a thousand trillion (actually 1,125,899,906,842,624) for 50 regions.

A two-dimensional map, however, does little more than scratch the surface of image capabilities. In three-dimensional pursuits such as architecture or engineering, an image means not only a picture but often a scale model. If a simple colored map is constructed as an actual physical object, it is infinitely more adaptable. Different regions in the map, like the individual pieces of a puzzle, could be picked up and regrouped together for comparison. With an architect's scale-model building, we are not restricted to a single surface picture but can obtain a variety of views by standing close up or far away and moving all around the model.

Many of the advantages of scale models and other three-dimensional images can be achieved with computer-graphics systems. By using a system of language and pointing, like the computer-graphics artists themselves, viewers of computer maps or architectural models can interact and communicate with the system, choosing and changing the two-dimensional video display to suit their interests. The computer's ability to store and retrieve means that in an interactive system you would be able to extract and regroup regions as easily as you clear the video display. In this case, the task would be accomplished by giving the names of the states you wish to see grouped. The regions are instantly redrawn on the screen and can be picked up and moved around simply by pointing with the system's electronic pen.

128. This image, a computer-created architectural rendering by A.C. Martin & Associates, literally takes the roof off the house. With the computer aiding architectural graphics, we can now electronically lift a roof as easily as we might open a door. We can float over a structure, travel through a heating system, or see a room from a fly-on-the-wall perspective. The ability to make architectural renderings in three-dimensions provides the advantage of really seeing what has been designed, of visually trying it on for size. With the proper program, the model can be changed again and again, a variety of comparisons can be made and a number of alternative solutions to the same architectural problems can be stored and retrieved on command.

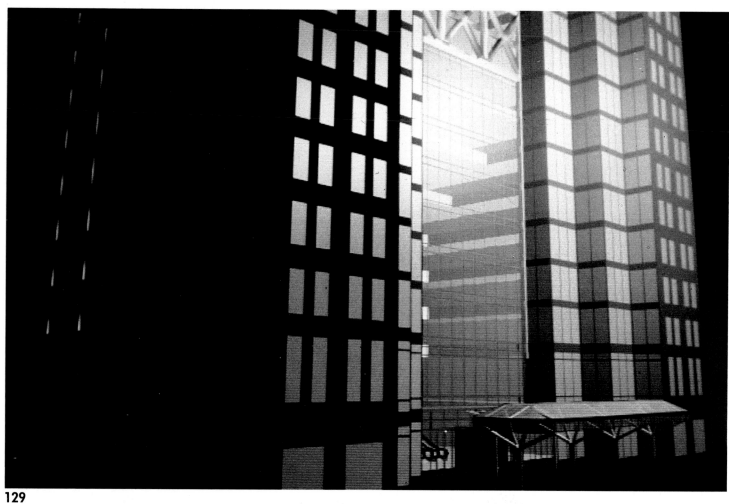

129

129, 130. Michael Collery's architectural studies of office buildings show the power and force the computer imaging brings to architectural rendering. Viewers of his architectural models can interact and communicate with the computer, choosing and changing the two-dimensional video display to suit their needs and interests.

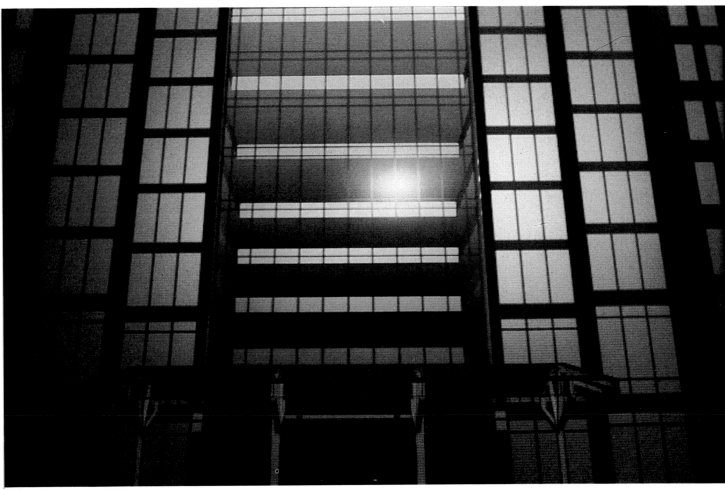

130

Successful visual communication can be achieved not just by recalling and displaying separate regions and objects but also by viewing a single subject in many different ways. One coloring of a video map may highlight population patterns. At your request, the screen will change to a new coloring of the same region, perhaps to describe agriculture, or again change upon command to display both features simultaneously. With such systems, maps are no longer static, lifeless records but become helpful, informative entities that shift and alternate colors and forms in direct response to the viewer's questions and commands.

Perhaps the stored images are not different colorings of a map but are different perspectives of a bridge or a building. An interactive graphics system can give the illusion of an actual tour moving the viewer around in order to see different aspects of the structure. Give the command "Zoom in!" and the present view will be erased and replaced with one that represents a closer vantage point. "Turn 30 degrees!" The image dissolves and a new one emerges, one that turned clockwise by 30 degrees (see photos 129 and 130). By simply naming them, you can summon various related projects or extract individual elements from the present structure.

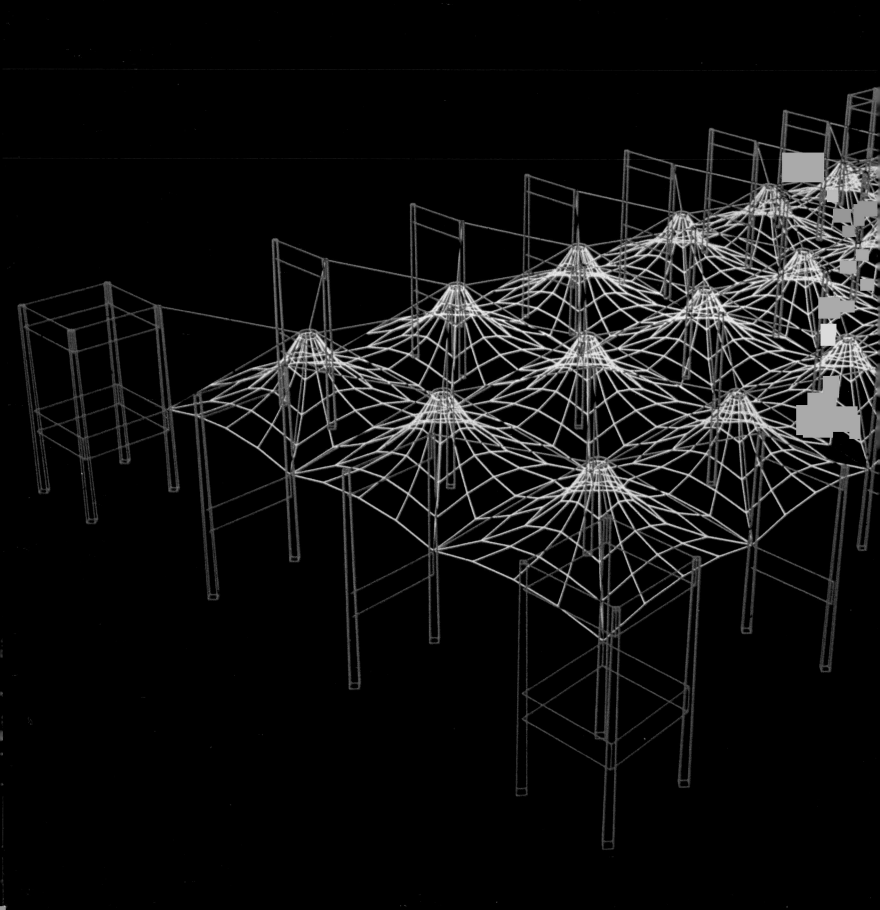

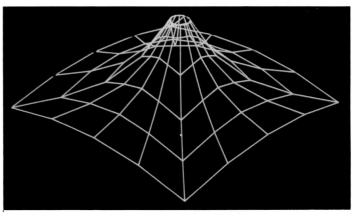

132

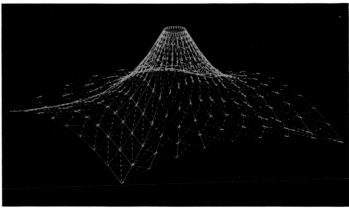

133

131–133. When large, complex architectural projects are being planned, the computer really has an opportunity to shine. These images, created by Skidmore, Owings and Merrill, show the various roof coverings that were considered for the design of an airport in Jedda, Saudi Arabia. The use of computer graphics enable the architects to depict and then test the different roof coverings and structural supports being considered for the airport buildings.

134

134. An Evans and Sutherland Picture System II imaging computer is used to project the various components needed to be designed in this scene from an industrial movie produced by Skidmore, Owings and Merrill, with animation assistance from Robert Abel & Associates. Once data is resident in the computer system, then it can be called up and used as the basis for pictorial representation of a design. In this way, different design possibilities can be tested graphically and presented for consideration.

All the realism of a traditional scale model has been captured. But because the computer model is formed in a dynamic memory-medium and not in a static medium such as wood, cardboard or papier-mâché, it can be employed with increasing versatility.

Computer imagery enables the designer to have the best of both worlds: the realism of a physical scale model as well as the insights provided by seeing tangible forms of what were until now strictly imaginary views. The artist creates a series of views, storing them in the computer's memory. The computer will then provide any tour the viewer chooses to take through these views. At the start, the video screen might display a realistic daytime view of an office building. At the touch of a button, a nighttime silhouette appears; another touch shows the structure's internal supports, glowing

in color through a new transparent external skin. At any point, the system will redisplay an image from a new distance or angle upon request.

The viewer is controlling video display by both language and gesture in the scenes of human and image interaction just presented (see photos 129–134). Only the visual concept needs to be communicated into the computer's memory. We have already seen the apprentice (that fictional character that embodies the ability of a graphics system to handle the painstaking and essential details of producing images) hard at work in creating its imagery: producing animation sequences from key frames, repeating and copying images and image elements, making transformations and even creating new images from existing ones by analogy. In visual communication, just as in crafting images, the apprentice plays a constant role.

If the interaction between computer and artist is based strictly on selections of images already in the computer's memory, the apprentice's role is simply clerical, fetching any named picture and sending it to the screen. In more dynamic interactions, however, the apprentice must be able to custom-tailor images rather than simply locate them ready-made. Mechanical parts such as those depicted here (see photos 135–142) furnish an excellent example. These parts could be turned and viewed in a thousand different ways and cross-sectioned, cut up or blown apart in ten thousand more. Instead of having human technicians enter and the computer memory store thousands of separate individual images, a simple concept should be stored, with the skills of the computer apprentice turned to generating any images resulting from it.

By generating images under viewer control, computerized visual communication can provide not only interactive tours around three-dimensional objects but a world of other dynamic effects as well. The most adaptable approach is to store images not as pixel-form surface views but as *structures* or *models* that the apprentice can transform into images, responding to viewer requests in a variety of ways. If the stored struc-

135

136

135,136. One of the most exciting applications of computer graphics technology is in the area know as CAD/CAM, which stands for Computer-Aided Design/Computer-Aided Manufacturing. It enables an engineer, designer or computer scientist to use a computer-graphics system to design a product, starting with its component parts and taking the product to completion. The computer keeps track of all the details, maintains the designs of all of the parts in its memory and combines the parts electronically as required.

137

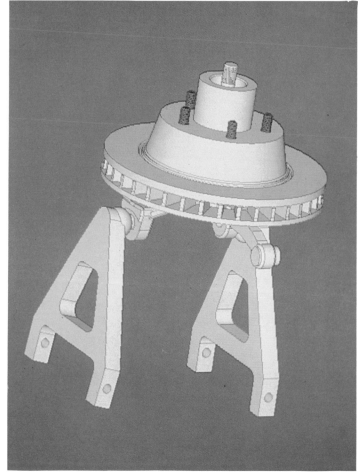

138

137, 138. Like the machine parts on the preceeding pages, these industrial parts were designed by a CAD/CAM system, which promises to be the next step in automating the workplace. CAD/CAM systems bring tremendous options to designers and engineers in the planning, design, implementation and fabrication of industrial products. The computer not only keeps track of all the design parameters and facilitates the comparison and testing of different design ideas, but it also allows for the collection and management of data relating to the manufacturing processes. The images on these two pages are from a CAD/CAM system made by the Applicon Company of Burlington, Massachusetts.

ture represents pipe routing in a pump, for example, the computer apprentice would use this structure in conjunction with transformation routines for color or fluid-flow animation. Whatever stage of pump operation the viewer requests, the system can show it by appropriately transforming the stored pipes to produce a colored, pulsing image. Unlike a physical scale model, the pump may be operated and seen cutaway simultaneously.

The most ambitious representation effects require the most sophisticated models. The modeling-transformation process itself will be further explored in the

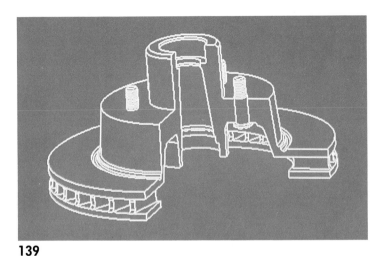

139

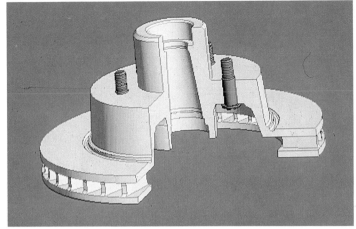

140

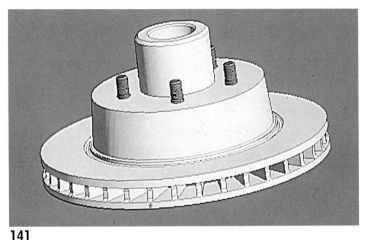

141

142

139–142. CAD/CAM systems operate as both image-making and data-management systems. The Computer-Aided Manufacturing part of the system takes care of managing the data needed to bring a designed product to the manufacturing stage. CAM capability means that the computer can inventory the parts of a product and the materials needed in the manufacturing of it. Sophisticated CAD/CAM systems can initiate interrogation of other computer systems to check on the availability of raw materials and specialized parts; they can initiate orders and track inventories; even reorder materials when necessary.

next chapter. We can, however, look at some simple geometry that leads to impressive images. Look closely at the computer-drawn machine parts shown (see photos 135-142) and you will see skillful composites and modifications of a few basic geometric shapes. You can obtain a clear insight into how complete geometric structures are stored and interactively transformed by understanding what happens to these individual, elementary geometric shapes. Perhaps the easiest shape to visualize is a sphere. Regardless of the angle from which it is viewed, its two-dimensional projection is a circle.

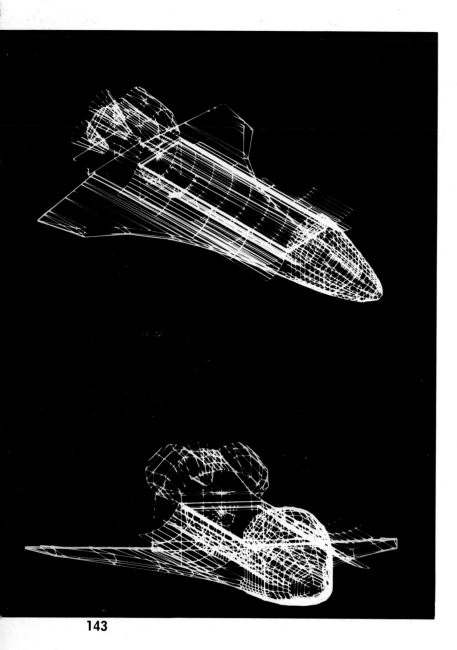

143

If the apprentice knows how to draw a shaded circle, it will have no difficulty transforming the sphere in memory into a screen image that matches any perspective selected by the viewer. The only factor will be distance: the farther away the viewer is, the smaller will be the circle that should be displayed. Straight thin rods or wires in memory structure are nearly as simple: on the screen they should always be shown as straight lines. If the computer can draw straight lines, it can show a rod from any distance and angle the viewer chooses by simply adjusting the length and the angle of the displayed line.

We could continue to enlarge the list of shapes indefinitely. For example, a flat, circular plate projects as an ellipse from any angle and distance. Ultimately, though, the power of the shape-and-projection approach rests on the computer's ability to make composites. An approximate cylinder could be composed rather than stored from a birdcage of two flat circular plates, joined together around their edges by closely spaced straight wires. A drawing of this cylinder from any perspective can be produced by drawing individually for the chosen perspective, the flat circular end plates (as ellipses), then each of the joining wires (as straight lines). As the space-shuttle images here clearly demonstrate (see photo 143), even a complex object can be built up and displayed as a close-fitting skin of connected straight wires.

143. These images produced using PATRAN-G on an Evans and Sutherland Picture System 300 portray a wire-frame representation of a space shuttle.

144. This image of a pump assembly was created on the Aurora system by Damon Rarey, using real-time animation and colors to show how the pump functions.

144 ▷

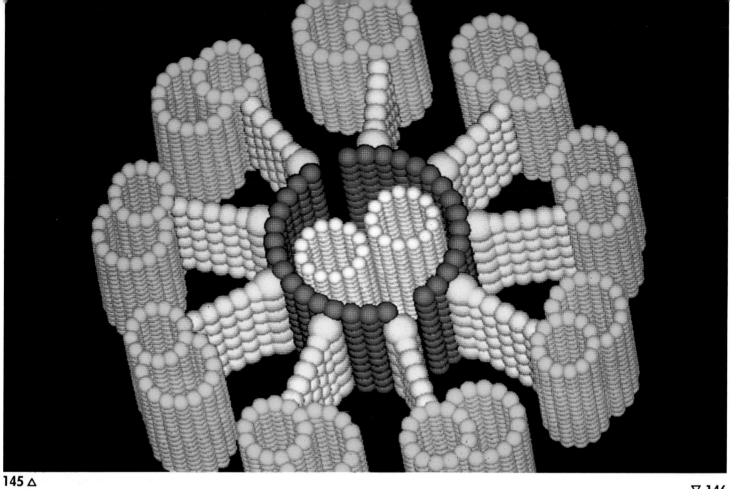

Image Assembly and Image Extraction

Scale models have always been very enlightening to view but difficult and time-consuming to build. Architects (or their patient subordinates) spend vast amounts of effort cutting and pasting cardboard to produce miniature buildings and developments. While chemists think about and work with sophisticated molecular structures, they find it equally important to relearn childhood skills such as choosing and stringing beads in building visible models. But once you discover that the computer itself will make models, all of the paste, wire and beads formerly required to build models can be dispensed with. Instead, the tools and techniques described in Chapter Three for crafting two-dimensional images can be applied. A wire-frame skeleton to represent a turbine or a space shuttle is no longer painstakingly soldered in place but is quickly penned in electronically. The spheres and sticks of a chemical model are recalled from an image bank and glued in place by pointing. Repetitive elements in the original construction, as well as later corrections and modifications, can be effortlessly produced with the concise language and motion commands of computer image craft.

While you may appreciate models made from computer memory more than those made from papier-mâché, you may not yet fully realize the savings in human effort made possible by the electronic medium. Not only can models and images be assembled by human designers but they can often be automatically extracted from existing nonvisual storage. Computerized data is inherently transportable and negotiable. It can be sent across the world by satellite to build electronic devices in one country that have been designed in another. The progress of graphics systems now makes it possible to capitalize on the mobility of computer data. After all, it is the information in a design that determines what a scale-model megalopolis or a molecule will look like. If a computer in another

147

145, 146. When we think of the computer acting as a design aid, as in CAD, Computer-Aided Design, we usually think of its applications to space shuttles, computer chips, automobiles and the like. But, the computer can be used as an aid in the design of almost *anything*. The two images opposite show different views of the internal design of a pharmaceutical product, the drug axoneme.

147. This image, the complexes between two forms of L-arabinose substrate and binding protein, was developed using FRODO on the PS 300. Using the PS 300's Color Display enables the crystallographer to pinpoint and identify different components with great accuracy and clarity.

148

149

148–149. Science Applications International designs the computer systems that aid in the training of United States military personnel. These simulations of terrain are direct photographs off SAI screens. These screens, on the video-display terminals, enable military trainees to relive a combat mission.

location already has that information, it can be extracted and translated rather than duplicated by hand.

Because they lack a telephone line to a graphics computer apprentice, scientists and designers often waste precious time and energy recreating their own stored data. Without a perspective-view video system, the architect's computerized blueprints are useless in constructing a three-dimensional scale model. A chemist might work for days with beads and sticks in an effort to translate the molecular data already stored numerically in a computer. But with electronic-image systems, the transportable and negotiable computer data can be tapped. Whether the information in memory originated as thousands of separate seismic readings, as the physical analysis of X-ray crystallography or as the output of a mathematical formula, it can be pictured by the apprentice. From the sea of input numbers, a landscape or a DNA double helix emerges.

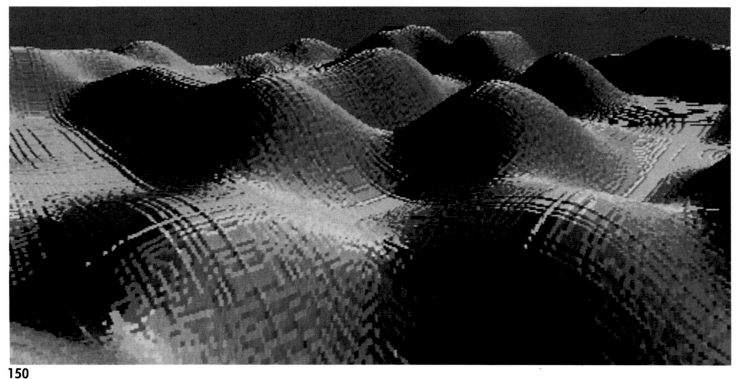

150

Image Enhancement and Analysis

The scale-model images produced with computer graphics may serve primarily to get a feel for overall structures such as buildings. The viewer who interacts with them is largely on a tour. Other images, however, are used as tools to search for valuable practical and scientific information. In this context, the viewer is not on a tour, but on a hunt. The image analyst looks not at the aesthetics of an image but at the evidence it provides.

Computer-graphics systems provide a wealth of tools for analyzing images. Zooming in to isolate suspicious regions in a brain-scan image substitutes for the examiner's scalpel. Electronic filters can be adjusted as the analyst observes the image, finding just the right settings where a curve or a shape emerges most clearly. Filtering electronically means much more than adjust-

150. When an attack maneuver is practiced in the field, various aspects of the mission, including the terrain, are recorded and stored in the computer memory. Later, the mission can be replayed, second by second, on the display terminals.

151

151, 152. The computer's modeling abilities are best exhibited in the area of molecular biology. These photographs show a computer-created image of a DNA double helix—looking up from within, opposite, and in its more familiar helical shape, left.

152

ing colors. Electronic filters can increase or decrease the contrast between light and dark in an image, blend or sharpen boundaries and detect and subtract unwanted effects such as background or noise. Data about a scene or a situation from entirely different sources, each converted to pictorial form, can be brought together to form one image: in this instance, by superimposing multiple satellite views with topological and seismic data, the oil-signaling signature of geological faults and folds took shape (see photo 71).

The information extracted from an interactive display is often needed to guide decisions and future actions, whether for oil drilling, corrective surgery or chess games. The computer enables the decision maker to visually follow and evaluate alternative scenarios and strategies. Which of two surgical procedures will relieve intracranial pressure with minimal disruption?

153, 154. Today, computer graphics systems let biologists create models of the structure of DNA, left and opposite. These models can be moved, molded and shaped to aid scientists in their understanding of the workings of the building blocks of nature.

153

154 ▷

155. Since the dawn of the computer age, just after World War II, Bell Laboratories has been a leader in computer applications and experimentation. Recent work, like this image by David Weimer and Turner Whitted, a Bell Labs computer scientist and artist, continues this long-standing experimental tradition. Note the clarity of the image and how the chess pieces are reflected in the polished surface of the chess board. Such computer-created imagery is among the finest being produced today.

How many pieces will be protected by the knight after an offensive move? (Chess players would have less trouble looking ahead many moves if they could actually reposition the pieces to see what happens.) The practical and scientific potential of computer-graphics systems is thus vividly demonstrated; by signaling with a word or motion, the physician or the chess player simulates an intended action and is then able to see the projected consequences on the screen immediately.

Dance:
New Body Language for Art

In drama, the script preserves the playwright's intent and the work's integrity. In music, the score is a constant resource and the ultimate reference as interpretations and performances ebb and flow. Dance, however, has historically had no written language that might be compared with the established records of dramatic script or musical score. In bridging that gap, the pioneering work of Alan Zenuk (see photos 159-163), which closes this chapter, represents a strikingly successful application of computer power to visualization and communication.

Dance stretches the boundaries of written language and notation. A dancer's arm, like a violin's pitch, can go up or down, requiring one dimension of description. It can also go from front to back, requiring another dimension. The dancer has two arms, and the arms have elbows, wrists and fingers that may be moved expressively. To that add legs, knees, ankles and toes, head motions plus the overall three-dimensional movement of the dancer's torso. Compared with two-dimensional music, that makes a conservative estimate of about 37 dimensions to be traced out over time for a single dancer!

It is, of course, possible for a dance composer to record the major features of a work in sketches. But detailed sketches become unwieldy and consume large amounts of time and space in the process of production. In addition, whatever the method of composition and transcription used, so much significant detail is usually lost that extensive direction must be provided during rehearsal in order to produce a trial performance. By comparison, even the most difficult symphony can be given at least a rough rendition by a trained orchestra from the first reading of the score. What is needed to produce effective dance notation is a simplified visual element (like the note used in music).

The requirements for dance notation are formidable. The notation should be:

156. The Apple microcomputer, here and on the following page, provides a model on the video-display monitor of this dancer's various positions. The computer is already proving to be a useful tool for dance notation.

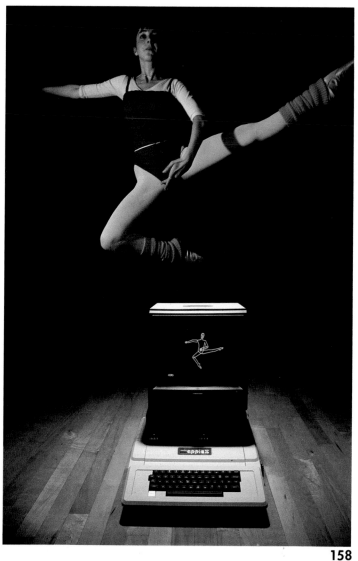

157, 158. The dancer's position is modeled with great facility and accuracy by the inexpensive Apple microcomputer. Choreographic movements, like the dancer's hand in front of her body as she leaps through the air, are delineated on the computer's video-display monitor. The computer will be able to record and play back the dance whenever it is needed, helping both the choreographer and the dancer to improve their work.

Accurate—in order to capture the essential movement of the dance.

Expressive—in order to communicate the movement to performers.

Concise—to be easily produced and modified.

Musical notes, for example, convey pitch accurately by position; are sufficiently expressive that playing or singing from them creates a lasting musical impression; and concise enough that even a symphony can be completely specified with manageable amounts of paper and ink. Because dance has so many simultaneous dimensions, however, the complexity of being accurate seems to rule out the possibility of being concise in paper and ink.

If we cannot be concise with paper and ink, then we have an ideal opportunity to utilize the capabilities of computer memory-medium and the now familiar computer apprentice. Borrowing the techniques of computer animation, we should be able to use a detailed animation sequence of a simplified figure dancing as a movement score. Our dance notes will not be realistic but schematic; even a stick figure will convey much of the desired human movement. The computer system will make the score expressive by playing it on the

159, 160. A dancer is fitted out with electronic sensors needed to gather data for a computer dance program. The individual sensors attached to her body relay information on positions and movements into the computer's memory, where it is abstracted and used as the basis for this computer graphics display. Choreographers working with computers are already changing the very nature of dance.

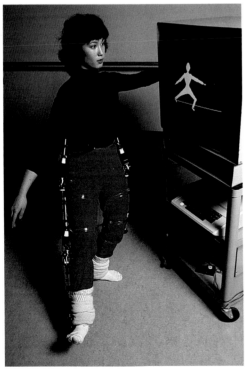

159

160

161–163. After computer sensors pick up a dancer's movements, as on the previous page, they are displayed on the screen, allowing the choreographer and the dancer to analyze and discuss the piece.

161

162

163

screen interactively. Like the better-than-real cutaway pump, the video dancer can be asked to stop in mid-air or execute other illuminating demonstrations that would be physically impossible for a human being. And with electronic assistance, an entire performance can be concisely transferred from human imagination into computer memory.

We have discussed body language as the computer's ability to be an interface through which human movement is directly sensed and translated into memory-medium patterns. The earlier example of body language was the hand movement of an artist. As Zenuk's work demonstrates, the sensory ability of the computer can even allow direct input of choreography, and not from a composer penning notes but from the actual movements of a dancer.

Captured and transcribed automatically, the dancer's movements become a working score. This score can be compared with the composer's original or used as the basis for developing a new work. Both the actual recorded performance and any subsequent variations developed on the computer can be dynamically and interactively evaluated by watching detailed animations. A composition can be communicated to new dancers both by a computer-printed score and by having them study a video-demonstration performance.

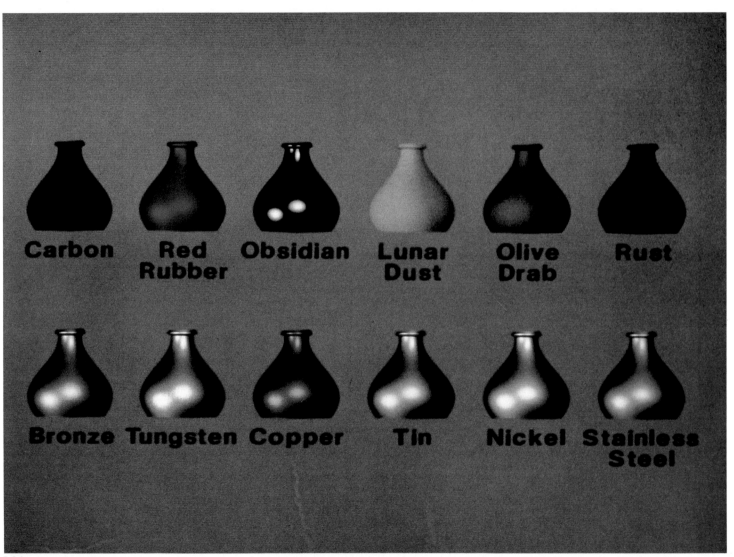

164

5. CONSTRUCTIVE IMAGERY

For all its accuracy and versatility, modern color photography is essentially a lifeless, inanimate thing when compared with the possibilities of a computer system. The camera records only what it sees; it cannot capture images from places where it has never been or subjects that are too fleeting for its mechanical parts and chemical processes. At present, computer devices are often more cumbersome and less accurate than the familiar camera. But unlike the camera, the electronic memory-medium is not simply a passive receptacle to be stamped with impressions but is part of an active engine for the processing of information and the creation of language. Drawing on the computer's processing power, information captured in the memory can represent not just an image but a comprehensive model from which an infinite variety of images can be produced on demand.

Beyond Photography

At first glance the images at the beginning of this chapter might appear to be photographs: a museum display of vases; a high-speed filming of a liquid-drop collision; a sculptured head (see photos 164-168). But there is more here than meets the eye. For although

165

164, 165. Opposite, Rob Cook of Lucasfilm's Computer Graphics Lab programmed a computer to create a series of flasks, all identical in shape and volume, but each made of a different material. Some of the flasks are made of chrome or other metals; one is made of moon dust. The surface of each flask reflects light from two sources. One is a distant but constant light source, like the sun. The other light source is local—perhaps a lightbulb. The computer graphically demonstrates the way different materials reflect light from different sources. Such simulation of light reflectance will become extremely important as computers model more and more of our real world. Above, Japanese artist and computer scientist Yoichiro Kawaguchi used the computer to model the stop-action of a drop dripping.

these scenes are presented with color-photograph realism, they have never existed in reality. Instead, they have been constructed by a computer using elements from its memory.

The key word in this chapter is "construct." The focus here is not on the computer's ability to store the human movements that make a drawing, sculpture or pirouette as before but on its ability to construct new images according to theoretical models it is given. In this dimension of the computer's creative ability, images are not crafted by the artist's movements but are formally deduced from these models as logically as any mathematical theorem. We will shortly see examples of these possible models. But before finding out how the computer makes images in this way, you might well ask why it does so at all.

Compactness: If you recall the previous discussion of the wire-skeleton space shuttle and other interactive video scale models, you will realize that there is one compelling reason for generating images from a model rather than from a hand-crafted scene—the sheer volume of images. No matter how large the computer's memory is, it can store only a limited number of images. To attempt to store all the possible views of a three-dimensional object in a computer's memory is as difficult and time-consuming as trying to memorize a multiplication table for all numbers less than a thousand, which entails knowing half a million distinct products! For humans or computers with limited memory, it is much more concise to store a relatively small amount of data (such as single-digit products or the lengths and relative angles of wires in the space-shuttle skeleton). By using this data in coordination with a model (which enables us to decompose multiplication of two large numbers into single-digit products or compute a new length and angle of a wire when the viewer's perspective changes), we can generate an infinite variety of appropriate new results on the spot. There is no need for vast amounts of memory to store data (or for all of the time required to set up that data

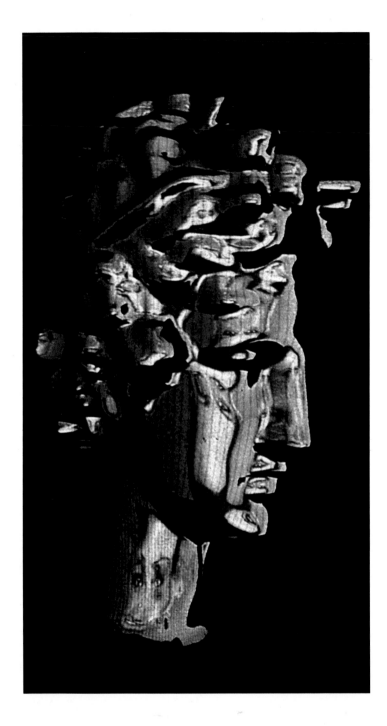

166. *Toshiba Greek,* an amalgamation of two images, was produced in 1982 by Special Services for DEI.

Flexibility: Imagine the dilemma of a painter who has just finished a still-life scene like the ones presented in this chapter. Unfortunately, the painter is not quite satisfied with the finished product. Perhaps the angle is not just right or the lighting should have been directed differently. A painter who has only the conventional techniques at his disposal would have no choice but to destroy a great deal of the canvas and begin again. The futility of this situation would be even greater for an animator, because it would be necessary to make changes on thousands of separate frames. A computer scale model would be far more difficult to modify than an old-fashioned cardboard structure if it were based on thousands of individually drawn two-dimensional views. But if the computer memory holds a model rather than individual images, the artist and the designer have unparalleled capacity to change and adapt their images to meet new demands. Any change made in the model will automatically carry over to all images it generates. By changing the information for the model, the computer artist can adapt the images, perhaps by substituting only a dozen or so numbers. Thus, if the lighting or perspective of a scene is not satisfactory, the computer artist can order the computer to redraw an entirely new scene based on this new information. Using a key-frame model, an animator would be able to change the entire animation sequence by reworking a few key-frame images. Changing the wires of a spaceship model or the coloring of a chemical structure automatically adjusts all of the images later reproduced on a video-display tour of the spaceship or structure.

Control: Using computer models gives us precise control over images and scenes. By adjusting the underlying model within the computer that generates it, the

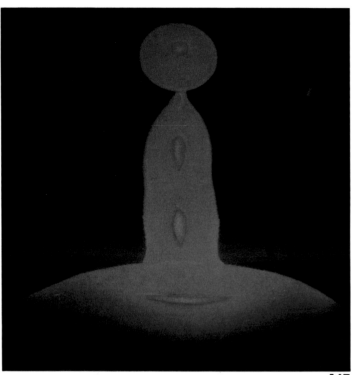

167

167, 168. In these two images, Yoichiro Kawaguchi captured the rebound of the drop seen on page 127.

168

computer artist can make an orange ripen or float in defiance of the laws of gravity or hybridize into an apple. Classical painters may neither need nor want a computer to help them capture a waterfall; they can simply place the canvas beside a flowing stream for inspiration. But perhaps the image of a volcano or a nuclear reaction is needed? In those instances the flowing stream will not be so cooperative, and it is then that the computer model becomes irreplaceable. Through the use of models, an image maker can stop dancers or hummingbirds in midair, melt granite or place ice sculptures in the Sahara Desert.

Accuracy: In scientific and technical investigation, the most valuable feature of an image is its accuracy, not its aesthetics; but a model can incorporate physical laws and relationships as well as accurate visual theory. While an artist's image of a bridge swaying in high wind may strive for drama, an engineer's construction must be accurate in order to allow the safety of its design to be evaluated.

Satellite data can be woven into a simple visual image of cloud formations pixel by pixel, but the single view formed would not be as informative as working with an underlying model and adjusting it to generate cloud-formation images that correspond with satellite measurements. Using a model that incorporates the physical relationships between pressure, temperature, moisture and other features, a meteorologist can visualize not only the present cloud patterns but future formations as well. To the extent the amount of data collected and the accuracy of the underlying models will allow, these cloud patterns are not just interesting images but essential elements of predicting the weather.

Structure, Rules and Development

We glimpsed something of the computer's power to construct imagery from a model when we explored the way in which an interactive video system simulates

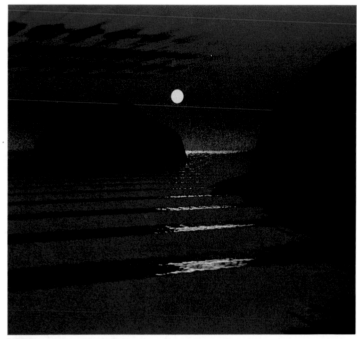

169

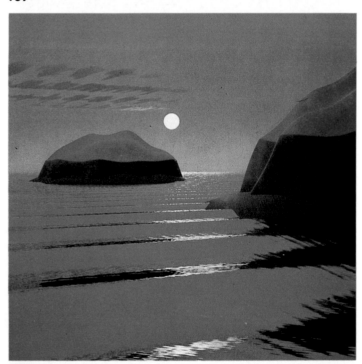

170

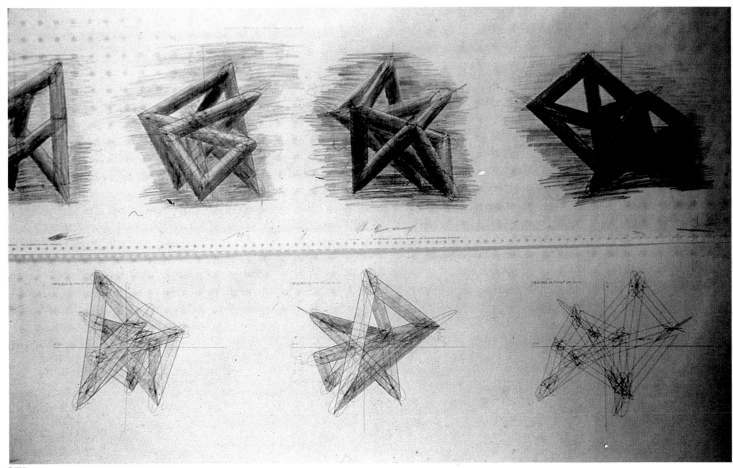

171

a three-dimensional object in our discussions of scale models. In this situation the human viewer selects a viewpoint (the distance away from the modeled object and the angle of the view); the graphics system then recomputes and displays the exact image of the model that would be seen from that viewpoint. Systems that allow one to view an image from different perspectives are only the beginning of computer-modeling capabilities. In order to produce photographically realistic images (rather than wire skeletons or other schematic forms), a more fully developed visual model of objects and illumination must be produced. It is essential to reproduce characteristics of objects other than their shape. In addition to perspective, then, the com-

169–171. Opposite, two stills from a computer-animated film entitled *Carla's Island*, created on a Cray supercomputer at the Lawrence Livermore National Laboratory in California. Nelson Max, the artist, wanted to show how a computer could artistically model a variety of natural actions. The film of the computer simulation shows the island washed by the tides as the sun first rises and then sets, followed by the arc of the moon across the sky. Above, the computer-augmented working drawings for a sculpture by Frank Smullin of Duke University.

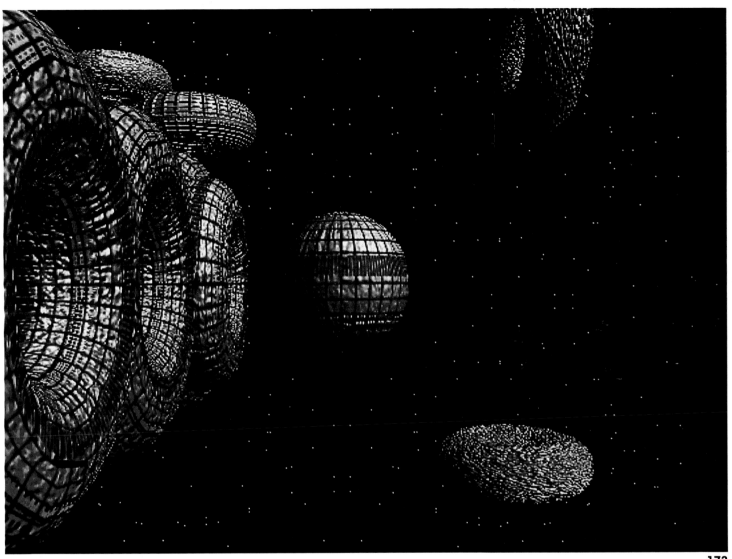

172, 173. Some of the most impressive art being created with the aid of computers is that of David Em, a California artist who works frequently in high-technology media. Just as a painter uses a brush, Em uses programs originally done for NASA by Dr. Jim Blinn as his tools in creating images like *Kapong*, opposite, and *Donuts in Space*, above. Em, who says that he now sculpts with "memory instead of space" and makes pictures with "light instead of paint," claims an incomplete understanding of the meaning and purpose of his images.

174. A whimsical robot image, produced at the New York Institute of Technology's Computer Graphics Lab.

the position and viewing angle of the observer

the positions, directions and color intensities of local light sources shining on the scene

the geometry of the objects and their component materials (determining how each point on their surfaces transmits, reflects and colors light scattered to the observer's viewpoint)

The resulting scene is then synthesized and constructed like a mathematical computation from given hypotheses. Once the appropriate parameters are set, the optical profiles they define allow the hue and intensity of every pixel to be computed mathematically. Surfaces, shadings and textures ranging from stainless steel to wood or velvet appear on the screen.

As impressive as optically synthesized images are, they represent only one aspect of objects that can be modeled. Not only can their static appearance be modeled and synthesized but so can their dynamic behavior. With an optical model, the artist or technician has only to issue such commands as "sphere," "rubber" and "red" to obtain a realistic image of a red rubber ball. If the computer incorporates physical models as well, the ball will bounce when it is dropped on the screen.

The vases by Cook (see photo 164) display a variety of materials as seen in visible light. Another study might show the thermal glow and pattern of these materials when they are used to cushion a spacecraft's fiery reentry into the atmosphere. Fluid dynamic images such as Kawaguchi's drops (see photos 165, 167 and 168) provide not only artistic beauty but insight into devices from vacuum pumps to automotive fuel injectors. Even the human body may be used as a subject for studies ranging from rehearsing spacewalks to developing artificial limbs.

Exploration of the artistic potential of synthesized images is only in its infancy. Yet the computer cinematographer can define an entire universe of visual forms and physical interactions, displaying its evolution in the process. The Nelson Max images (see photo 169 and

puter must be able to incorporate optical theory and computational rules, and it does so with marvelous skill.

The vase display (see photo 164) and the still-life images (see photos 174 and 175) are excellent examples of the realism attainable when computer models incorporate optics as well as geometry. These images are totally synthesized. Rather than motioning with brush or pen, the artist here specifies a set of conditions and *parameters:*

175. Crafted on the computers of Information International Incorporated, a Los Angeles computer-graphics house, this image shows the depth of field and intensity of color that can be created with a two-dimensional computer-graphics system. This simulation of everday objects gives an eerie indication of the computer's imaging powers. Note the reflected lights gleaming off the surface of the glass, the orange, the tea pot and the vase.

176

176–178. Dick Lundin and Lance Williams of the Computer Graphics Lab at the New York Institute of Technology crafted this spectacular image wholly by computer. It is part of a scene from their computer-graphics film in progress entitled *The Works*. At first glance, the picture seems to show some broken instruments in an instrument case. Upon closer inspection, a variety of fabrics and textures reveal themselves. Opposite, Bubblemen, human forms conjured up by computer graphics at the University of Pennsylvania's Computer and Information Department.

170) represent such a world. In *Carla's Island*, Max creates an island, the water that surrounds it and the nearby mainland. The sun and moon rise and set, changing the appearance of the land and the water. Water sparkles and flows with the movement of synthesized tides. As models and modelers proliferate, countless scenes like *Carla's Island* will be created; in fact, computer models and the images they generate may soon be exploited as the most versatile movie lot available.

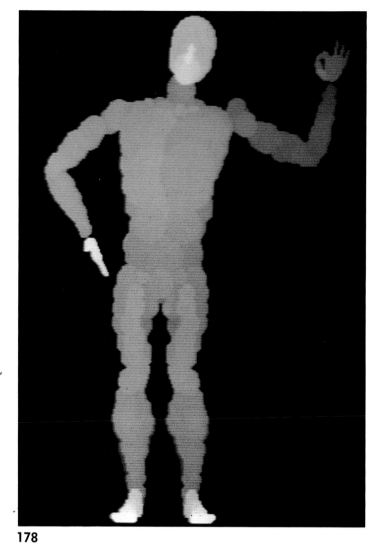

177

178

Human Models

For all its visual beauty, *Carla's Island* is uninhabited, but images like it will not remain so for long. The human body is an irresistible subject for artistic, scientific and technical study. The practical cinematographer may be primarily concerned with models of human form (the electronic movie lot could not function effectively without a plentiful supply of extras). But a great deal of fascinating and practical modeling is required

if one is to go from simply establishing a plausible human form on the screen to achieving automatic and realistic movement. The anatomy of muscles and joints and their coordinated control is an active area of scientific research and, with ever-increasing realism, computer models of human movement are producing active and responsive images. If the cowboy on the movie screen of the future actually hears the audience and returns for a final bow, the reason will not be magic but an in-theater computer using sophisticated mod-

180

els of human anatomy and kinematics to drive the screen display.

Even more than its form, the functions of the human body will ultimately be the focus of sophisticated modeling. What are the forces exerted by the muscles in a sports event? How effectively are these forces applied to propel a golf ball or the human body itself? The interplay of models and images can provide significant insights into these questions (see photos 179 and 180). Long after the student or professional golfer would have collapsed from fatigue, a coach can experiment with new movements, clubs and swings to

179, 180. The hottest area of activity in computer imaging is sports, with athletes and trainers using computers to improve performance. Opposite, a computer registers the radii in a golf swing, saving the picture in its memory for use in improving technique. Above, the computer marks a runner's body for alignment, showing the way the various parts of the body work together, or against one another, as the runner strides.

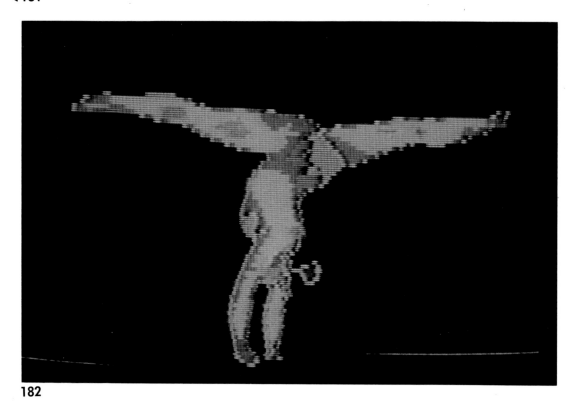

182

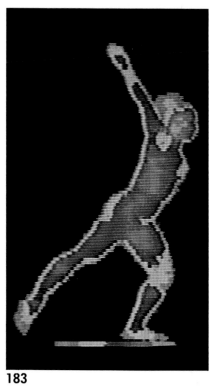

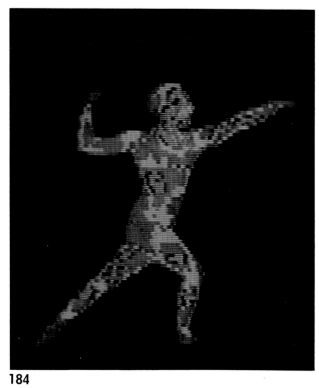

181–184. Computer artist Douglas Nelson's thermographic gymnast in action.

183

184

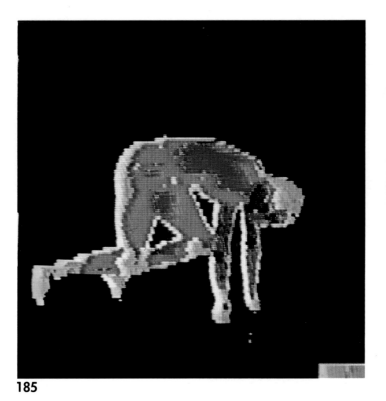

185

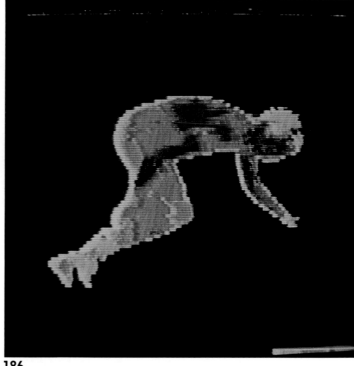

186

improve performance and correct problems. The experiments are carried out not with a human golfer but by studying a computer model that has been tailor-made from information about the athlete's physique and actual measurements made during past performances. Guided by a wealth of data, the coach can then go through hundreds of variations; each new swing can be completely monitored, giving typical velocity and angle of the club at impact, variability of velocity and angle and efficiency of movement. Other model forms of athletes can be called up on the screen and used for comparisons. When the right combination is found, the real athlete can then be summoned to practice the changes —and do so without wasting time or acquiring bad habits in the process.

This combination of imagery and modeling is ideally suited for sports, such as gymnastics, that demand not just a performance product but grace in the pro-

cess as well (see photos 181-184). Suppose a tumbler begins to twist a little earlier than he or she should? Can this dismount routine be accomplished more gracefully? Is the performer physically capable of an additional turn? Without models, these questions cannot be answered with any certainty unless the athlete is willing to master each new routine and risk possible injury simply to find out. With accurate computer systems to show both performance limits and visual effects, creative new routines and styles can be developed. In addition, the computer can help to develop training programs and performance milestones: What are the component skills that build an effective handstand or somersault? What muscles are used? How can they be tested and efficiently developed even before the gymnast successfully completes the composite routine? Dynamic computer models have been successfully used to design and test potentially dan-

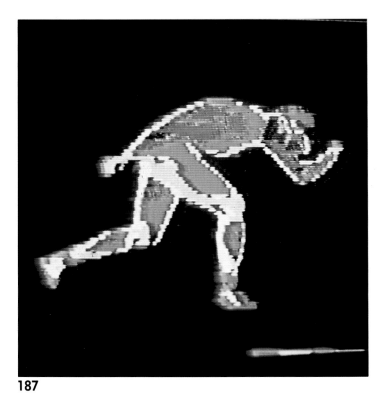

187

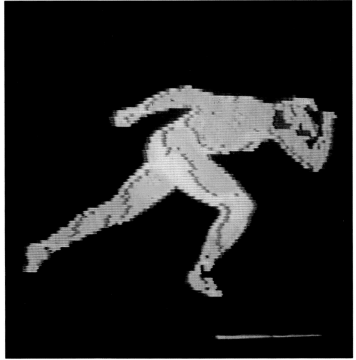

188

gerous leaps ranging from fighter-plane maneuvers to automobile acrobatic stunts. Having directed the computer to assess the chances and take most of the falls, the human athlete can eventually fly through the air with the greatest of ease.

Image Analysis and Interpretation

Models can take making images far beyond the passive record of photographic film. Constructed images and their underlying models provide a tool that is unprecedented in its potential power for human craft and understanding. At the frontier of computer research, though, there is an even more radical use of models. Researchers in the field of *artificial intelligence* are developing computer programs and systems that are capable of processing information with an independence and a sophistication that approach those of the human

185–188. Nelson's beautiful thermographic imagery shows a sprinter on his mark and starting his race.

143

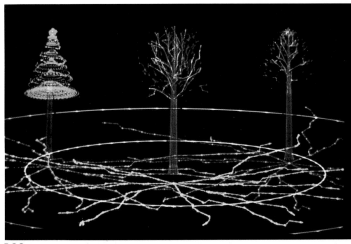

190

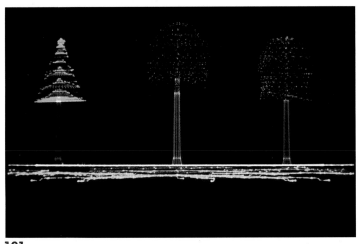

191

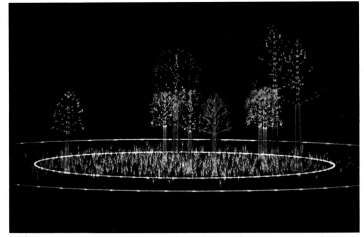

192

mind. Such an intelligent system does far more than store models and manipulate images under human direction: it can scan its environment independently, (with human or superhuman eyes and ears) and comprehend the sensation it captures.

Unlike either a simple camera, which will capture a picture of a forest, or the fundamental tree-model program, which will build a forest on the screen at your command to allow you to see the effects of rainfall or pesticide scenarios, an intelligent forestry computer system can scan a real forest with its television eye and draw its own conclusions: What type of trees are present? What are their probable root structures and relationships? What management and harvesting actions are indicated? An intelligent medical scanner will not only record an internal image of a kidney but will independently identify and isolate abnormalities within the organ as well (see photos 189-194).

189–192. The work of Fred Stocker uses the imaging power of the computer to aid forestry. Here the computer constructs and then visually presents a model of trees growing together and the interrelationship of their root systems.

Overleaf: 193, 194. Although they look more like tree branches or tributaries of a river, these images produced on Gould computer equipment are actually renderings of X-ray pictures of the human kidney. The false coloring is used to make the circulatory system more visible.

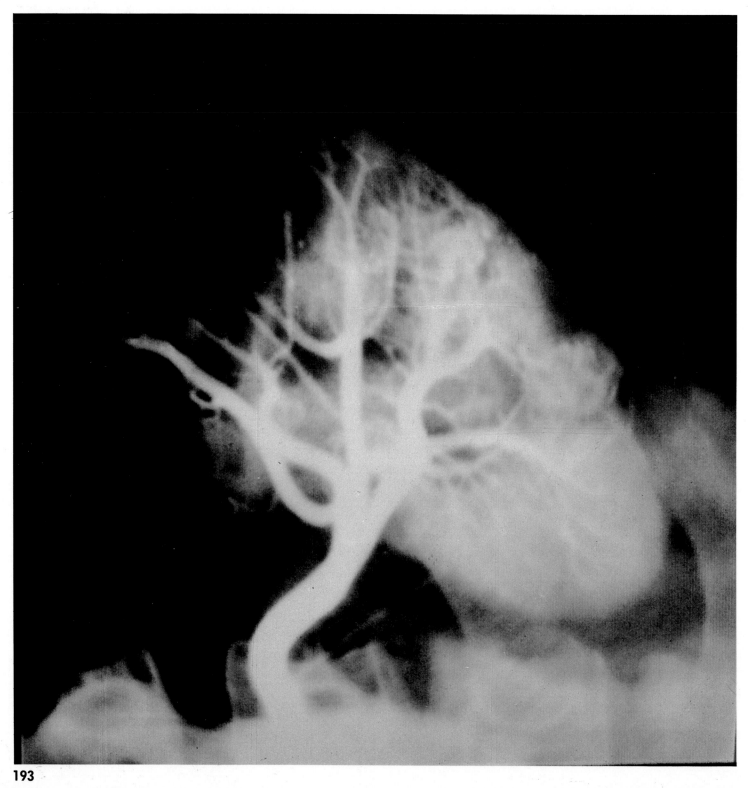

195. A photograph of the Stanford University computer-graphics aircraft-design system.

Can a computer actually understand an image that has been transferred into its memory by sensory devices? There are many possible answers to this question, as well as intriguing philosophical questions to address. The concept of a model, however, provides one concrete and important approach in which true computer understanding has already been achieved and will continue to develop:

Step 1: Sensory data are *captured*. Active scanning is used to preprocess the data so that an ocean of incoming bits is reduced to a skeletal representation, such as the edges in a visual scene or the frequency shifts in a spoken conversation.

Step 2: *Pattern Matching* routines operate on the captured representation to activate models from a hierarchical system stored in memory. These models represent concepts. At an early level, a *concept* might be as general as "form," and its model may be used only to extract and isolate a single connected geometric entity from a stored flat mosaic of light and dark pixels. At later stages, the model-concept might be as specific as "tree" or "kidney" or "long-range bomber."

Step 3: *Tuning routines* automatically adjust the internal parameters of activated models to match the sensory input as closely as possible. For instance, the theoretical outline of a plane, shown in green (see photo 195), must be adjusted as well as possible so that it is aligned with the recorded image. If the tuning process produces an acceptable match, then the computer "understands" the sense data. For example, if the activated model represents the concept "aircraft," then the computer both understands that it is watching an airplane and is able (from the parameter settings in the model that matched this scene) to deduce and hypothesize further details such as the type of aircraft, its cargo weight and probable origin and destination.

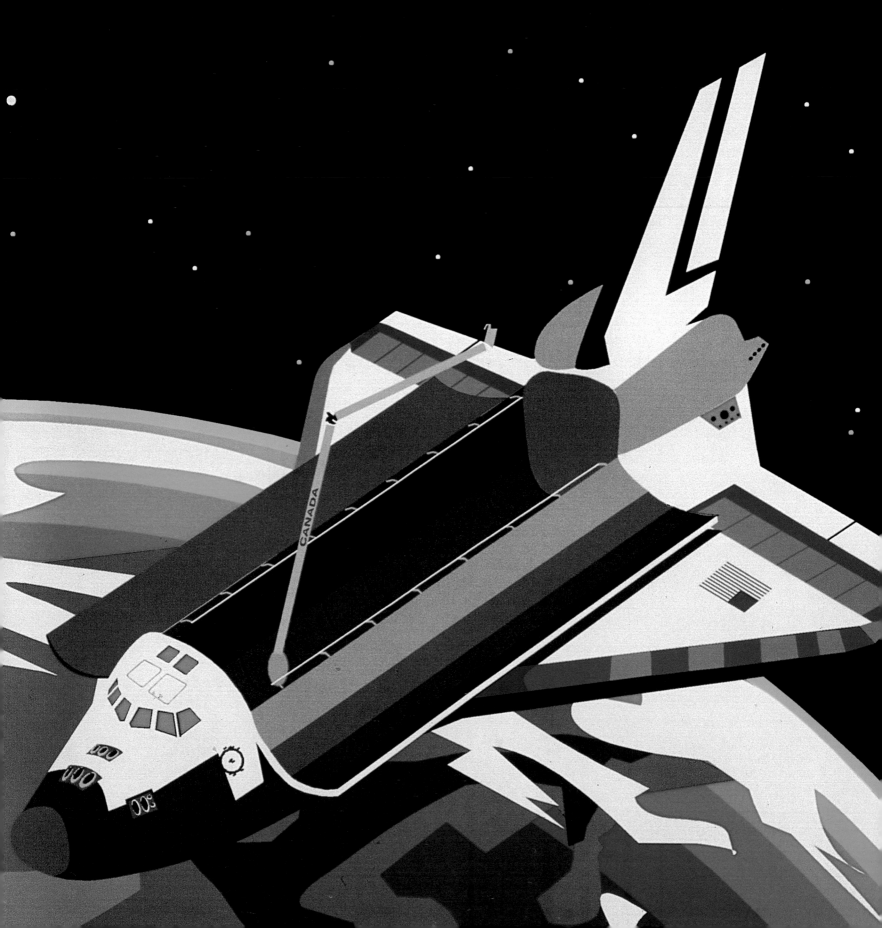

6. REALITY REVISITED

A pilot is bringing in a large jetliner. The plane begins its approach, and the lights of a crowded airport come into view. A mile and a half from the runway, unstable wind conditions catch the plane and thrust it downward. Unfortunately, the pilot does not react to this unexpected threatening situation quickly enough. As the plane hurtles to the ground, the co-pilot sadly comments, "I'm afraid you've lost this one, Pat. We'd better restart the program."

This scene is an excursion into science fiction and a journey into the everyday world of *computer simulation* as well. Practice makes perfect in areas from flight training to tank maneuvering, and realistic practice in a computer-controlled simulation environment is more economical and efficient than the real thing, and it is also safer. However, work is not the only area computer simulation will affect. Our leisure-time activities, too, will reap its many benefits. It is highly probable that computer-generated imagery and environments will someday become a common means of transportation for the armchair traveler.

The Realicorder

The most popular computer of the twenty-first century may well be a high-fidelity "realicorder," which would be capable of capturing and storing the sights, sounds and other elements of a vacation or some other memorable situation. Not only that, but it could be replayed for a return trip at your leisure. Visiting a town or a country? Unlike the conventional movie or video recording, the realicorder will allow you to walk different streets and experience different sights and sounds on every playback. Reliving a tour on the space shuttle? Perhaps this time you would prefer to sit on the starboard in order to get a different perspective, or try your hand at the controls.

Is such a realicorder feasible, though, or is it simply a science-fiction dream? Given the realicorder's seemingly magical properties, this is a question you may well ask. However, mechanisms for the interactive reconstruction of reality are not only feasible but are in daily use. In fact, the realicorder can be developed not by some new magic but by building on the image-making techniques and technology we have already discussed.

The word "tour" was used in describing the interactive display of architectural and other three-dimen-

196. A Dicomed image by Mike Newman of the space shuttle floating in space over a stylized rendering of the earth.

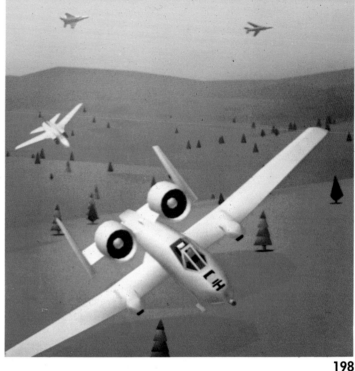

197

198

sional scale models stored in computerized form. In such systems, the viewer uses verbal or body language to communicate changes in viewpoint to the computer, which automatically responds by adjusting the screen image to simulate a view from the new perspective. In a computer-model building, the computer video screen functions much like the window of a helicopter that the viewer directs around the actual building by using body-language commands. Computer-model viewing systems are like the gramophone that did not so much illustrate the height of technology as the beginning of a new recording principle, for the computer memory captures not just sight and sound but the structure of things. In the same way that old Victrolas paved the way for modern stereo high fidelity, the computer capture/replay process is paving the way for the technology of the future, toward machines such as the imaginary realicorder. With an advanced realicorder, the participant (no longer simply a listener or a viewer) can immerse himself in high-fidelity illusion.

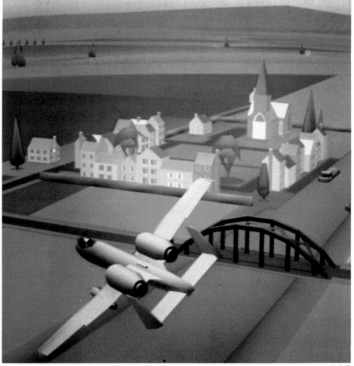

199

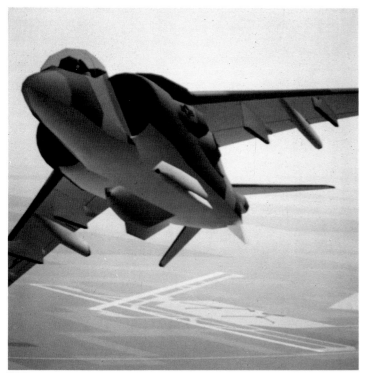

200

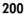

201

202

197–202. One of the most exciting and exacting areas of computer imaging is in the field of flight simulation. Flight simulators train pilots how to fly specific airplanes, including spacecraft like the shuttle. A flight simulator provides an exact replica of the cockpit of an aircraft. Every gauge, dial, switch and knob is present to give the pilot-in-training the look and feel of flying the aircraft. Computer imaging depicts what the pilot sees when he looks out of the aircraft's windows. All of these tactical training scenarios were created on Evans & Sutherland aircraft-simulation equipment.

203

204

Flight Training—the Economics of Illusion

Some of the most advanced computing equipment and programs in the world have been developed not, as might be imagined, to perform intricate mathematical, accounting or financial calculations but rather to create and sustain sophisticated illusions. This computer game leaves the familiar electronic arcade varieties far behind, for the people who play it are training for life-and-death decisions. The game is flight simulation (see photos 203 and 204). And what an illusion it is! You sit in the actual cockpit of an aircraft. Your view, which is provided by the computer, changes through the cockpit window every instant, reflecting outside conditions, events and the effect of your actions. You see clouds in the distance or haze as you fly through them. Other planes appear and pass by. All of the cockpit controls are electronically "bugged," to sense and react to your guidance instantly. Hidden motors physically tilt and twist the cockpit in response to maneuvers or turbulence. Through the window, the ground rushes up as you dive or careens away as you turn. Genuine airsickness can attest to the hi-fi realism.

Flight-simulation systems are advanced and expensive. (Only by comparing their price with the cost of destroying a multimillion-dollar aircraft can they be considered economical.) Nonetheless, equally effective movie-theater or home realicorders will undoubtedly be introduced as *microprocessor* (computer-on-a-chip) technology makes electronic hardware of all sorts easier to acquire, cheaper and more powerful. For despite their impressive sophistication and lavish budgets, flight-simulation systems have their foundation in the basic ideas on computer imagery presented in the preceding chapters of this book: high-resolution graphics display, sensitive body-language interface and comprehensive modeling.

All three graphics system components—*display, control interface* and *modeling*—must be highly developed and coordinated if they are to produce effective

203–206. Flight training is only one area in which computer simulation is being used. Singer Link uses the computer simulations, opposite, to train tank commanders.

illusions. Let us briefly examine some of the special challenges that simulation poses for each component and the ways in which these challenges have been met. The resulting image systems have opened up entirely new worlds of illusion ranging from tank maneuvers to ocean travel and space flight.

Graphics Display: A simulation must be realistic to be effective. An airplane, tank or building seen on the video screen, the simulation's "window," should be as credible as a photograph or a view seen from a picture window. This requirement demands high-resolution display. The pixel tiles of the video mosaic must be minute, and the palette of available colors must be rich enough to make smooth transitions between brightness and color values possible. Animation must also be accomplished in real time: if the ship or the tank turns and accelerates, all of the computations necessary to display the new, accelerating world passing by the window must be done on the fly. A new image must replace its predecessor on the screen every thirtieth of a second or so, thereby maintaining the movielike impression of continuous animation.

Control Interface: Because no explicit graphics commands will be given, the simulator must be completely unobtrusive in making its adjustments to human reactions. The system must capture the normal responses elicited in the situation being simulated and automatically react by adjusting the simulation environment. For example, in an automobile simulation, a normal response to some suggestion of danger might be to step on the brake or veer to the right. By "bugging" the steering wheel and the brake pedal in the simulated automobile, either of these responses would be captured by the computer and used to adjust the environment: scenes viewed through the windshield would slow down or turn, or the car might even realistically dip forward in an abrupt stop.

Replacing the video screen with electronic glasses and headphones (thus allowing only simulated sights

205

206

155

and sounds to be perceived) creates a subtle visual illusion (see photo 213). Instantly and imperceptibly, electronic sensors transmit each movement of the head to the computer. Wherever the viewer looks, the appropriate scene is automatically displayed. There is no need for elaborate stage settings to simulate environments from aircraft interiors to ski slopes. Similarly, large-scale movements could also be monitored imperceptibly, with the result that rather than being moored to a chair, the participant could actually walk around an empty room, surrounded by synthesized scenes displayed by the realicorder, which has transformed the room into the bridge of an ocean liner or the flight deck of a spacecraft.

Modeling: Both optical and physical models must be used effectively in order to achieve convincing simulations. For example, display systems often store visual objects as flat-edged polygons to make high-speed computation of apparent sizes, shapes and hidden surfaces possible as the viewpoint changes. Optical models must be used in the final display to both control the apparent illumination of these surfaces and smooth over any artificial edges. Physical models must be used to keep track of the state of the system and to compute the dynamic changes that would result from applying the controls. The simulated plane, for example, has a simulated airspeed. If the pilot uses the controls to climb, the underlying model must be able to compute the proper rate of climb based on the airspeed or even to simulate the sights and motion of a stall if the airspeed is too slow to climb. Pushing the brake pedal to the floor on a simulated automobile should produce vastly different results at low and high speeds or on dry and wet roads.

An added asset of coordinated display, interface and modeling is the possibility of multiple perspectives. The pilot in a simulated aircraft sees a view that the computer has constructed by recording his or her movements and then translating them into adjustments in the motion of the aircraft. The entire sequence of read-

207

208

207–209. One of the most delicate operations in aviation is mid-air refueling. Despite its difficulty, it must be accomplished several times every day by various aircraft around the world. The problem: how to train pilots to achieve this critical maneuver without risking millions of dollars of equipment. The solution: the Singer-Link simulator displays shown here. By first trying mid-air refueling on a computer simulator, a pilot can perfect the technique before actually having to link two heavy, expensive aircraft thousands of feet above the ground.

209 ▷

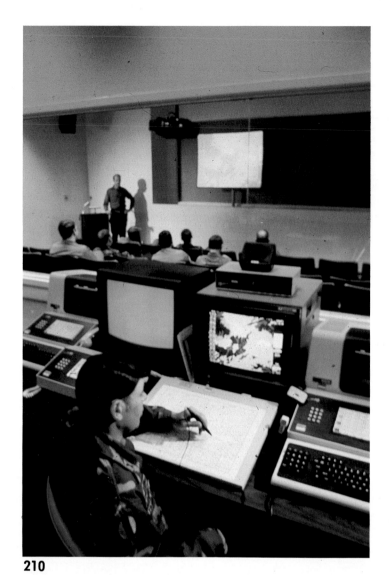

210

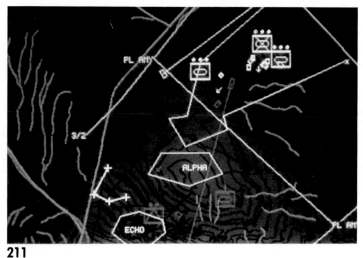

211

212

210–212. Both Science Applications International and Gould Inc. make simulation equipment for use by the military. The scene directly above shows SAI workstations where military personnel sit to relive, via simulation, the battle scenes they have just been through. The Gould images, right top and bottom, show the kinds of maps and imagery that can be seen at similar workstations.

ings can also be stored, transmitted and reused to provide a different perspective. While the pilot sees the aerial view, the readings previously captured may be tracing a course on an air-control map or generating model drawings and computing stresses for an aircraft engineer. Student pilots or tank commanders can go from the cockpit to the classroom to review graphics charts and displays generated by the computer from the recording of their past performances.

Travel, Entertainment and Education

Illusion on command is fascinating as well as economically important, and it would be disappointing to think that only airlines and armies would ever be able to afford it. Fortunately, that is not the case. The potential of a large education and entertainment audience will undoubtedly attract large investments to create computerized simulation environments, just as large budgets are now routinely allocated to making feature movies. Once developed, these environments can then be distributed through specially equipped theaters and eventually to home computers.

Even with the relatively limited power of inexpensive computers and technology of the early 80's one can manipulate an impressive image bank, thus achieving many of the effects of a primitive realicorder through *interactive videodisc* technology. Present videodisc recorders can store perhaps as many as 50,000 individual scenes. Unlike film or tape recordings, each individual scene is directly accessible (the beam in a laser disc player can be instructed to jump to the scene on any disc track in much the same way a phonograph needle can be lifted up and placed in any groove.) A self-directed "travel environment" can be constructed for interactive videodisc using nothing more than conventional film or video recording. Imagine a film truck moving through the streets of a town. As the truck slowly drives up and down every street of the town, four cameras simultaneously record the view at the front, back, left and right. When the recording is finished, the movie frames from each camera are transferred to a videodisc in a systematic order. Subsequently, as a video traveler you can "drive" down any street of that town: just name it, and the computer will retrieve the appropriate movie frames and display them in order. At any time you can look right or left for a different view, and at every intersection you can either continue on your present course or turn right or left and travel in a different direction.

213. As the military's use of simulation becomes increasingly sophisticated, the means of simulation display becomes increasingly important. These goggles were developed as an experiment in improving the viewing of military simulation displays.

214

215

214–216. If an army is sending a force of soldiers into foreign territory, what better training than to show them a movie that depicts the area they will travel through. But, if movies of the scene are not available, simulation of the locale is the next best thing. Simulation can be so good that it is often hard to distinguish it from photographs. These photographs are of a computer-controlled laser videodisc map of Aspen, Colorado, prepared by the Architecture Machine Group at MIT for the U.S. Defense Advanced Projects Research Agency. By using two laser disc players, linked and controlled by a microcomputer, a viewer can literally move through the streets of Aspen. With the touch of a finger on a touch-sensitive display screen, the viewer can leave the street and enter a building.

217, 218. The images of scene simulation opposite were created on the CT5 simulator, which was developed by Evans and Sutherland and Rediffusion Simulation, in order to test vehicle handling and performance.

216

Entertainment realicorders are a natural spin-off of flight simulation and other training technology. One can fly the skies not only to learn realistic aviation but perhaps to experience nose dives, barrel rolls and parachuting in complete safety. For those who find the possibility of an airborne dogfight with a friend or neighbor more riveting, realistic game systems are already being developed with the use of home computers, allowing many players to compete with each other simultaneously by transmitting the control and guidance information over telephone lines. The same data-compression techniques that allow you to update realistic real-time imagery over telephone lines may soon allow you to dial up an interactive tour of foreign sights or cities with your home computer as easily as you now retrieve weather or sports information.

Image-bank techniques can also be applied to such static situations as architectural views and scenic landscapes with satisfactory results. However, as the success of aircraft simulation demonstrates, model-driven techniques can be vastly more lifelike and enticing. Higher powered microcomputers and special video microprocessors now being developed for low-cost production may soon provide affordable model-driven computer displays that feature elements of realism comparable to that of early, expensive aircraft simulators. "Bugged" equipment and realistically modeled displays will enable you to polish up golf or tennis skills in your living room, before or after venturing outdoors. You will be able to duplicate laboratory experiments in physics, chemistry or geology inexpensively. Animation models will bring large amounts of educational and artistic literature to life. Imagine the thrill and triumph of conversing with realistically displayed images of Shakespeare and Einstein that have been modeled to "speak" the writings of their human models.

218

7. FANTASY

It is only a short step from the mind's eye modeling and the realistic, real-time imagery we've already explored to the realm of fantasy. This chapter highlights the more telling features of fantastic worlds. The computer makes possible an added dimension in which there are new rules for time and space; light bends and changes color as you travel. Objects with familiar forms and powerful connotations move in unexpected environments, obeying laws of physics unknown to Newton or Einstein. Fantasy—as simple a pleasure as electronic games and adventures, as deceptive a lure as the sirens' sweet song. We are crossing a vast uncharted frontier of the mind.

Plausible Fiction

The real world and the laws of nature provide the basis for our everyday experiences. When we drive an automobile, for example, we expect to see the landscape through the windshield unfolding in a predictable and orderly progression that is consistent with our actions. When a computer-driving simulator is used instead of a real automobile, we can obtain the realistic experience of driving without actually having been on the road. From the computer's point of view, though, there is nothing unique either about the real world humans experience directly or the special laws governing that world.

220

219, 220. Not all computer images illustrate practical information. Manfred Kage uses the computer to create kaleidoscopic fantasies.

◁ **219**

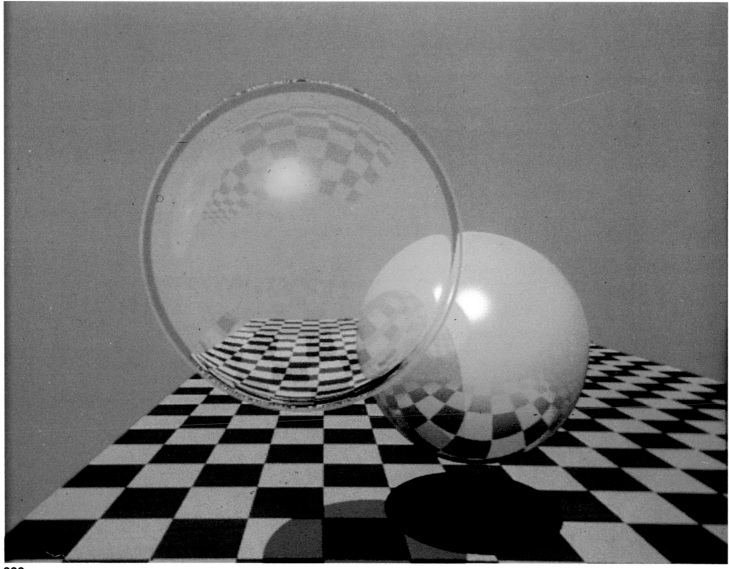

222

221. The fantasy picture opposite is part of a simulation workstation image created by SAI.

222. Turner Whitted, an artist and computer scientist from Bell Labs, made this image to demonstrate the nature of reflectivity. As each sphere rotates, it captures the reflection of the background and mirrors the reflection of the other sphere. Reflections of reflecting reflections....

The science of physics has developed over centuries to accurately describe and predict the real-world phenomena we experience. It gives a specific recipe for how a physical object such as an automobile accelerates and for how quickly it can be stopped. There is nothing in the design of an electronic computer that enables it to know what that recipe is; the appropriate formulas must be programmed into its memory in ex-

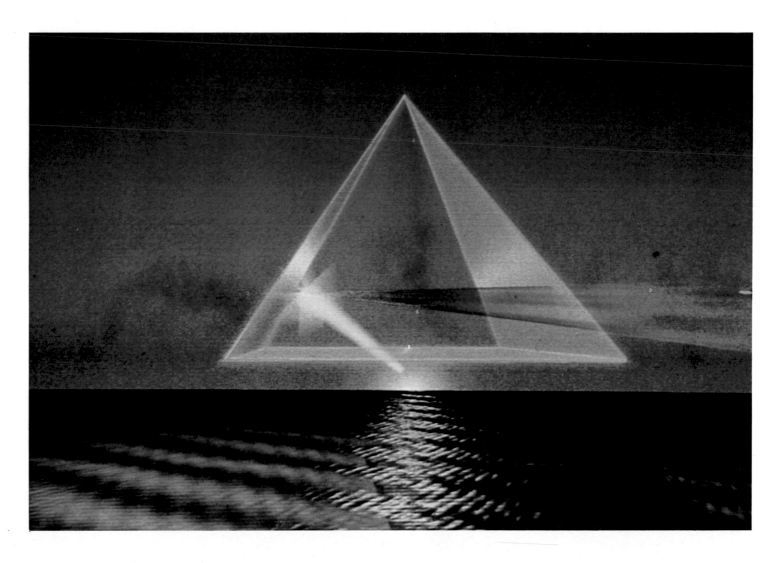

223. The artists and engineers at Information International Incorporated created this transparent tetrahedron floating over water. The image was a demonstration of the ability of the computer to create complex, reflective imagery.

plicit detail. With one set of instructions (physical laws) in its memory, a realistic computer simulator can be designed to train real drivers of real cars. But change these internal instructions, and the same machine that formerly trained drivers for the road is now able to prepare astronauts for maneuvers in space, where the laws of physics must be applied to an entirely new and different set of environmental circumstances. The machine itself has no bias toward the right laws or the correct physics. To the computer, it does not matter that unaccelerated objects on earth eventually come to rest while in space they travel forward or orbit

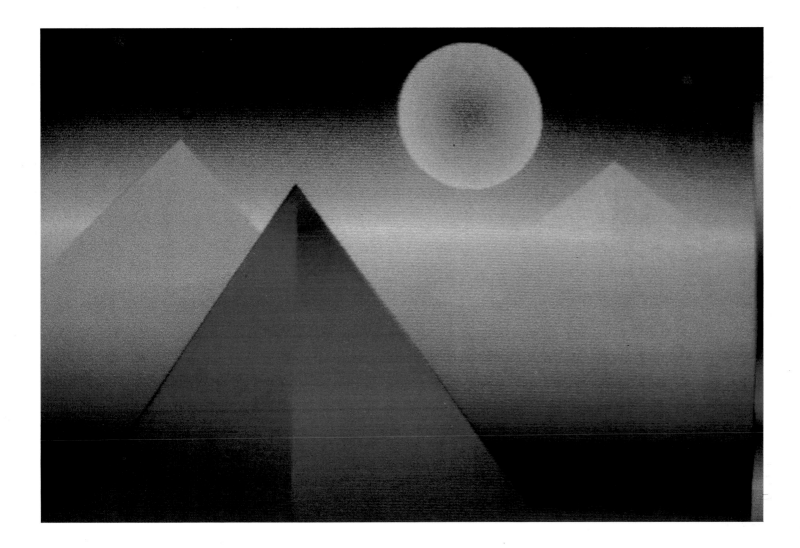

indefinitely. Whatever rules are programmed into the computer become the laws in force, governing precisely both the appearance and the dynamic evolution of the simulated world. The "realicorder" traveler will experience that world so realistically that no suspension of disbelief is required.

The images presented in this chapter are like windows that look out onto many different fantastic worlds in which the laws of physics are strikingly different from those we encounter in the course of our ordinary experiences. While we are familiar with the rainbow, perhaps we are less familiar with the same spectrum

224. Yoichiro Kawaguchi of Nippon University in Tokyo has created a futuristic world with his mathematically simulated imagery. Here is one of his more abstract landscapes.

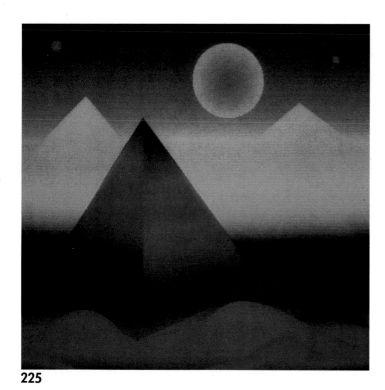

225

225, 226. Kawaguchi uses complex mathematical formulas to produce his intense, colorful computer-graphics landscapes filled with elemental shapes and imagery. By combining familiar shapes and forms with vivid coloring, he draws the viewer into an exciting new world.

of colors split apart by a prism. Are the color patterns of the opening images (see photos 219-220) struck off from prisms formed from new materials in a new geometry or have the physical laws of optics been rearranged? Looking through some of the other windows, we find worlds in which objects float without regard to gravity. The computer artist's skill, which is so well illustrated here, is to model the fantastic world so thoroughly and present it so accurately that it is convincing and compelling. Are the spheres floating above the tiled plane (see photo 222) held there by a magnetic repulsion? Are they light enough to spin under the force of the rays that illuminate them?

In computer simulation, fantasy is often interwoven with reality, as in the case of the student attempting to pilot an electronically simulated jetliner. There the situation being simulated is one that takes place hundreds of times a day. Yet there are other situations, quite as real as flying, in which even the presence of a human being in that environment is imaginary. While all of the stars and planets in the universe are real, many are closed off to human travel. According to current theories, there are stars even in the close neighborhood of our sun that no human explorer will ever be able to visit and report about. The distance from earth to these stars is far too great to be covered during the short span of human life on earth, and traveling faster than the speed of light is considered impossible. Yet by deftly combining fact and fantasy, we can "travel" to otherwise inaccessible worlds via the computer. Using the computer, we might approach a planet orbiting the two central stars of a binary star system, if you wish. Then, with the facts of astronomy and physics ever at our disposal, we can take the controls of a simulated spacecraft and either orbit around or descend to this planet, alternating between fantasy and reality. For all its fantastic appearance, the ensuing spectacle of evenings and mornings we will see in this world of two suns is as real as the rest of the galaxy. Other journeys might take us not just beyond the speed of light but across other equally formidable physical barriers. **226 ▷**

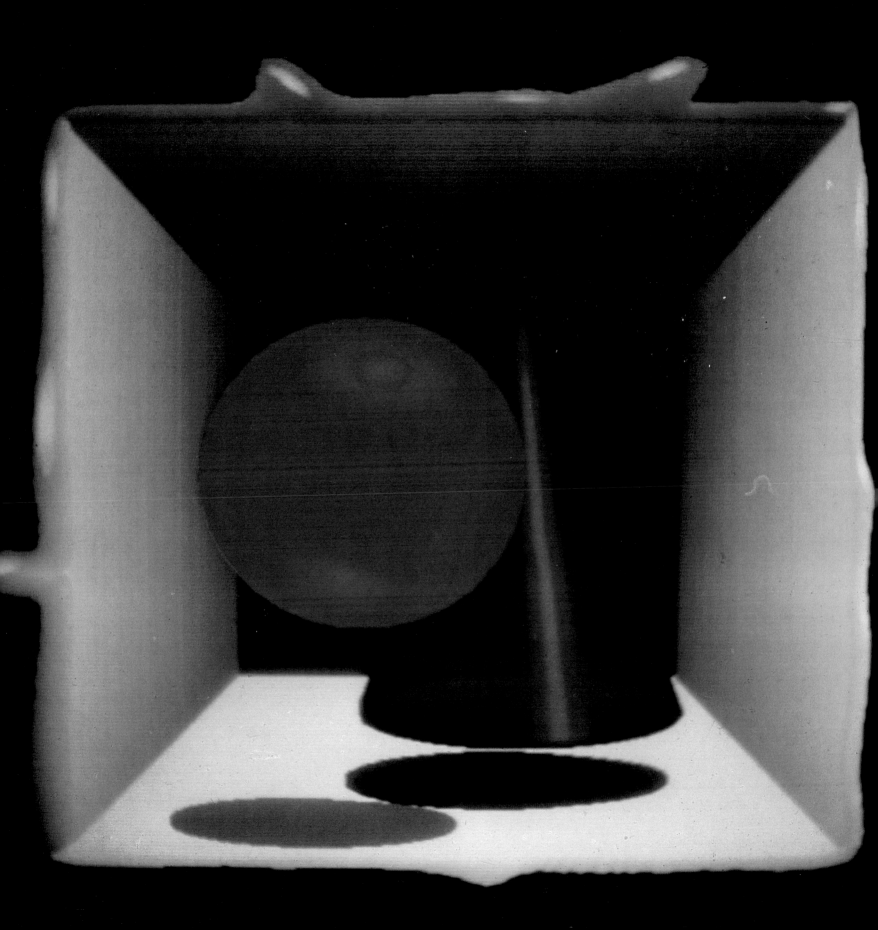

227

We might journey backward in time to watch the formation of the continents and the demise of the dinosaurs or forward to watch the next few visits of a comet.

Imaginary travels to real places are not the only computer fantasies capable of blending the impossible with the real. The computer makes it possible for the artist and the cinematographer to combine real objects with startling technological effects. Objects with familiar forms and strong connotations are brought together and made to interact in ways that we might previously have imagined only in dreams but are now able to see with credibility and clarity. If the images here (see photos 223–227) are any guide, computer fantasy seems naturally suited to generating powerful surreal images. Simple geometric shapes appear in deep, vivid colors, with tones and textures that extract and combine the optical properties of many diverse physical materials.

The pillars of Stonehenge and the figures of Easter Island (see photos 228–229) are the inspiration and beginnings of fantasies. These images challenge our previous assumptions and fill us with questions. What is the material that stands massively and glows with the sheen of a satin ribbon? We see the columns of Stonehenge bulge. Is space distorted on this spot? Has gravity increased a hundredfold to compress the stonelike material? What mysterious light source illuminates these

228

229

227–229. Yoichiro Kawaguchi's realistic fantasies: opposite, a ball floats in space; above, his impressionistic view of Stonehenge; right, a haunting depiction of an Easter Island statue.

Overleaf: 230, 231. Industrial Light and Magic Company used Evans and Sutherland's Digistar digital planetarium projection system, PS II and CSM Color Display to create these starships for the movie *Star Trek II: The Wrath of Khan.*

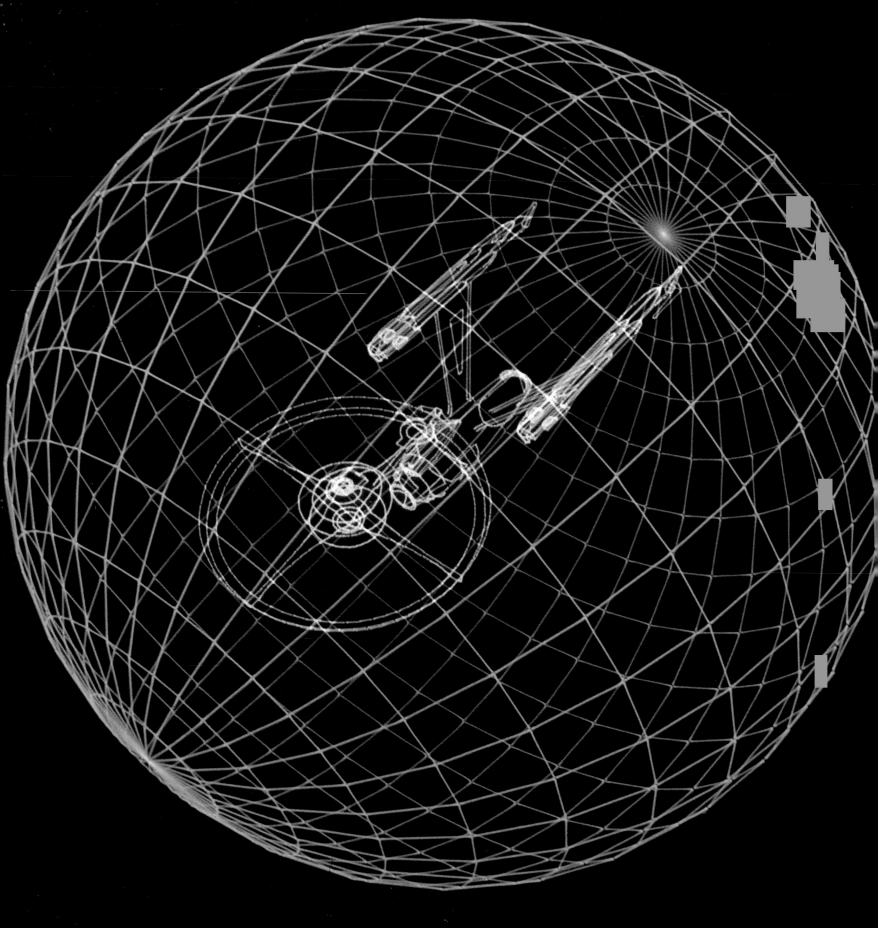

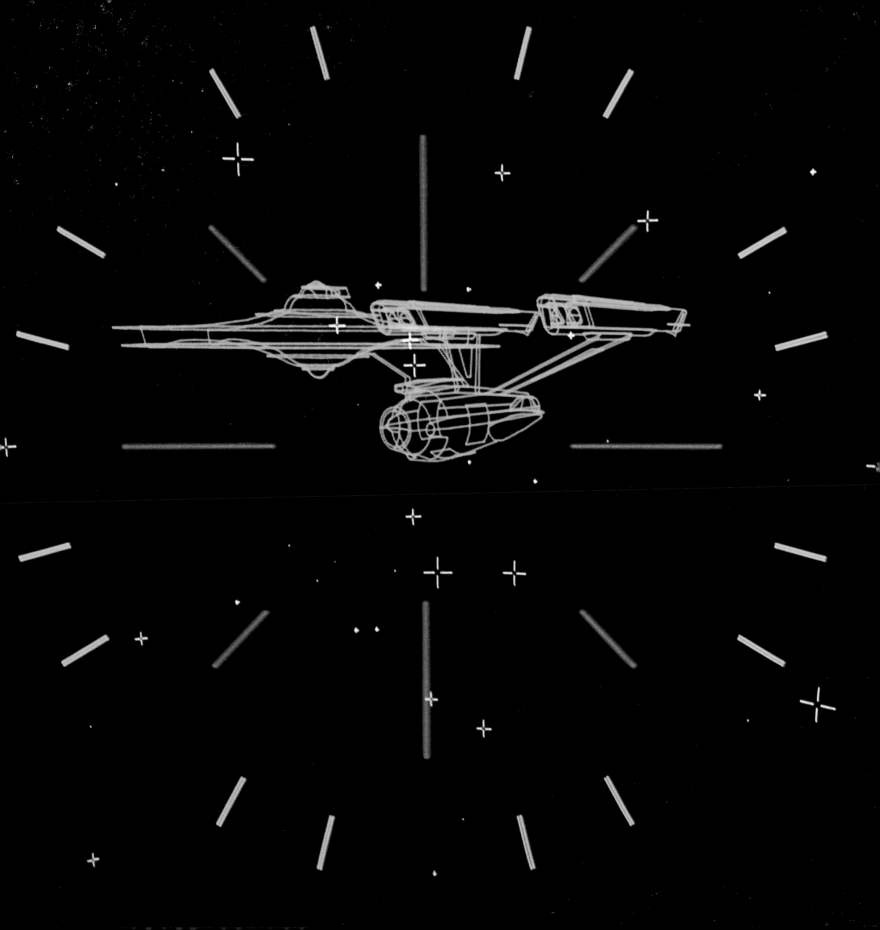

colossal masks? And why do they seem to echo the color of the galaxy beyond? These questions have many answers. Some have been encoded within the computer's memory by the artist, creating new physical laws that transform shapes and optical properties. Other answers are left for the viewer to discover and formulate.

The flexibility of the computer-modeling process makes an image situation both adaptable and responsive. The basis for the image in the computer is a mathematical structure replete with settings and parameters, like a fantastic sound system with hundreds or thousands of dials. The artist tunes the image and observes it, finally freezing one special instant on the screen. If one view does not capture the scene, then the artist can collect several different viewpoints. Dynamic sequences arise naturally, perhaps to be captured for an animated film. By turning the dials the artist can make the image: a galactic sunrise begins and the figure materializes from thin air, colored by the hue of the emerging stars (see photo 229). The ultimate option available to the artist is to create the situation and leave it, with its "life-support" computer, to the audience. Rather than simply being a conventional work of art, it has become a participatory fantasy.

Mind Games

Fantasy worlds created in the computer medium are not simply illusions but responsive, interactive environments ideally suited to provide both the setting and the substance for captivating and challenging games.

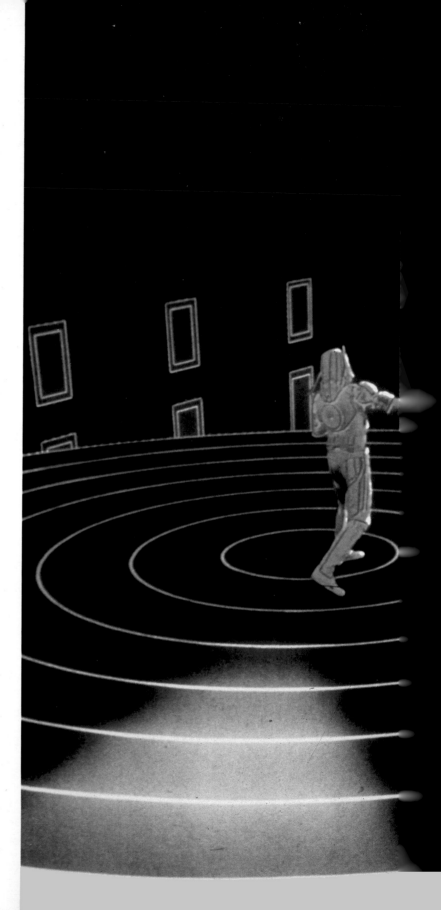

232. A game player in *Tron* throws some light, jai-alai-style. The images from *Tron* were often made by combining live action with matte paintings and computer graphics. The result was to create one picture by overlaying as many as two dozen separately created scenes.

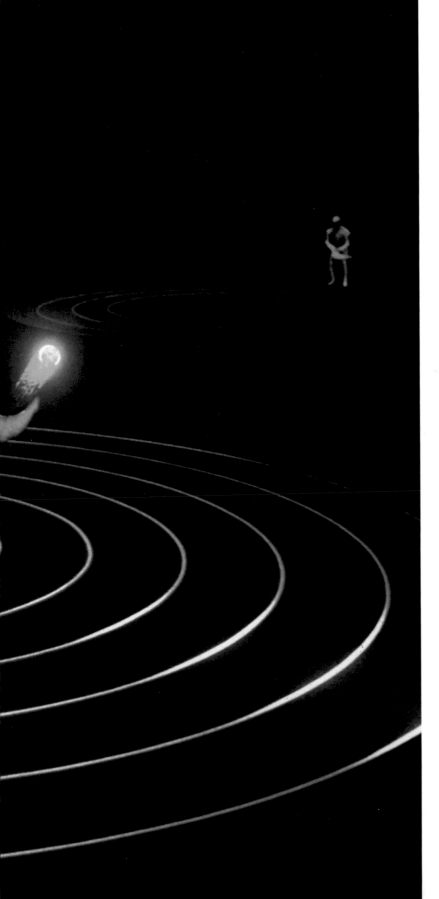

One game we have already seen is "exploring." Whether you wish to prowl around Aspen, Colorado, or Alpha Centauri, no book or travel movie has ever been as effective as interactive computer imagery in equipping your imagination with the raw material needed to take you there. For amusement, your travels can include a treasure hunt if you wish. Other, more exotic environments may attract you as well. Size and speed constraints and all those nagging human requirements of oxygen, moderate temperatures, and so on, can be dispensed with immediately. If the structure of the environment is known, the computer can model it and whisk you there for a tour. Why not explore the human cell from the perspective of a protein molecule? Or ride the trajectory of a subatomic particle, accelerating to a spectacular, identity-transforming collision. It may just be a pleasure cruise to these exotic worlds or, as in the best tradition of science, you may bring a human perspective to vast amounts of data.

Other fantastic environments are more remote from their inspiration in natural science, other games more complex and artful than simple travel. There are new identities and powers to be assumed, new challenges to be met, new battles to be fought. The starship captain must respond in seconds to plot a new course, jumping faster than light to evade an enemy. Shielded by glowing armor, you may become an electronic gladiator hurling photonic Jovian thunderbolts in a titanic struggle. (Beneath this mask of fantasy, your opponent is simply another enthusiastic human player.)

The lure of interactive electronic games has made them a mainstay of the personal computer industry even though the quality of early home-computer graphics is primitive by the standards of Hollywood films or professional aircraft simulators. Games are a perennial form of fantasy that can captivate the participants with no more than colored cards or stones or wooden figures moved on a board. And even rudimentary electronic screens provide color and interaction in abundance. The player's attention is focused for fine-tuned reactions and split-second decisions in a way that static

boards and markers could never accomplish. In a hundred variations, and in a thousand electronically crafted fantasy environments, computer games that are no more than hide-and-seek or tag in concept flourish.

Low-cost, high-quality computer-graphics systems based on microcomputers have already begun to appear. Today a graphics-workstation computer for industry or art costs approximately one-tenth of its price three years ago—less than many automobiles. As the downward trend in price and the upward trend of power continue, the home computer will eventually gain as much respectability for synthetic image generation as home stereo systems have acquired for reproducing high-fidelity sound. How will this affect computer games? It is an obvious fact that mechanical pinball machines are an endangered species. It would be a mistake, however, to conclude that more widespread and sophisticated computer graphics will simply mean better and more baroque versions of spot-and-swat.

The games of the mind are also beginning to benefit from image technology, albeit in a less gaudy fashion than the galactic chases and games of reflexes. For example, chess can easily be shown on a screen symbolically, the image changing as the game progresses. The display is more interesting if it is not merely symbolic but is a realistic three-dimensional view. Developing the interaction even further, though, it is possible to tap into the structure beneath the surface of the display and bring it more clearly into view. The computer can be a tutor or an opponent, visually highlighting weak spots and patterns on the board, perhaps by showing threatened pieces noticeably quaking, or weak squares on the board displayed as gaping pits. In addition to their visible forms, pieces might cast shadows along their main avenues of attack, thus warning the player. At your request, the computer can match the present game position in some respects with games it has stored in memory and recall these to the screen for review. The game program can also look ahead and evaluate a possible move or suggest a number of alternatives. The pieces themselves may be invested with personalities so that they have the ability to speak up and suggest either individual or joint moves with their cohorts. The intent of such personification may be to teach the game or perhaps to create a new chess hypergame in which the personalities of the pieces are a new dimension that actually affects the rules and strategies of play.

Computer fantasy, as even the static images of this chapter convey, is as beautiful and alluring as the sirens' song. Unfortunately, like that song, it can lead to enslavement. The optimistic promises of educational and intellectual innovation that accompanied the introduction of television are now memories belonging to a bygone era. As more powerful home computers and interactive videodiscs enter the scene, is an even bleaker world of video junkies over the horizon? Are we destined to be plagued by hordes of arcade games and their descendants as they replace the sitcoms? Without being unrealistic in our optimism, it is encouraging to think that though chess lies at the other end of the spectrum from electronic pinball reflex games, its pleasures too can be substantially enhanced by computer visual support. In addition, that support will enable more people to participate in challenging intellectual activities like chess (at least as competent

233. David Em's artwork combines images from fantasy and reality. With the help of Jim Blinn's programming expertise, Em's work comes out of the computer as an extraordinary amalgam. In *Bill*, eggs and columns rise from a marbleized background.

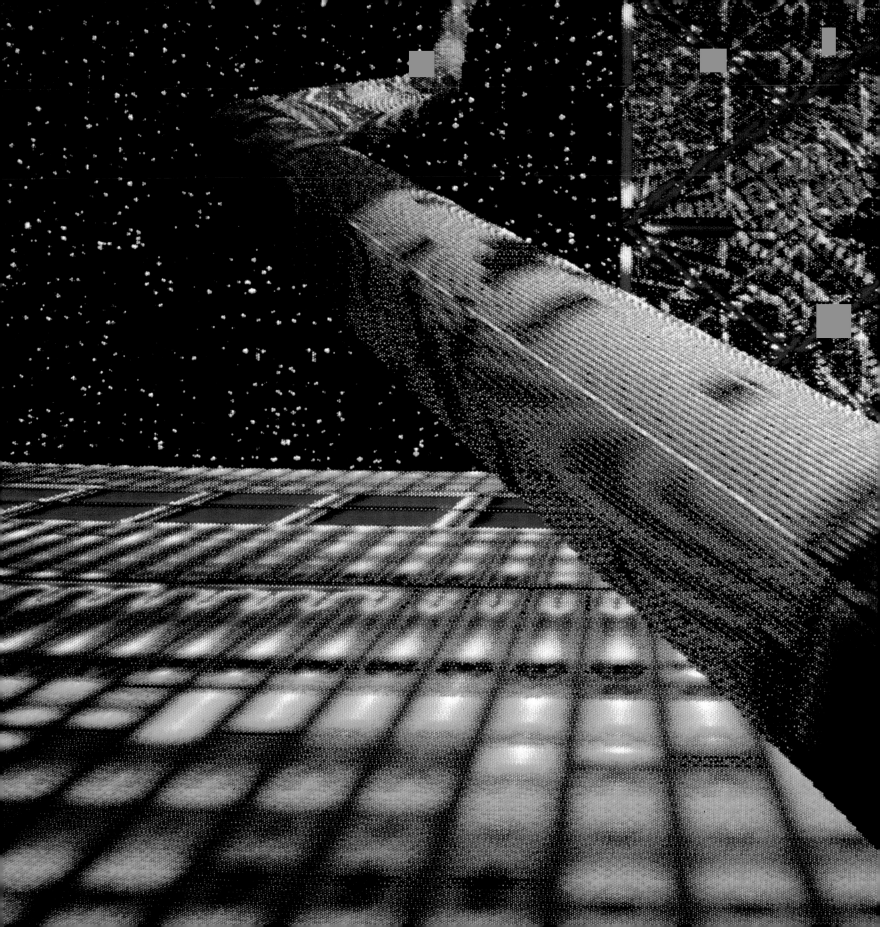

amateurs). There are few limitations to the productive potential of the computer. It has the capacity to labor untiringly with a magician's visual repertoire and a master teacher's concern for his students. In the hands of creative computer artists and teachers, the computer can be used to enrich the human mind as well as occupy it.

In his book *Mindstorms—Children, Computers, and Powerful Ideas* (Basic Books, 1982) the pioneer educator Seymour Papert describes the results of his years of research designing computer fantasy worlds for children. In these microworlds for learning, young children develop intellectually and acquire a wealth of skills as easily as they absorb language in the ordinary world. The microworld is a friendly world, one with turtles that move, communicate and draw pictures. The fantasy is totally and thoroughly supported by computers (self-directing computerized turtles often roam the classroom rather than being confined to a video screen). There is no rigid curriculum; there is the fun and challenge of teaching new words to turtles and observing their fascinating behavior in interactions. In the process, the youngsters develop the ability to think scientifically as well as a practical grasp of epistemology and substantial insight into such subjects as differential geometry and Newtonian physics.

234. David Em's *Transjovian Pipeline* brings us inward to outer space. This computer artwork demonstrates the depth and "three-dimensionality" that are possible from a two-dimensional image generated by a computer.

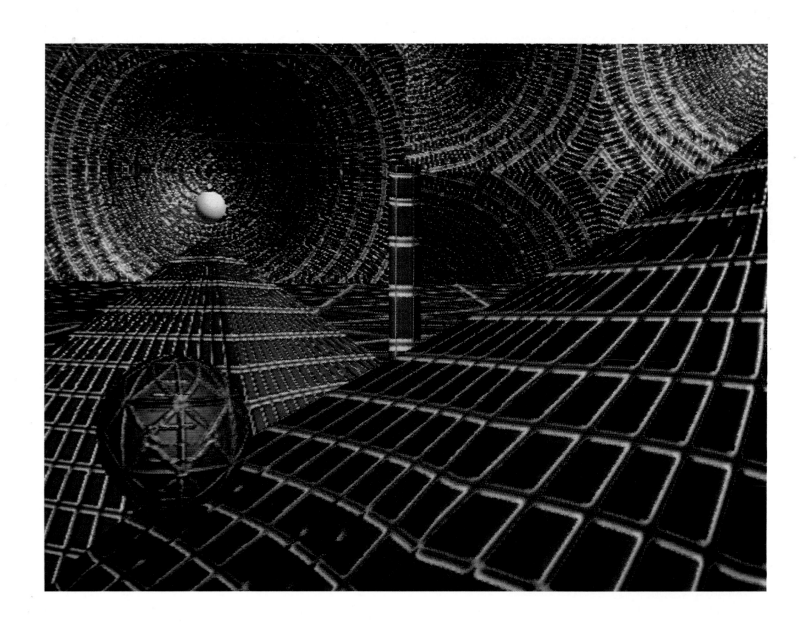

235. *Orejo* by David Em shows the depths of contemporary computer-created art.

236. This Digital Productions image is an abstract, fantasy staircase leading, perhaps, to the heavens.

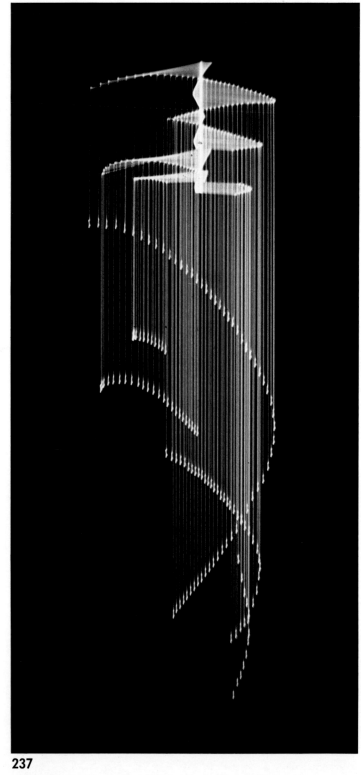

237

238

The inevitable arcade games and other spin-offs, such as potboiler fiction and mass-produced artifacts, should not obscure the role and value of computer-generated fantasy: As a creation of the human mind, it is a mirror that reflects the human psyche. As a medium for fantasy, the computer polishes that mirror to unprecedented clarity. If the fantasy itself is orderly and communicative, as Papert's microworlds are designed to be, even children can find within them the roots of active human reasoning. If the fantasy is surreal, we may begin to see the structures of human dreams and states of consciousness. If the fantasy is beautiful in its interactive display, we can perceive the sensations and emotions of art in fundamental new ways.

239

237–238. Fred Stocker and Rob Fisher of Penn State University turn their artistic hands to sculpture design and analysis studies.

239. This abstract design was taken from Psychological Studies of Dynamic Form and Motion done in the 1970s by Fred Stocker.

184

8. IMAGE EVOLUTION

The computer-image engine plays an even more fundamental part than its previously discussed role as an unsurpassed medium for capturing and expressing human designs. Within the computer environment, information reactions take place, spreading through the memory-medium like fire. The simple spark of a mathematical relationship develops here, producing a spatial pattern of color, shape and form. More sophisticated reactions lead to stable, actively evolving constructions that mimic the processes of biology and developmental genetics. In supporting these evolving images, the computer has become an electronic ecology. History will record the construction by human beings through genetic engineering of new life-forms that breathe oxygen and assimilate carbon. The images shown here demonstrate the existence of other invented species that breathe information and assimilate silicon.

Information Reactions

From the discovery of fire to the technological advances of the present, the taming of chemical processes has been central to human development. Fire has been with us for millennia, and we have used it for everything from cooking food to working metal to generating electricity, sometimes without fully understanding how these chemical reactions work. Like the oxygen we learned to mobilize by fire, information, too, permeates our human environment. By using our primitive computers, we are now learning how to kindle new fires of information reaction, just as we used the rough flint tools and tinder of ages past to kindle fire. These self-sustaining chain-reaction processes can be initiated within the computer; they then spread by feeding on information as thermal fires feed on oxygen. The images that begin this chapter are the flickering lights of such newly kindled fires; they suggest the wonder our predecessors must have experienced at the first sight of captive flames.

To illustrate self-sustaining information in a graphic way, I will describe here the fundamental "Turing machine" concept developed by Alan Turing, but replace his "finite state machine" with a more easily described humanlike "actor." The description is as follows: Imagine a mosaic, perhaps a large one, with tiles numbered 1, 2, 3,... from left to right and from top to bottom in orderly rows and columns. An actor

240. H. W. Franke, who wrote one of the first books ever published on the computer as an artistic tool, uses the computer himself to create this dazzling artistic display.

241. Lexidata equipment was used to create the design for an Oriental carpet.

goes from tile to tile, coloring the faces of these tiles to make images. (Imagine that he gets around very rapidly, visiting millions of tiles per second.) There is enough space on the back of each tile for the actor to write messages to himself, and the actor also carries a slate for temporary instructions. The actor knows how to carry out only a limited repertoire of instructions, for example: "Go to a new tile"; "paint the front of the tile"; or "write a message on the back." Whenever the actor finds he has nothing to do, he will read the back of the tile he is currently on and do what it says.

This actor-and-paint ecology may seem whimsical.

If you prefer, consider the tiles as computer-memory locations and, instead of the actor painting them, imagine using memory mapping to translate tile contents into screen images. Whether or not it is embellished with technical details, the result of this computer ecology is an infinite variety of information reactions we can set off with a small initial spark. The reaction will grow like a well kindled fire, eventually lighting up the entire mosaic. As you will see, the actor (or a computer's processing unit) does not know the final image but acts merely as a catalyst, spreading information through the mosaic. No human or computer draws

242. A cartoon frame made by Ed Catmull, the founding director of New York Institute of Technology's Computer Graphics Lab and now the head of Computer Graphics at Lucasfilm Ltd.

243

244

these images any more than the laws of chemistry them-selves create a biological organism. Rather, the initial image itself, like the initial biological cell, creates the final image by evolution.

As a simple example of an information seed which will evolve to fill the entire mosaic, suppose we write only one message for the actor, on tile number 1, and then position him on that tile to carry out its commands. Here is the message:

Copy this entire message onto your slate.
Replace (in the message on your slate):
 —any number with the next number.
 —the word "red" with the word "black."
 —the word "black" with the word "red."
Go to tile number 2.
Move (i.e., remove and copy) the instructions from
 your slate onto the back of that tile.
Paint the tile red.

Like a biological seed, this first message is copied, transformed, and then duplicated over the tiles. For example, the first transformed version (which appears on tile number 2) is:

Copy this entire message onto your slate.
Replace (in the message on your slate):
 —any number with the next number.
 —the word "black" with the word "red."
 —the word "red" with the word "black."
Go to tile number 3.
Move (i.e., remove and copy) the instructions from
 your slate onto the back of that tile.
Paint the tile black.

The reaction outlined above is uncomplicated, thus the resulting pattern is simple. If the number of col-umns of tiles in the mosaic is odd, the final design is a red-and-black checkered pattern. If the number of col-

188

245

243–245. These abstract images are developed by mathematical functions on SAI workstations.

Overleaf: 246–255. Yoichiro Kawaguchi is one of the most accomplished artists using the computer for creative purposes today. His fascination with the mathematical relationships inherent in the spirals of shells, trees and roots is shown in these spectacular images.

umns is even, the final design is alternating red-and black vertical stripes. In more artistic examples implemented by computers (even the modest personal type), self-sustaining reactions that produce vastly more sophisticated images can be initiated. The computer can store and copy long and intricate messages at extremely high speed, rapidly covering a mosaic of minute tiles with a large spectrum of colors. The pattern that spreads out over this space can combine both regular features such as geometric shapes with fluctuating naturalistic effects such as waves, clouds and mist.

A fundamental way to kindle more interesting reactions is to take into account not just the simple, direct instructions given to the computer regarding the color of a specific tile but the colors of neighboring tiles as well. By "seeding" the initial mosaic with scattered colored tiles, diffusion and suspension effects such as those shown here (see photos 243–245) can be achieved. The resulting color variations may settle into a stable pattern or change continuously like the colors of a soap bubble.

A simple but interesting example of such a reaction (where neighboring tiles influence the way in which information is copied, transformed and recopied) is furnished by J. H. Conway's game "Life." To play this game, pick a color and paint some of the tiles of the mosaic with it. Leave the remaining tiles uncolored. The rest of the game is easy: simply sit back and watch the information reaction. The rules of this reaction are that in painting any tile of the mosaic, the computer will take into account the colors of all neighboring tiles that touch it. (Inside the mosaic, a tile has eight neighbors: the four that share its north, south, east and west borders in addition to the four tiles at the corners.)

The rules are as follows:

1) Any uncolored tile that has exactly three colored neighbors will be colored.

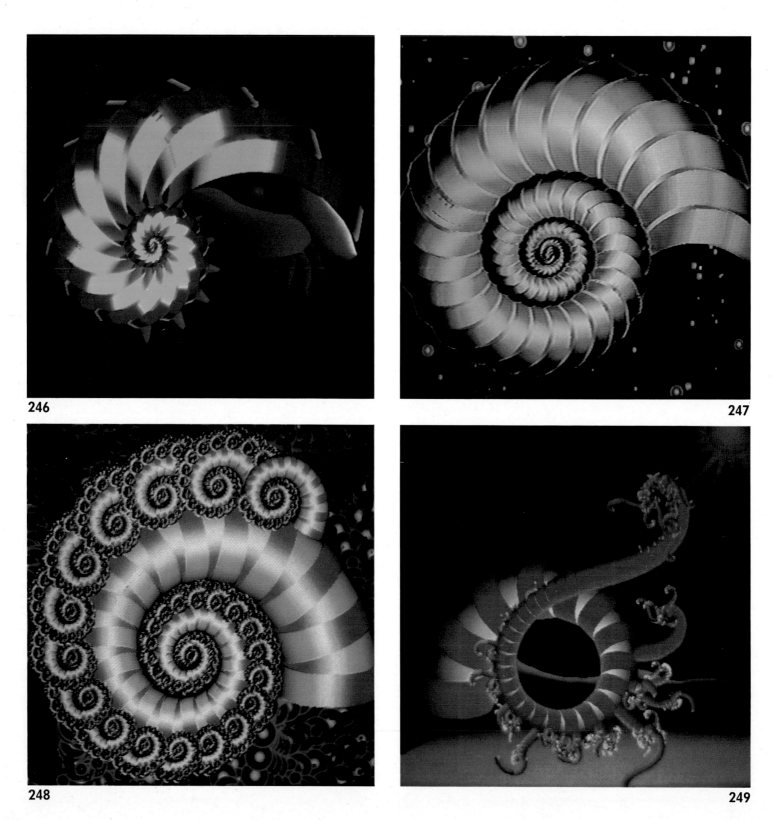

246

247

248

249 250

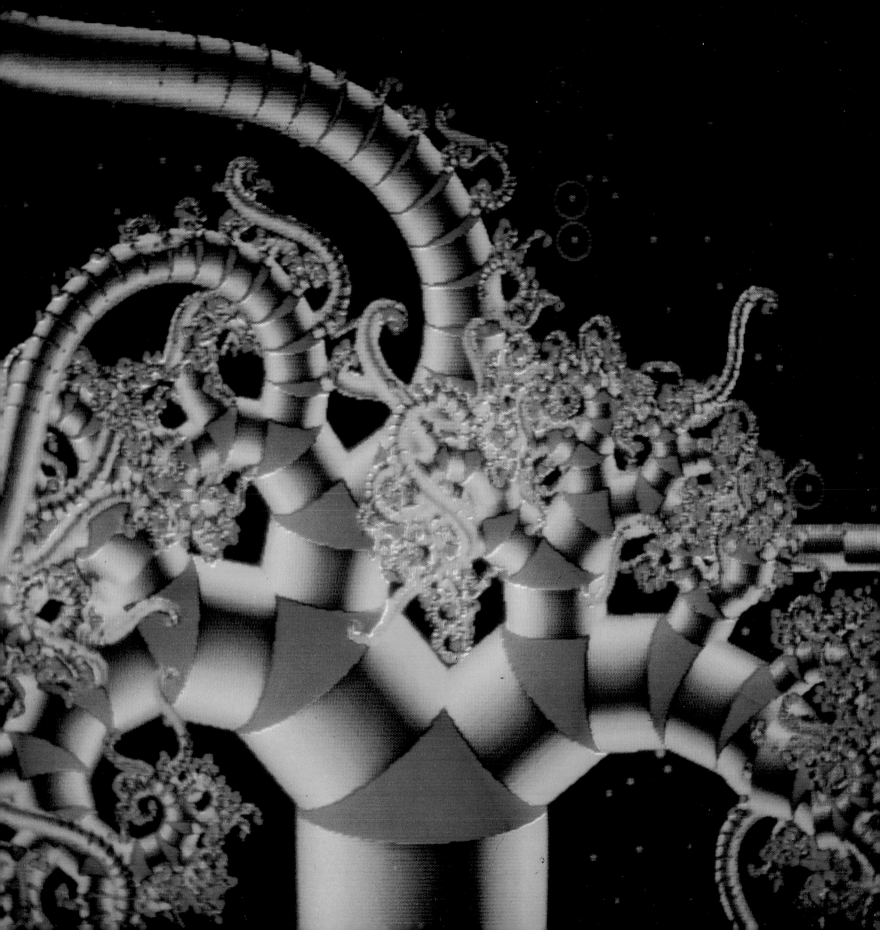

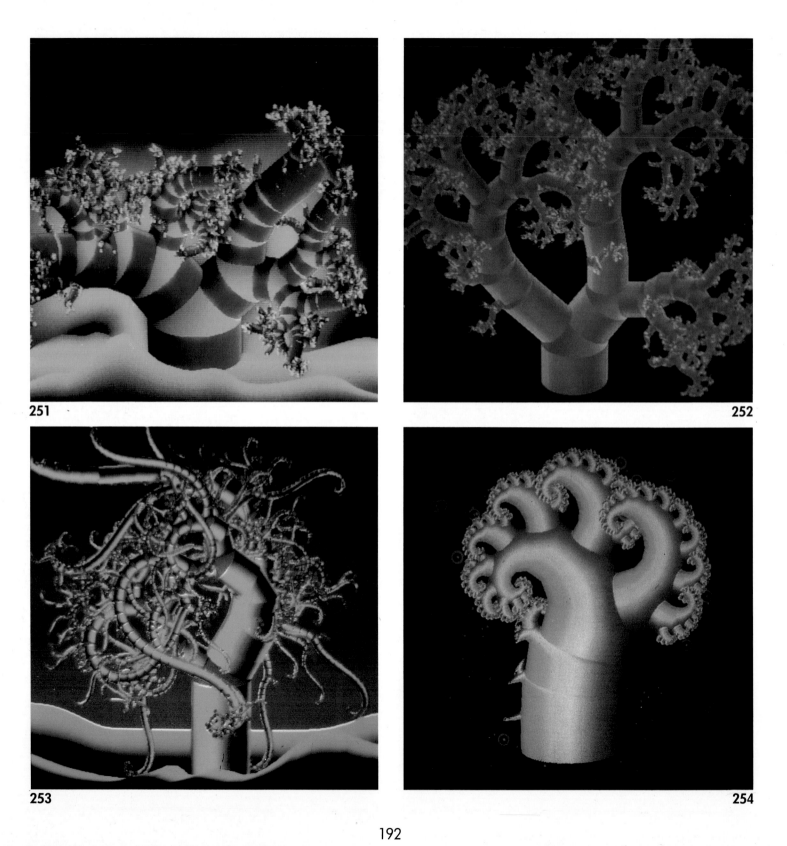

251

252

253

254

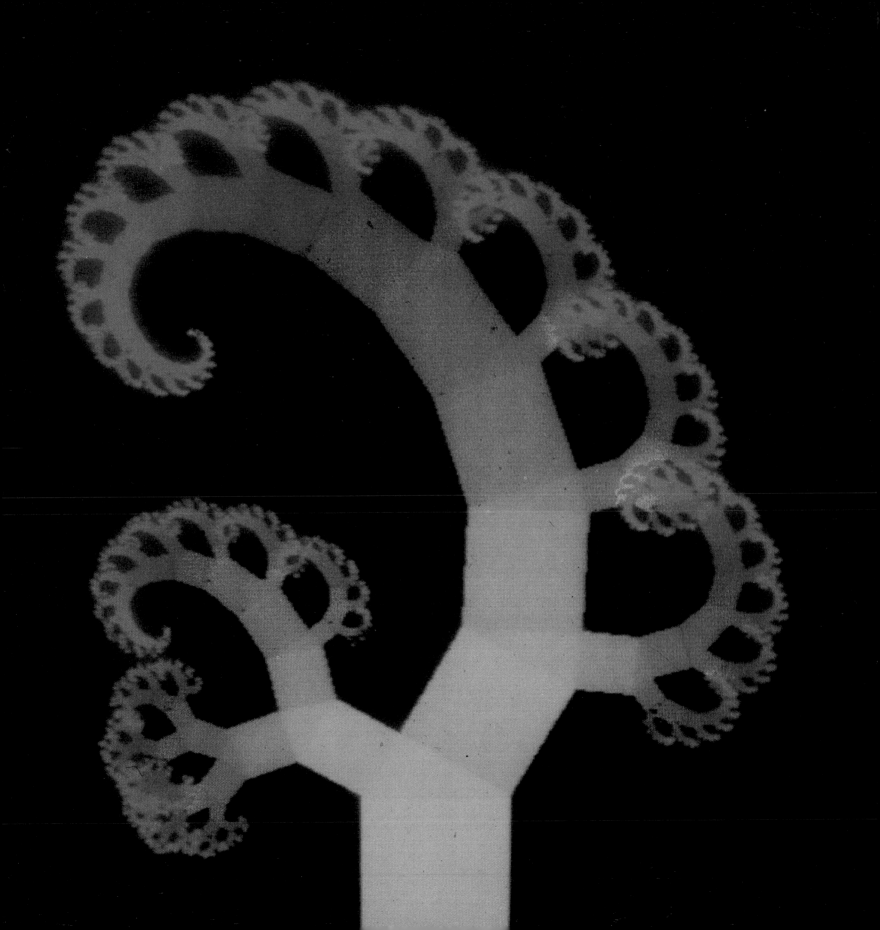

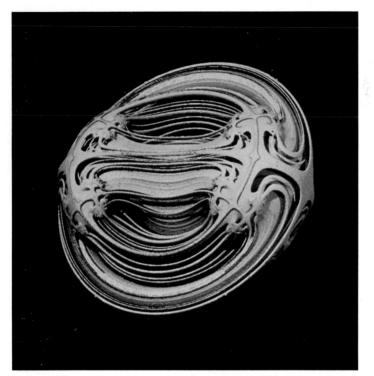

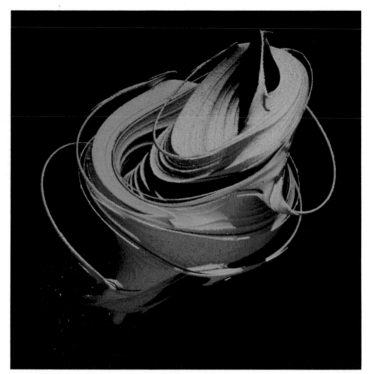

256, 257. Alan Norton is a mathematician, computer scientist and artist working at the IBM T. J. Watson Research Center in Yorktown Heights, New York. These images show his manipulation of fractal geometry (created by IBM colleague Benoit Mandelbrot) to create three-dimensional fractal imagery. The results are forms that were never even imaginable before the advent of the computer.

2) Any colored tile that has two or three colored neighbors will remain colored, otherwise it will be uncolored.

To appreciate the word "Life" as a title for this reaction, think of the colored tiles as cells that are born and survive under the proper social conditions but die if they become either too isolated or too overcrowded. Life patterns continuously develop from their initial shapes and arrangements, stabilizing, migrating and disappearing throughout the mosaic. While it may seem farfetched to describe the aggregation and dispersal of these undifferentiated electronic prokaryotes as life, remember that their development has scarcely begun compared with that of biological organisms. But the process of electronic implantation has been initiated. The final images here (see photos 246-257) suggest how rapidly new life-forms can evolve.

Morphogenesis

Almost simultaneously with their invention of the stored-program computer ecology, intellectual pioneers like John von Neumann recognized the capacity of infor-

mation to self-replicate. The subsequent discovery of the biological storage and reproduction of information executed by the mechanism of DNA marked this original insight into self-replication as prophetic. Beyond replication, though, biological cells are capable of active processes such as metabolism. In ways that are far less clearly understood than the replicative mechanism of nucleic acids, the cells' own activity and products guide not just further duplication but *morphogenesis,* the evolution of the forms and systems of a complete organism.

The single biological cell replicates to form not only a dispersed set of duplicates or an amorphous aggregation, but a differentiated structure, whether this is an early blastocyst or a fully functioning complete organism. And it is fascinating to observe that the first significant approach to human understanding of this process of morphogenesis as well as for self-replication, emerged from another computer pioneer, von Neumann's contemporary, Alan Turing. Turing's early work, which explained the capabilities of a vast variety of potential computers by reducing their operations to that of a universal computer, is a cornerstone of modern computer science. From there, he went on to elaborate on the nature and potential of "machine intelligence," anticipating computer developments that may not be achieved until the end of this century. Turing's most lasting contribution, however, may well be an entirely new approach to the evolution of form. In his kinetic theory of patterns, Turing proposed (for the first time) a detailed "chemical basis of morphogenesis."

The systems of equations that Turing developed are actively being studied, elaborated upon and implanted in the ecologies of today's computers as scientists try to explain biological morphogenesis. In that context, the images formed are not simply fascinating abstractions or "games of life" but models representing the foundation of biological life and structure. If those models should be successful, these images will represent the earliest beginnings of the parallel evolution of new life-forms inside computers. Because the computer has become the primary tool of scientific research and language, that parallel evolution will undoubtedly be guided to converge with and illuminate our own biological experience. Realistic, recognizable analogs of earthly organisms will form and exist independently in the electronic environment. However, it is information reactions rather than the specially restricted chemistry and physics of planet earth that comprise the driving force behind the evolution of "live" computer images. Hence that evolution must also be expected to diverge, creating forms and functions of life in varieties and dimensions that we can but dimly imagine.

INDEX

Italics indicate illustrations.

PHOTO CREDITS

1. Dolphin Creative Team and John Corporon of Independent Network News.
2. Lisa Zimmerman/Aurora Systems
3. Amagin, Inc. of Erie, PA. Robert J. Chitester, Executive Producer. Anthony Machi, Producer/Director.
4, 5. © Dan McCoy/Rainbow
6. Paul Jablonka, Tucson, Arizona 85719
7. *Frozen Suncone* Joanne P. Culver, 1982
8. Melvin L. Prueitt, Los Alamos National Laboratory
9. Richard Balabuck. Produced at Ohio State University Computer Graphics Research Group.
10. Damon Rarey/Aurora Systems
11. Courtesy Gould Inc. DeAnza and Acme Productions
12. Huitric and Nahas
13. Software: Infomap, Inc. on the Superset, Inc. PGM hardware
14. Huitric and Nahas
15. © Richard Lowenberg
16. Akuma Takegami Courtesy of JCA
17. MAXFLI DDH "Energy." Executive Producer: Robert Abel; Producers: Clark Anderson, John Hughes; Designer: Clark Anderson; Directors: Clark Anderson, John Hughes; Animators: Con Pederson, Clark Anderson; Editor: Rick Ross; Agency: J. Walter Thompson/Atlanta; Creative Director: Michael L. Lollis; Copywriter: Bruce Levitt; Art Director: Bill Tomassi; Agency Producer: Michael L. Lollis. ROBERT ABEL & ASSOCIATES.
18. Mike Newman/Dicomed Corporation
19. Ned Greene Courtesy NYIT Computer Graphics Lab. Technical support: Paul Zander, Jr. and Lance Williams
20. Created & Produced by Acme Cartoon Company, Inc., Dallas.
21. © 1982 Nancy Burson with Richard Carling and David Kramlich
22, 23. Mike Newman/Dicomed Corporation
24. © 1982 Walt Disney Productions

25. Pirelli, 1981 for Pirelli Tires. Production House: Cucumber Productions; DEI Design/Direction: Jeff Kleiser; Animator 1: Don Leich, Animator 2: C. Robert Hoffman, Animator 3: Stan Cohen; Contributor: D.L. Deas
26. Subway, 1981. Production House: DEI; DEI Design/Direction: Mark Lindquist; Animator 1: Mark Lindquist
27. Courtesy of Gould Inc. DeAnza and the European Southern Observatory
28, 29. © Dan McCoy/Rainbow
30. Yoichiro Kawaguchi
31, 32. © Richard Lowenberg
33. Lumbar vertebra, 1982 for Dr. Steiner of Rutgers Medical School. DEI Design/Direction: Judson Rosebush; Animator 1: Alan Green, Animator 2: Donald Leich, Animator 3: Gene Miller; Contributor: C. Robert Hoffman III
34. © Richard Lowenberg
35–39. © Dan McCoy/Rainbow
40, 41. Courtesy of Gould Inc. DeAnza and Tony Ricci of the Lab of Nuclear Medicine, U.C.L.A.
42–61. © Richard Lowenberg
62–65. Douglas B. Nelson, Sun-Star Productions, P.O. Box 3916, Beverly Hills, CA 90212
66–70. Evans & Sutherland/Petty-Ray Geophysical, Geosource
71. Courtesy of Gould Inc. DeAnza and Seiscom Delta
72. Photo by Curtis Fukuda, courtesy Gould, Inc. DeAnza and the European Southern Observatory
73. Courtesy of Gould Inc. DeAnza and the European Southern Observatory
74. Dicomed Corporation/Mpls., MN
75. © Dan McCoy/Rainbow
76. Landsat/Dicomed Corporation, Mpls., MN
77. Lexidata Corporation
78. Courtesy of Gould Inc. DeAnza and NASA Ames Research

79. Mike Newman/Dicomed Corporation
80. Damon Rarey/Aurora Systems
81, 82. © 1982 Walt Disney Productions
83. *Decor,* courtesy of Digital Equipment Corporation
84. Video Palette Image. Production House: DEI; DEI Design/Direction: Andrea D'Amico
85. Link Flight Simulation Division, The Singer Company
86. Timex, 1982 for Timex. Agency: Grey Advertising; Agency Producer: John Greene; Production House: DEI; DEI Design/Direction: Jeffrey Kleiser; Animator 1: Alan Green, Animator 2: Don Leich
87. *Decor,* courtesy of Digital Equipment Corporation
88. Lisa Zimmerman/Aurora Systems
89. David Patton/Aurora Systems
90, 91. Mike Newman/Dicomed Corporation
92. Levi Strauss "Someday Santa." Producer: Robert Abel; Creative Director: Randy Roberts; Technical Director: Bill Kovacs; Animation: Con Pederson. ROBERT ABEL & ASSOCIATES.
93. Peter Crown/Romulus Productions, Inc.
94. © James T. Hoffman 1980
95–101. Mike Newman/Dicomed Corporation
102, 103. © James T. Hoffman 1980
104. © James T. Hoffman 1981
105. © James T. Hoffman 1982
106. Digital Scene Simulation (sm) by Digital Productions, Los Angeles, CA. © 1983. All rights reserved.
107. Ken Knowlton/Via Video, Mt. View, CA
108. © Phillip A. Harrington, Peter Arnold, Inc.
109. Lexidata Corporation
110. © Phillip A. Harrington, Peter Arnold, Inc.
111. © Manfred Kage, Peter Arnold, Inc.
112. © Phillip H. Harrington, Peter Arnold, Inc.

113. Photo courtesy of COMSAT
114. Peter W. Baker and Victor H. Leonard/Boeing Aerospace
115. Courtesy Patrick C. Orum, Martin Marietta Aerospace
116. Science Applications International
117–122. Wisconsin National Bank for AT&T. Production House: Harold Friedman Con.; DEI Design/Direction: George Parker; Animator 1: Donald Leich, Animator 2: Alan Green; Agency Producer: Gaston Braun
123, 124. *Decor*, courtesy of Digital Equipment Corporation
125. Dicomed Corporation/Mpls., MN
126. *Decor*, courtesy of Digital Equipment Corporation
127. © 1982 H. Lischewski, Most Media
128. Photograph courtesy of ARCAD, Los Angeles, Calif.
129, 130. Michael T. Collery, Cranston/Csuri Productions
131–133. Skidmore, Owings & Merrill
134. Dade County Stadium done for Skidmore, Owings & Merrill. Producer: Robert Abel; Directors/Designers: Bill Kovacs, Nick Weingarten. ROBERT ABEL & ASSOCIATES.
135–142. Photo courtesy of Applicon, a division of Schlumberger
143. Evans & Sutherland; PDA/PATRAN-G, product of PDA Engineering
144. Damon Rarey/Aurora Systems
145, 146. © Dan McCoy/Rainbow
147. Prof. F.A. Quiocho, Department of Biochemistry, Rice University
148–149. Science Applications International
150. Brad De Graf/Science Applications International
151, 152. © Langridge/McCoy
153, 154. © R. Feldman, NIH/Rainbow

155. *Foggy Chessmen*. David Weimer and Turner Whitted, Bell Laboratories.
156–158. © Dick Zimmerman
159–163. © Alan Zenuk
164. Rob Cook at Cornell University
165. Yoichiro Kawaguchi
166. Toshiba Greek, 1982 for Toshiba. Production House: Special Services; DEI Design/Direction: Judson Rosebush; Animator 1: Donald Leich, Animator 2: C. Robert Hoffman III, Animator 3: Gene Miller; Agency Creative Director: Soren; Contributor: Miguel Bronstein
167, 168. Yoichiro Kawaguchi
169, 170. Nelson Max, Lawrence Livermore National Laboratory
171. *Labyrinth of Datalist*. Art: Frank Smullin, software: Frank Smullin, Eric Bam, Richard Scoville and David Tolle
172, 173. © 1978 David Em
174. Courtesy New York Institute of Technology Computer Graphics Lab
175. Copyright 1982 by Information International, Inc. All rights reserved.
176. Courtesy NYIT Computer Graphics Lab. Artists: Dick Lundin and Lance Williams
177, 178. Conception: Norman I. Badler; Model: Joseph O'Rourke; Position: Jonathan Korein; Hands: Mary Ann Morris. Work done at Computer and Information Science Department, University of Pennsylvania.
179. © Dan McCoy/Rainbow
180. Chuck O'Rear
181–188. Douglas B. Nelson, Sun-Star Productions, P.O. Box 3916, Beverly Hills, CA 90212
189–192. © Frederick R. Stocker and Stanley Fitch 1980
193, 194. Courtesy of Gould, Inc. DeAnza
195. © Dan McCoy/Rainbow

196. Mike Newman/Dicomed Coporation
197–204. Rediffusion Simulation and Evans & Sutherland
205–209. Link Flight Simulation Division, The Singer Company
210. Science Applications International/U.S. Army
211. Courtesy Gould Inc. DeAnza and SAI
212. Courtesy Gould Inc. DeAnza and U.S. Army
213–216. © Dan McCoy/Rainbow
217, 218. Evans & Sutherland
219, 220. © Manfred Kage, Peter Arnold, Inc.
221. Brad DeGraf/Science Applications International
222. *Spheres*. Turner Whitted, Bell Laboratories. Reproduced with permission of Communications of the ACM.
223. Copyright 1982 by Information International, Inc.
224–229. Yoichiro Kawaguchi
230, 231. Evans & Sutherland/Paramount Pictures Corp.
232. © 1982 Walt Disney Productions
233. © 1982 David Em
234, 235. © 1979 David Em
236. Digital Scene Simulation (sm) by Digital Productions, Los Angeles, CA. © 1983. All rights reserved.
237, 238. © Frederick R. Stocker and Rob Fisher 1980
239. © Frederick R. Stocker 1978
240. © Dr. H.W. Franke, Peter Arnold, Inc.
241. Lexidata Corporation
242. Courtesy New York Institute of Technology Computer Graphics Lab
243–245. Brad DeGraf/Science Applications International
246–255. Yoichiro Kawaguchi
256, 257. IBM, T.J. Watson Research Center/Alan Norton

The text was set in Futura Book by U.S. Lithograph, Inc., New York, New York.

The book was printed on 150 gsm R400 gloss coated paper by Amilcare Pizzi s.p.a.—arti grafiche, Milan, Italy. Bound in Italy by Amilcare Pizzi.